GRACEFUL AND TRUE

Drawing in Florence c.1600

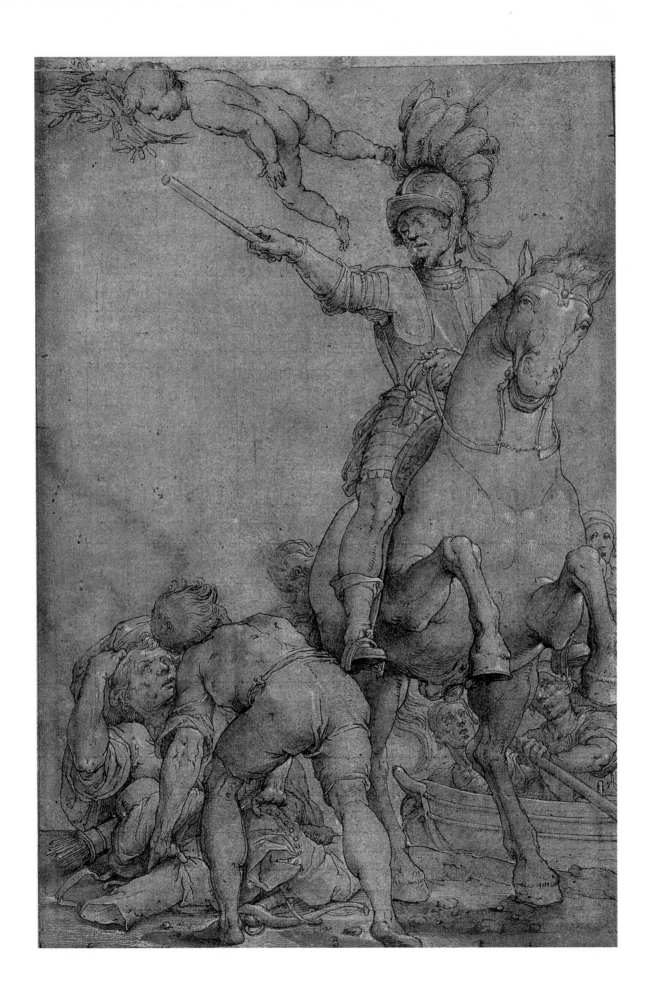

GRACEFUL AND TRUE
Drawing in Florence c.1600

JULIAN BROOKS
with an essay by CATHERINE WHISTLER

ASHMOLEAN MUSEUM 2003

Organized by the Ashmolean Museum
in conjunction with the Djanogly Art Gallery, Nottingham,
and supported by P. & D. Colnaghi

THE ASHMOLEAN MUSEUM, OXFORD
15 October 2003 – 18 January 2004

P. & D. COLNAGHI, LONDON
30 January – 2 March 2004

THE DJANOGLY ART GALLERY, NOTTINGHAM
12 March – 9 May 2004

British Library Cataloguing in Publication Data

A catalogue record for this book is available from the British Library

ISBN 1 85444 191 4

Catalogue designed by Tim Harvey
Typeset in Monotype Baskerville

Printed and bound in Belgium by Snoeck-Ducaju & Zoon, Gent, 2003

cover: Jacopo da Empoli, *A young man standing, in contemporary dress*, cat.51 (detail)
frontispiece: Jacopo Ligozzi, *A victorious commander on horseback*, cat.57
back cover: Lodovico Cigoli, *Joseph and Potiphar's wife*, cat.39

CONTENTS

FOREWORD

L INKS BETWEEN COLNAGHI and the Ashmolean have traditionally been strong: the previous Director of the Museum, Sir Christopher White, joined Colnaghi in 1965 after working in the Department of Prints and Drawings at the British Museum. Prior to that, James Byam Shaw, who spent his working life as a director of Colnaghi, collaborated on acquisitions with his close friend, Sir Karl Parker, Keeper of Fine Art at the Ashmolean from 1934 until his retirement in 1962. With a relatively small budget (and assistance from the National Art Collections Fund), Parker was able to buy extraordinary works of art from Colnaghi, either little-known paintings by important artists, or beautiful paintings by artists who were still relatively neglected, including works by Giovanni Battista Moroni, Luca Carlevarijs, Giorgio Vasari, and Francesco Maffei. A variety of drawings across all schools were added to the collection thanks to the collaboration of Byam Shaw and Parker, including sheets by Giovanni Battista Piranesi, Pietro da Cortona, Boucher, Watteau, van Dyck, Goltzius, and Stradanus. Byam Shaw also personally presented drawings by Taddeo Zuccari and Giovanni Battista Tiepolo to the Ashmolean during those years. As recently as 1998, a drawing by Francesco Vanni of the *Madonna of the Rosary* was purchased by the museum from Colnaghi, with the aid of the National Art Collections Fund, V&A Purchase Grant Fund and the Friends of the Ashmolean.

The mounting of loan exhibitions has a longstanding tradition at Colnaghi. A good example is the 1955 *Loan exhibition of drawings by the Carracci and other masters, from the collection of the Earl of Ellesmere*, organized with the Leicester Museum and Art Gallery, or the *Loan exhibition of drawings by old masters from the collection of Mr Geoffrey Gathorne-Hardy*, held at Colnaghi and the Ashmolean in 1971–2. The close links between Colnaghi and Oxford were strengthened in 1988 with the sponsorship of an exhibition, *Rubens in Oxford*, organized by Brigid Cleaver, Catherine Whistler and Jeremy Wood that brought together for the first time drawings from Christ Church and the Ashmolean by Rubens and his circle.

Today, Colnaghi is again the sponsor of a scholarly exhibition that begins in Oxford. *Graceful and True: Drawing in Florence c.1600* brings together for the first time in this country a selection of some of the most beautiful and important drawings of the period from British private and public collections. We are delighted to be able to support this initiative, which will make these drawings known to a wider audience in Oxford, London and Nottingham. It is particularly satisfying for us at Colnaghi that the tradition of working with the Ashmolean Museum continues in such an exciting way.

Katrin Bellinger, Konrad Bernheimer, Rachel Kaminsky
P. & D. Colnaghi and Co., Ltd.

PREFACE

W HEN FRANCESCO SCANNELLI described the art of Lodovico Cigoli (1559–1613) and his contemporaries as "graceful, delicate and true" in *Il Microcosmo della Pittura* of 1657, he was recording the emergence of a new mode of painting and drawing in late sixteenth-century Florence. He was not the first to recognize a distinctively different Florentine style, since Giambattista Marino had singled out Cristofano Allori (1577–1621) and Domenico Passignano (1559–1638) as the new luminaries of Tuscan art in a poem of 1628. Other writers of the seventeenth century admired the lyricism and naturalism of this generation of Florentine artists, as distinct from the more convoluted, virtuoso style of their predecessors. The practice of drawing – particularly drawing from the life and from nature – was at the heart of this stylistic revolution in Florence, which is comparable in its innovations and effects to the changes brought about at the same time in Bologna by the Carracci.

We cannot claim that the artists mentioned above, and others such as Jacopo da Empoli, Bernardino Poccetti, Andrea Boscoli and Gregorio Pagani, are familiar names to anyone outside a circle of specialists in this country, yet their achievements as draughtsmen are well represented in our museums and private collections. This exhibition highlights the quality, beauty and importance of drawings by this generation of artists, whose work was often connected with the Medici court and its public festivities and ceremonies. The range of drawings from this period held in Britain cannot be compared with the great holdings of the Uffizi in Florence; nevertheless, a variety of preparatory and exploratory studies are presented here, relating to secular and religious commissions, to artistic education, and to theatrical and literary projects, together with some sheets made as independent works.

Katrin Bellinger, a long-term benefactor of the Ashmolean, generously offered to support the museum in this scholarly and celebratory exhibition, and the collaboration of the Djanogly Art Gallery at the Lakeside Arts Centre, University of Nottingham, made it possible to present it to a wider audience.

A substantial number of the drawings on view have been selected from the rich holdings at the British Museum, and we are particularly grateful to Antony Griffiths and Hugo Chapman for their generous support of the exhibition; similarly, Christopher Baker, Jacqueline Thalmann and Anthony Hopwood have been extremely co-operative in arranging an ambitious loan from the drawings collection at Christ Church. We are also greatly indebted to other colleagues in lending institutions for the advice they have given and the trouble they have taken with loan procedures and would like to thank the Hon. Lady Roberts, Martin Clayton and Theresa-Mary Morton at the Royal Collection; Joanna Selborne at the Courtauld Institute Gallery; Aidan Weston-Lewis and Christopher Baker at

the National Gallery of Scotland; Mark Evans and Anne Steinberg at the V&A; and David Scrase at the Fitzwilliam Museum (to whom further thanks are due for his kindness in sharing his draft catalogue entries for the Fitzwilliam drawings shown in the exhibition).

Warm thanks are especially due to Miles Chappell, for looking at parts of the catalogue text and for his valuable comments on them, to Annamaria Petrioli Tofani for her helpful discussion of some of the drawings, and to Julien Stock for access to the Pouncey/Stock fototeca and for his help in arranging the three loans from private collections. Luca Baroni and Stephen Ongpin have been extremely supportive of the project, particularly in the formative early stages. Other people Julian Brooks and Catherine Whistler would like especially to thank for their help during the preparation of the exhibition and catalogue are: Alessandra Baroni Vannucci, Mario di Giampaolo, Hilary Hunt, Ulrike Ilg, Bert Meijer, Lucia Monaci Moran, Paolo Nannoni, Alana O'Brien, Lucy Phillips, Janice Reading, Jaco Rutgers, Gert Jan van der Sman, and Sarah Louise Wilkinson.

Finally we would like to acknowledge the commitment and efficiency of the Ashmolean staff involved with the exhibition, particularly the Registrar Geraldine Glynn, her assistant Clare Farrah, and Julie Summers, Exhibitions Officer.

At the Djanogly Art Gallery the exhibition has been co-ordinated by Neil Walker (Visual Arts Officer, Lakeside Arts Centre) and Jeremy Wood (Senior Lecturer in Art History, University of Nottingham) with administrative support from Tracey Isgar (Visual Arts Assistant, Lakeside Arts Centre), who have contributed to it with energy and enthusiasm; Florian Härb has been helpful in organizing the showing at Colnaghi's in London.

This exhibition is the first dedicated show of late sixteenth-century Florentine drawings in the United Kingdom, and represents a major achievement in highlighting such little-known treasures. While recent exhibitions in Italy, America, and elsewhere have encouraged the study and appreciation of drawings from this period, the richness and quality of works from British collections is explored here for the first time, and in a fitting fashion.

Christopher Brown *Director, The Ashmolean Museum*
Shona Powell *Director, Lakeside Arts Centre, Nottingham*

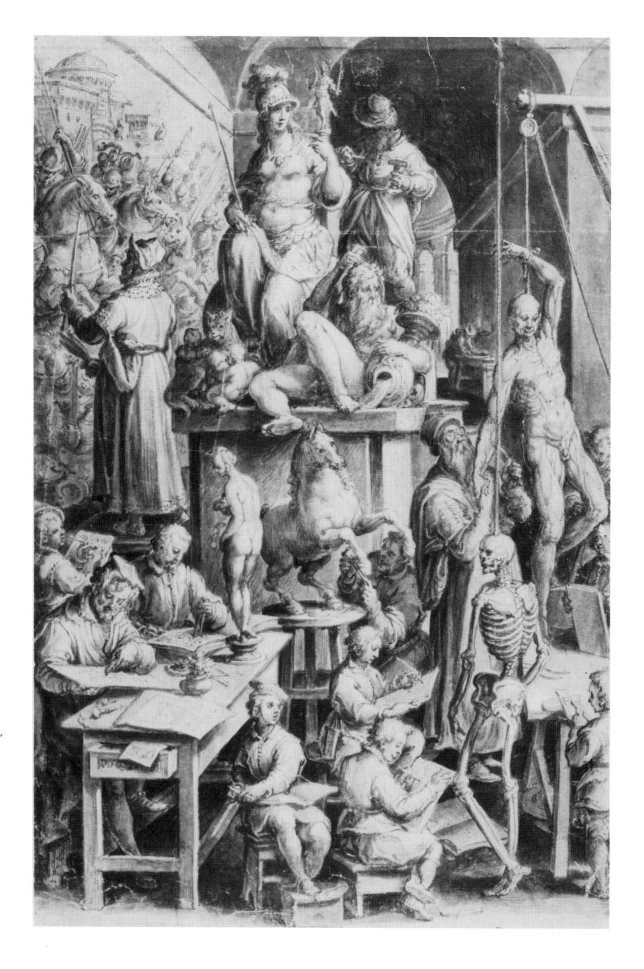

Artists, collectors and the appreciation of Florentine drawings of the early seventeenth century

Catherine Whistler

D RAWING or *disegno* had been viewed as central to Tuscan art by writers and historians from the time of Petrarch, who noted that painting and sculpture sprang from one source, the art of drawing,[1] and Giorgio Vasari was summarizing contemporary opinion when he wrote in his *Lives of the Artists* (1568) that *disegno* is the father of the three arts of painting, sculpture and architecture.[2] The concept of *disegno* encompassed draughtsmanship and design – both the manual or technical act of making a drawing, and the intellectual and creative act of giving visual form to a new idea in a drawing. Federico Zuccari, with some virtuoso word-play, identified the meaning of *disegno* as "di Dio segno", the sign of God, echoing the view of an earlier Florentine writer on art that God was the first designer.[3] The prestige of drawing or design was confirmed by the establishment of the first artists' academy in 1563 in Florence, the Accademia del Disegno, while the continuing Tuscan identification of *disegno* as the key quality in art is borne out by the fact that Filippo Baldinucci's biographies of artists, published from 1681, are entitled *Notizie dei Professori del Disegno*.

The artists represented in this exhibition were highly aware of this intellectual as well as technical heritage. They were prolific draughtsmen who prized their own drawings, who were often in demand as teachers of drawing, and whose drawings were admired and sought after by scientists, by writers and by noble collectors. Thus, the poet Giambattista Marino praised the talents of Cigoli as a draughtsman, Cristofano Allori's skill in *disegno* was admired by Pietro Accolti, while Raffaello Gualterotti wrote a poem in praise of Sigismondo Coccapani's drawings. Cigoli was a friend of Galileo, who compared his drawings with those of Michelangelo.[4] According to his disciple Vincenzo Viviani, Galileo told his friends that if he had not been a scientist, he would have become a painter, such was his inclination towards *disegno*.[5] Baldinucci's biographies of the artists represented in the exhibition are peppered with comments on their habits in making and using drawing, such as when he evokes a heated discussion between Cristofano Allori and Passignano in the presence of Grand Duke Cosimo II regarding foreshortening, where Passignano made several chalk drawings on the spot to demonstrate the effects of different angles of vision.[6] A recurring topos is that of the young artist whose talents are discovered thanks to his gifts as a draughtsman: thus when Cosimo II saw some drawings by Francesco Bianchi he realised that the boy would go far; similarly a Vallombrosan priest spotted the young Passignano's talents.[7] In an early instance of what was to become a favourite statement of eigheenth-century artists, we hear that Francesco Furini, a pupil of Rosselli, showed an impatient patron his drawings and studies, saying that the painting would be finished when he had completed his preparatory drawings.[8] Of course Baldinucci was aware of Giorgio

Fig.2 Federico Zuccari, *Artists drawing in the New Sacristy, San Lorenzo*. Black and red chalks, 200 × 264 mm, Louvre, inv.4554

Vasari's use of colourful anecdote to characterize an artist or make a didactic point; nonetheless while observing rhetorical conventions he included a variety of information on artists' practice and collecting, the veracity of which we have no reason to doubt.[9]

As well as teaching at the Florentine academy, a variety of artists ran private academies, including Santi di Tito, Lodovico Cigoli, Gregorio Pagani, Domenico Passignano, Jacopo da Empoli, Giulio Parigi and Cecco Bravo. A considerable number of drawings showing artists at work survives from this period in Florence, from the elaborate set-piece of Stradanus (fig.1) depicting the practice of art, preparatory for one of a series of engravings on contemporary professions, to drawings of individuals (cat.48) or of informal gatherings. Federico Zuccaro sketched artists copying Michelangelo at San Lorenzo (fig.2), while a drawing from the circle of Empoli now in Rome shows artists standing or sitting before a model in contemporary dress posed on a low trestle table, in a grand vaulted setting.[10] Many other drawings provide quick glimpses of studio life. A sheet in the Uffizi in pen and ink by a follower of Cecco Bravo which functioned as a frontispiece to an album of his drawings includes a representation of a life-drawing class, with the nude model posing on a low platform, and artists sitting on stools, or on the cube-like blocks that turn up frequently in life-drawings, while a large moveable chandelier provided light and, no doubt, heat for the model.[11] Studio life was not all work, however, particularly in Pagani's case where amateur theatricals took place in his studio, while his passion for hunting meant that he kept his dogs there. Many artists enjoyed music-making, among them Biliverti, Cristofano Allori, or Pagani. Baldinucci notes that "Piero de' Medici would hardly leave [Pagani's] studio, so involved was he in drawing or painting, and sometimes in playing the lute with him": a drawing by Empoli in Amsterdam showing a young man playing the lute

evokes this lively studio atmosphere.[12] Giulio Parigi's noble pupils gave him presents of their portraits, which gradually filled his studio.[13] The many distinguished or noble students of these and other artists – whose names Baldinucci sometimes lists – would have recognized the different possible functions of drawings. They would also have understood the role of collecting in teaching and learning, through their appreciation of how artists not only made drawings but also assembled and used their own collections.[14]

Artists generally kept drawings for teaching or reference purposes. Thus on a number of sheets by Alessandro Allori we find the inscription "D'Alessandro Allori donò Cristofano Allori suo figliuolo" in what appears to be Cristofano's hand, testifying to his activity as an early collector of his father's work; similarly Verginio Zaballi collected drawings by his master, Empoli.[15] According to Baldinucci's notes, Sigismondo Coccapani intended to make "a book of drawings by the most famous artists with a detailed treatment of each, so that, as he said, one could absorb the manner of each with more ease and knowledge".[16] A large number of Cecco Bravo's life drawings were collected together apparently by his students, in an album with the frontispiece described above.[17] Biliverti had a collection of drawings by Cigoli, giving some to the young Baccio del Bianco to copy, while later the studio of the sculptor Giovanni Battista Foggini (1652–1725) contained numerous drawings by Rosselli as well as a collection of life-drawings by various early and mid seventeenth-century Florentine artists.[18]

The fact that the artists in this exhibition valued their own drawings is also attested by the number of signatures and autograph inscriptions on many sheets, possibly occurring with greater regularity than elsewhere in Italy at this time. These annotations suggest that artists envisaged an after-life for their drawings, beyond their immediate functions in the studio. Some drawings were signed and dated because they were made as finished, often independent works, as with many of Ligozzi's elaborate drawings (cats.54–56); others may have had some role in discussions of a commission with the patron or with an engraver, as is possibly the case with a squared compositional study by Cigoli, signed *Lod.Civ./F...1599*, for the *Pietà* now in Vienna.[19] A preparatory drawing of *Apollo and Daphne* by Biliverti for a painting made for Lorenzo de' Medici has the artist's monogram and the autograph inscription "del Ser.mo Principe Don Lorenzo", presumably added by the artist as a useful reference.[20] Similarly some drawings by Giovanni Battista Paggi, who had a lengthy sojourn in Tuscany from 1581, contain neat autograph inscriptions regarding the owners or locations of the related paintings, as with an *Adoration of the Magi* sheet inscribed "Al Sig.r Pietro del Nero a Firenze", suggesting that that they were records, perhaps also to be shown to admirers or potential clients.[21] A sheet with a wonderfully rapid series of scribbled ideas for different projects by Buontalenti is signed with his monogram and dated 1586, with the inscription "il giorno di Carnovale/ ch[e] piove bene" – made on a rainy day during Carnival.[22] Poccetti sometimes made inscriptions on his drawings regarding their subject-matter, or, in the case of a compositional study for a battle scene for Palazzo Capponi, he drew in a frame including a *cartiglia* or label beneath with an inscription describing the subject.[23]

Of course, the great precedent in Florence both for an artist prizing drawings and for the prestige of a drawings collection was the celebrated collection of Giorgio Vasari. By the late sixteenth century it seems to have been taken for granted that any nobleman with claims to being a *virtuoso* would collect drawings in addition to bronzes, medals, antiquities

and paintings. While such drawings collections would be viewed by friends and visitors in the owner's house, it is significant that signs and marks of ownership start appearing on drawings or on mounts in a way that was not always felt necessary with other objects. Perhaps this was because of the inherent vulnerability of drawings to damage or theft. As a result the sheets were often glued to mounts and in turn given distinctive borders identifiable with individual owners, though not usually as elaborate as those Vasari designed for his collection. Many old master drawings carry one or more collectors' marks, usually from the late seventeenth to the nineteenth centuries, such as cat.48 or 82, but the idea of stamping a visually distinctive mark on a drawing may have originated in Florence in the late sixteenth century. A major early collector was Niccolò Gaddi (1537–91) who had close links with many of the artists represented in this exhibition, either because of his own patronage or because of his important role in the 1589 Medici wedding celebrations; soon after his death, he was described as highly knowledgeable regarding the arts of *disegno*.[24] Gaddi owned five volumes of drawings from Vasari's collection, together with sheets by old master and modern artists, and a large number of architectural drawings. In his will, his explicit wish was that on all of his sheets a seal should be stamped, with the intention of preserving the collection intact: he wished it to be kept at the Ospedale degli Incurabili and made available for inspection to any Florentine or foreign gentleman who desired to consult it. He specified a particular kind of seal, a cornelian with a complex design involving a shepherd and animals.[25] In fact Gaddi's collection began to be dispersed in 1637 (with the Vasari volumes first examined by Passignano, who had a high reputation as a connoisseur)[26], while a major sale to the state in 1778 meant that the old mounts or surrounds were lost in successive re-mounting campaigns in the Uffizi. However a small group of drawings carries a distinctive mark of a falcon on a laurel branch with a scroll and motto: this large mark would have been disfiguring on the actual drawings and is found where drawings still have their old decorative borders.[27] We do not know if this was a mark sometimes used by Gaddi in his lifetime, or if he changed his mind about the type of seal that was to be stamped on his drawings after his death. However, the falcon and scroll motif is found on the verso of a portrait medal of Giovanni Gaddi (d. 1485) and must have been a family emblem or *impresa*.[28]

An early to mid seventeenth-century Florentine collector may have emulated Gaddi in leaving a visual image on his sheets to denote ownership rather than an inscription.[29] A member of the Brandini family, this collector used a small seal with a device of his family coat of arms: he owned drawings by Empoli, Biliverti (cat.10), Pagani (cat.66) and Poccetti amongst other Florentine artists, and some of his drawings were acquired by Baldinucci. Many early collectors were content with inscribing their drawings with a number and/or the name of the artist; one erudite late sixteenth-century Florentine collector wrote Greek inscriptions on his.[30] (fig.3) Sometimes inscriptions refer to the owner, as with the name *Franc.o Rosi* that appears with a number on the *verso* of a variety of drawings including sheets by Cigoli and Cristofano Allori: this Francesco Rosi may have been a relative of Zanobi Rosi, a pupil and collaborator of Allori.[31] Again, the name *Cristofero Noferi*, with a date of 1651 or 1652, is written on the back of drawings by Cecco Bravo: a friend and pupil of the artist, Noferi was an architect and mathematician.[32] The familiar initial *R* inscribed on drawings belonging to the art historian Carlo Ridolfi (1594–1658), whose collection, assembled from around 1630, included a number of sheets by Florentine artists such as

Fig.3 Jacopo da Empoli, *Youth kneeling at a prayer-stool* (detail). Pen and brown ink, 246 × 175 mm, Christ Church, inv.JBS 244

Passignano, Cigoli, and Poccetti, was added after his death. Ridolfi generally inscribed attributions on his drawings rather than using a mark of ownership.[33]

Perhaps the use of a visual device, whether emblematic or heraldic, was associated with aristocratic collecting. The Florentine-born Coccapani brothers were related to the nobility of Reggio Emilia and were keenly aware of their status. An extraordinarily talented pair, they shared various mathematical, architectural and engineering interests, with Sigismondo practising more consistently as an artist. They were each entitled *Maestro di Disegno*, Sigismondo for the teaching he gave at the academy of science established by Piero Strozzi, and Giovanni for his public instruction of Florentine and foreign noblemen – indeed, he held the first chair of mathematics in Florence from 1638.[34] A complicated embossed stamp with the Coccapani coat of arms is found on a large number of drawings not only by the two brothers but also on sheets by Cigoli in particular and by some artists in his circle such as Empoli and Rosselli. This mark is stamped on the drawings themselves, rather than on the mounts or borders, but is sensitively placed in a way that is often visually effective (cf. cat.37).[35] Acanfora has argued that Sigismondo made the collection; certainly Baldinucci tells us that he loved *disegno* so much that he spent most of his time working on a treatise or making drawings and models, rather than painting. As mentioned above, he is said to have had the intention of compiling a study collection of drawings by celebrated artists, while Leopoldo de' Medici apparently described Sigismondo as his master, but whether for the artist's command of drawing or his ambitions as a collector is unclear.[36] By contrast Chappell has argued for a more leading role for Giovanni, suggesting that the drawings collection was begun by Sigismondo and continued by Giovanni, with the brothers sharing the aim of paying homage to the great masters, especially Cigoli, and instructing others.[37] In fact, their father, Regolo, made over a substantial number of prints and drawings to Sigismondo in 1618, as Julian Brooks has discovered, providing the core of the original collection.[38] In any case the stamping of a recognizable mark of ownership by using a visual image recalls Gaddi's and Brandini's practice. The same concept of a recognizable visual device appears in England in this period in a slightly different form: Nicholas Lanier (1588–1666) stamped a small star-shaped mark on his drawings, again placing it with great sensitivity. His mark possibly originates with punch marks used in bookbinding,[39] and thus has different associations from the family *impresa* or heraldic devices of Florentine collectors.

How did Florentine collectors keep their drawings? The inventory of Niccolò Gaddi's

large collection of art and antiquities reveals that some of his drawings were framed, others were bound in books or kept loose in portfolios, while some were unmounted: the framed drawings, consisting of heads, chiaroscuro drawings and drawings in red chalk, were displayed in an antechamber together with small sculptural reliefs and bronzes.[40] This kind of display was not unusual: thus in 1589 a drawing by Ligozzi of a landscape with flowers hung in the new Tribuna of the Uffizi, while by 1638 there was a *stanzino de'disegni* there with precious framed drawings on view.[41] An inventory of the collection of Romolo Riccardo (1558–1612) at his death included prints and drawings hanging on the walls of the Palazzo di Gualfonda.[42] Many drawings were kept bound in books, as in the case of Vasari's collection, or the precious volume of natural history drawings by Jacopo Ligozzi documented in the Medici Guardaroba in 1619, which was signed out for study every so often by members of the Medici family.[43] However, the term "libro di disegni" could also signify a leather-bound portfolio in which mounted drawings were kept loose, so that new acquisitions could be added to a particular sequence. Prince Leopoldo de' Medici (1617–1675), who became Cardinal from 1667, amassed an extraordinarily rich collection of Florentine, Emilian and Venetian drawings. He wrote to a friend in 1662 "I am gluing my drawings to sheets and organizing them so as to place them each time into books. I would like to have these as full as possible both in terms of quantity and quality."[44] His agent in Bologna, Fra Bonaventura Bisi, had advised him in 1658 not to put too many drawings together in one book (or portfolio) since, as with picture galleries, the overwhelming richness of the ensemble can kill the individual work of art.[45] When Baldinucci was appointed curator of Leopoldo's drawings collection around 1665 (after first passing the test of correctly attributing 200 sheets shown to him by the Prince), he organized it in chronological order, decade by decade, on the same principles on which he would publish his artists' biographies. The drawings were kept in portfolios, bound in red leather with the Medici arms.[46] They were mounted in a sober, scholarly manner, without decorative borders, just two simple ruled pen lines and with numbers and attributions inscribed (fig.4).[47] Baldinucci ceded his personal collection to Leopoldo, but from *c.*1690 assembled a second one which was kept in leather-bound volumes, with the drawings mounted in a similar way.[48]

The artists represented in this exhibition had a strong presence in both Leopoldo's and Baldinucci's collections: this contrasts with contemporary English or French collections such as those of Everhard Jabach (1618–95) or Sir Peter Lely (1618–80) in which Roman and Emilian drawings were more prominent, together with Florentine drawings of the early and mid sixteenth centuries. This was for a combination of reasons to do with taste, knowledge and availability. Both Leopoldo and Baldinucci were convinced of the extraordinary talents of artists such as Santi di Tito, Cigoli, Poccetti, Empoli and others of the same generation in terms of *disegno*; moreover the achievements of these artists testified to the efficacy of Medici patronage and encouragement of good *disegno*. Baldinucci sometimes purchased directly from an artist's heirs what amounted to the studio contents, as with his acquisition of a large number of drawings by Santi di Tito from his grandson, Captain Francesco Siretti.[49] Similarly, the collection of Giovanni Battista Cardi, Cigoli's nephew and heir, was sold after the death of his widow in 1646, with many Cigoli drawings eventually being acquired by Leopoldo.[50] And a variety of mid and late seventeenth-century Florentine collectors had known and admired these artists and were buying up their drawings in large

Fig.4 Gregorio Pagani, *Study of a standing nude youth* (detail). Red chalk, 425 × 284 mm, Christ Church, inv.JBS 251

Di Gregorio Pagani Fiorentino

quantities: Francesco Fontana, for instance, who was in the service of the Grand Duchess Vittoria, was a passionate collector of Cigoli's drawings, while Apollonio Bassetti (1631–99), secretary to Cardinal Giovanni de' Medici, Leopoldo's brother, amassed a considerable collection of sixteenth and seventeenth-century Florentine drawings.[51] Another enthusiastic collector was the Marchese Ferdinando Cospi (1605–86) of Bologna, whose mother was a Medici and who had been educated in Florence: a close friend of Leopoldo, he too built up a major art collection. Cospi described in a letter of 1665 how he had many high-ranking Bolognese visitors to his palazzo, and was now decorating a new *camerino* that linked different rooms which were already full of framed drawings by modern Florentine masters; he needed to fill a wall in this new room with Tuscan drawings, and asked for Leopoldo's help.[52] It is very likely that many of the noblemen and *dilettanti* who frequented the studios of Boscoli, Cigoli, Pagani, Parigi, Empoli and others would have collected the master's drawings, as with Cosimo de' Noferi mentioned above. We have some evidence for noble collectors obtaining drawings directly from the artist, as when Raffaello Gualterotti wrote to Sigismondo Coccapani in 1627 asking him for any drawing that he no longer needed, or when the Cavaliere Raffaello Ximines bought great quantities of drawings, particularly life-studies, by Empoli, who was short of money in his old age.[53]

English interest in Florence was strong in the early 1600s, especially with the proposed marriage of Henry, Prince of Wales and Caterina de' Medici, and visitors and art collectors including Fynes Morison and the Earl of Arundel admired the grand-ducal collections; Tobie Matthew, the son of the Archbishop of York, who had converted to Catholicism in Florence, wrote around 1607: "I live in Florence in an excellent coole terrene, eate goode melons, drink wholesome wines, looke upon excellent devout pictures heer choyse musique".[54] However, English and other foreign drawings collectors of the early to mid seventeenth century were in search of works by famous sixteenth-century Tuscan draughtsmen such as Andrea del Sarto, Michelangelo or Francesco Salviati, and did not necessarily seek out drawings by contemporary or recent Florentine artists. Even if they had done so, such works might not have been available, given the strong competition from Leopoldo de' Medici and other local collectors.[55] The celebrated drawings collection of Christina of Sweden (1626–89), for instance, contained virtually nothing of Florentine drawing after the time of Michelangelo.[56] Everhard Jabach, who assembled two extraordinary drawings collections, owned very few sheets by Florentine late sixteenth and

early seventeenth-century artists; Catherine Monbeig Goguel has noted the lack of interest amongst French collectors generally for this period.[57] On a smaller scale, the collection of Rubens provides an indication of contemporary taste, with its emphasis on Raphael, Giulio Romano, Polidoro, Correggio, the Carracci, and some Venetian artists.[58]

While various sheets found their way into English collections of the mid and late seventeenth century, such as cat.35, 37 and 82, which were owned by Lely, in general it was not until the early eighteenth century that substantial quantities of drawings by our artists began to appear in collections in this country, although very often under other attributions. The art-historical views of Padre Sebastiano Resta (1635–1714), as seen in the arrangement of his drawings collection and in his notes on artists, had a considerable impact in England, particularly through the critical writings of Jonathan Richardson the Elder. For Resta, Tuscan draughtsmanship was important in the fifteenth and early sixteenth centuries, whereas the Carracci and their followers held the field from the 1580s.[59] Moreover, Baldinucci's biographies of artists from Cigoli onwards appeared only in a posthumous publication from 1728, so that relatively little art-historical information was accessible about these artists (and Baldinucci's text has never been translated into English). Opportunities increased for the acquisition of Florentine drawings: after the death of Leopoldo, his collection was transferred from the Pitti Palace to the Uffizi, and some 5000 sheets were discarded, eventually finding their way onto the art market. Many were acquired by collectors such as Francesco Maria Gabburri (1676–1742) and Ignazio Hugford (1703–78), and doubtless by English artists and dealers acting for a growing number of drawings collectors.[60] In 1726 an unknown "Inglese" was said to be interested in acquiring a large number of Florentine drawings from the fifteenth to the seventeenth centuries that had belonged to Francesco Maria de' Medici (1660–1711), but these were purchased instead by Neri Corsini (1685–1770), and today form an important part of the Gabinetto Nationale delle Stampe, Rome.[61] Gabburri, an art historian, dealer and collector, owned over 400 drawings by Cecco Bravo amongst many other sheets from that period, and his collection was sold by his heirs to an English dealer, William Kent, active in Florence in the late 1750s.[62] Kent subsequently sold the drawings in London, without exciting any particular interest, as Pierre-Jean Mariette, a friend of Gabburri, reported. They included a group of approximately thirty *Dreams* by Cecco, formerly owned by Baldinucci (see cat.63); some were then acquired by Nathaniel Hone (1718–84), and subsequently smaller lots of these sheets appeared at different auctions, such as eight "large dreams...very fantastical" sold by Knapton on 27 May, 1807, and "Four singular designs of dreams by Cecco Bravo in red and black chalk" sold from the collection of Paul Sandby on 8 March, 1812.[63]

Old attributions bear witness to the relative lack of interest in, or knowledge of, Florentine draughtsmanship of the generation around 1600. Numerous sheets by Poccetti, Empoli and Santi di Tito, for instance, from French and British eighteenth-century collections, bear old inscriptions identifying them as Annibale Carracci (cf. cat.69), Federico Barocci (cf. cat.59) or Andrea del Sarto, attributions that are perfectly understandable given the fact that artists in this period copied Sarto, studied Barocci, and in their unaffected naturalism often have strong affinities with the Carracci. Similarly many of the Florentine drawings owned by Sir John Guise (1682/83–1765), now at Christ Church, Oxford, have early or mid eighteenth-century attributions to the Carracci, Domenichino, or other Bolognese artists, while four finished drawings by Ligozzi on the life of St Francis from his

collection were attributed to Titian. The taste of the period is further reflected in a variety of lavish publications from the mid-eighteenth to the early nineteenth centuries that presented high-quality reproductions of drawings with different kinds of accompanying texts. These volumes celebrated both the achievements of Italian draughtsmen and the discernment of individual collectors from whose collections drawings were reproduced. The same pattern can be traced there of a strong representation of Parmigianino, Correggio, and the Carracci and only sporadic appearances of the Florentine artists with whom we are concerned.[64]

By the end of the eighteenth century in any case baroque art in general was beginning to be regarded as decadent and derivative, and Florentine drawings of around 1600 were often viewed as unworthy of consideration. In the 1790s William Young Ottley was apparently offered the chance to buy 1500 drawings, formerly in Leopoldo's collection, by a dealer in Florence, while the art historian Carl Friedrich Von Rumohr had a similar opportunity around 1828–29, but neither took advantage of these possibilities.[65] During negotiations for the acquisition of four bound volumes of drawings from Baldinucci's personal collection by the Louvre in 1806, François-Xavier Fabré reported to Vivant-Denon that unfortunately two volumes were almost entirely dedicated to the masters of the decadent period (i.e. Tuscan artists of the late sixteenth and seventeenth centuries).[66] Von Rumohr collected drawings by Santi, Cigoli, Bilivert, Poccetti and others, presumably because he admired their naturalism and their affinities with Andrea del Sarto. However his correspondence regarding his gift of drawings to the new Copenhagen Print Room in 1841 reveals his opinion on the period: "Yesterday as I went through my endless possessions, I came upon a collection of Florentine painters' studies from around 1600. Many talented people were mannered naturalists, I have never been able to persuade myself to condemn them entirely. Nevertheless they do cause me trouble..."[67] Rumohr's view was that while these drawings were of no importance, a public collection needed to have drawings that characterized epochs. Sir John Charles Robinson expressed the same view in 1869, reflecting his advice to John Malcolm of Poltalloch on acquisitions: he explained that it was "a special object to avoid the accumulation of comparatively uninteresting material" in a private collection, whereas a public museum should form a universal collection: thus the Malcolm collection included virtually no drawings by late sixteenth-century Florentine artists, although one drawing was attributed to Santi di Tito (cf. cat.5).[68]

Nineteenth and early twentieth-century English attitudes towards Florentine art of the seventeenth century as second-rate or degraded have already been outlined in some detail by Miles Chappell in a magisterial survey of the broader critical fortunes of artists from Santi di Tito to Giovanni Battista Foggini, which concludes with an examination of the gradual revival of interest in this period over the last forty years.[69] The variety of drawings by our generation of Florentine artists now in British collections arrived in this country at different times – including numerous recent acquisitions – and often in disguise, under other names. The appreciation of these drawings today may not equal the admiration that the same sheets could command in seventeenth-century Florence, when *disegno* was pre-eminent and the value that artists and amateurs placed upon drawing and collecting was extraordinarily strong, yet the achievements of these draughtsmen and the quality and beauty of their work are enjoying growing recognition and acclaim.

Footnotes

1. Petrarch, *De remedus utrusque fortunae* (1354–66), quoted by Baxandall, 1971, p.61.
2. Vasari-Milanesi I, p.168.
3. Heikamp, 1961, p.196; "Il disegno non è altro che speculation divina": Doni, 1547, p.7.
4. Chappell in Florence, 1984, p.12 on Accolti; Chappell in Florence, 1992, p.vii for Galileo and Cigoli; p.xx on Marino; Gualterotti's verses accompanied a letter of 1627, in Baldinucci, VII, pp.99–100.
5. Edgerton, 1984, p.231, n. 6.
6. Baldinucci, III, p.443.
7. Baldinucci, IV, p.312; III, p.430.
8. "sappiate...che allora io dico di aver finite le opere, quando io ho finiti questi", Baldinucci, IV, p. 636.
9. See Goldberg, 1988; Baldinucci was in fact a pupil of Matteo Rosselli; on his own drawings see Matteoli, 1988.
10. Rome, F.C.125714, red chalk, 266 × 290 mm, see Florence 1986, II, no.2.90, p.144.
11. Uffizi 10564F, 412 × 269 mm, reproduced by Contini in Florence, 1999, p.43.
12. Baldinucci, III, pp.51–52; Rijksmuseum inv. 1948.357, red chalk, 308 × 224 mm, see Forlani Tempesti in Florence, 1980, no. 209, pp.114–115.
13. Baldinucci, IV, p.141.
14. Baldinucci lists the names of noble pupils of Empoli, III, pp.17–18, IV, p.535; of Parigi, IV, p.141, and of Giovanni Coccapani, IV, p.403.
15. Prosperi Valenti Rodinò in Rome, 1977, p.18, under cat.7; Baldinucci, III, p.16.
16. Baldinucci, VII, p.96, "un libro dei disegni degli autori più celebri col trattato particulare di ciaschedun mestro; che così (dice egli) con più facilità e dottrina s'impossesserà delle maniere di essi".
17. Barsanti in Florence, 1986, II, under 2.282, pp. 315–6, reported that the present inscription on the frontispiece design, "Studio di disegni di Cecco Bravo" is glued over the original title of "Libro primo dell'Accademia aperta del disegno dedicata al Sig.r Jacopo Benvenuti". Jacopo Benvenuti was a pupil and collaborator of Cecco who became head of the workshop in 1654.
18. Baldinucci, V, pp.22, 31; Fusconi and Prosperi Valenti Rodinò, 1982, p.82 and 116. Three volumes containing drawings by Rosselli, *accademie* by Tuscan seventeenth-century artists, and drawings by Foggini respectively (158H 10, 11, 12) were bequeathed to the Biblioteca Corsini by Pier Francesco Foggini, the nephew of the sculptor, who was librarian there from 1769–82.
19. Louvre, inv.880: Viatte, 1988, no.142, p.88; Chappell in Florence, 1992, p.90, under no.52.
20. Uffizi 9646F, Contini in Florence, 1986, II, pp.229–230, no.2.185, red chalk and wash with pen and ink, 168 × 131 mm.
21. Genoa, Palazzo Rosso, inv.2518, pen and brown ink and wash, 210 × 180 mm; Sasso in Florence, 1997, p.286, no.232; see also Newcome, 1991.
22. Uffizi 2416A, pen and ink, 213 × 272 mm, Faro in Florence, 1998, pp.95–96, no.34.
23. For example see Hamilton in Florence, 1980 (Poccetti), p.55, no.40, and p.94, no.83; the *Battle*, Uffizi 1572S, pen and ink with brown and blue washes, 137 × 286 mm, p.33, no.12.
24. Acidini Luchinat, 1980, p.142, quoting Giuliano de' Ricci in 1595, "era intelligentissima di tutte l'arte del disegno"; see also Dal Pozzolo, 2003, pp.59–61 on Gaddi's interest in acquiring contemporary Venetian drawings.
25. Acidini Luchinat, 1980, p.167, n. 10.
26. Baldinucci, III, p.449; see p.448 on his connoisseurship of medals and paintings, and p.449 for his views on frames, while his opinion that one of Francavilla's anatomical models was "ammanierato" is also reported, III, p.65. See Petrioli Tofani, 1981, pp.170–172, on the re-mounting of this collection.
27. Lugt Supplement 2807e; see Byam Shaw, 1976, I, p.11 and II, pl.35.
28. As pointed out by Popham and Pouncey, 1950, p.178, under no.279.
29. Lugt 2736, and Byam Shaw, 1976, p.11; Julian Brooks has identified the heraldic device as the coat of arms of the Brandini family and is carrying out research on this collection.
30. Byam Shaw, 1976 pp.11–12.
31. Chappell in Florence, 1992, p.26 and n.35.
32. Barsanti in Florence, 1986, II, under 2.282, pp.315–16.
33. His drawings were bound into volumes with frontispieces from 1631 onwards, judging from the fragmentary remains at Christ Church: see Petrioli Tofani, *et al.*, 1993–94, p.73, and Byam Shaw, 1976, pp.9–10, 401–8.
34. Baldinucci, IV, p.418 (Sigismondo); pp.403, 409 (Giovanni).
35. Chappell, 1983.
36. Baldinucci, VII, p.100; Acanfora, 1989, p.76.
37. Chappell, 1994.
38. Julian Brooks will publish this document which specifies in addition "altri schizzi, disegni, et bozze di matita, carbone, et penna"; Baldinucci, IV, pp.401–402, recounts how Regolo came to own a collection of prints by northern masters thanks to his generosity in 1600 towards a Flemish pilgrim who had been attacked and robbed.
39. Wood, 2003.
40. Acidini Luchinat, 1980, p.157: "otto libri legati di disegni", "undici libri sciolti di disegni", and "due mazi di foglie" or bundles of drawings.
41. Petrioli Tofani, 1981, pp.166–67.
42. Chiarini in Florence, 1999, p.13; see also Monbeig Goguel, 1987, pp.25–31.
43. Tongiorgi Tomasi in Florence, 1984 (Anatomiche), pp.47–48, 52; Bacci in Florence, 1986, II, p.73, under no. 2.10.
44. "sto attaccando sopra i fogli ed aggiustando i miei disegni per mettergli ogni volta entro ai libri. Vorrei che questi fusser più pieni che fusse possibile e di quantità e di qualità", quoted by Petrioli Tofani, 1981, p.167.
45. Chiarini de Anna, 1976, p.36: "un libraccio tanto grosso e così copioso pare troppo, e quando in un libro si vedono 40 o 50 disegni rari è una bella cosa, e così si

possono dividere le classi, o scuole, e quando è un solo libro li disegni fanno l'effetto che fanno le pitture delle gallerie che per la moltitudine tra di loro s'ammazzano, né si possono ben godere..."

46. Bacou in Rome, 1959; Petrioli Tofani, *et al.*, 1993–94, pp.75–78.

47. Petrioli Tofani, 1981, p.170. Interestingly the drawings in the Riccardi collection that were acquired at the time of Francesco Riccardi (1648–1719), or possibly by Romolo himself, do not show any signs of having been glued to other sheets or to mounts: Chiarini in Florence, 1999, (B.R.) p.17.

48. Tordella, 1996; see Chappell, 1992, for comparisons between Baldinucci's personal collection and the drawings he acquired for Leopoldo.

49. Lecchini Giovannoni and Collareta in Florence, 1985, pp.6–7; Baldinucci, II, pp.551–53.

50. Chappell in Florence, 1992, p.xvii.

51. Baldinucci, III, p.281; on Bassetti, Petrioli Tofani *et al*, 1993–94, p.81 and Chappell in Florence, 1992, p.xx–xxi: his collection of 938 sheets, including Venetian and Emilian drawings, was bequeathed to Cosimo III and entered the Medici collections in 1699.

52. Fileti Mazza, 1993, I, p. 27, 14 April 1665, "poi che anco ho gusto che il camerino sia pieno per lo più di disegni toscani."

53. Baldinucci, VII, pp.99–100; the letter is quoted by Acanfora, 1989, p.72; Baldinucci, II, p.16.

54. Quoted Fischer, 1984, p.9. See also Webster and Crinò in Florence, 1971.

55. Leopoldo's influence of course extended far beyond Florence, as when, for example, the widow of the Marchese Coccapani in Modena refused to sell a major drawings collection to a "pittore Inglese" in 1655 because she knew of the Prince's interest in acquiring it: see Filetti Mazza, 1993, p.14.

56. Van Tuyll, 2000, p.29.

57. See the close analysis of his second collection by Py, 2001; Monbeig Goguel in Paris, 1981, under no.40 (Ciampelli).

58. Wood, 1994 and Wood in Edinburgh, 2002.

59. Warwick, 2000.

60. See Turner, 2003, on Gabburri, and Borroni Salvadori, 1983, on Hugford; other Florentine collectors such as Giovanni Filippo Marucelli (d.1772) whose collection was rich in works by Poccetti, Cecco Bravo, Della Bella, Callot and other Florentine artists may have benefitted from this influx of drawings onto the market: see Brunetti, 1990.

61. See Prosperi Valenti Rodinò in Rome, 1977, and Fusconi and Prosperi Valenti Rodinò, 1982, pp.81–82; these drawings probably were amongst the rejects from Leopoldo's collection.

62. Turner, 2003, p.196; see further on Kent, Ingamells, 1997, pp.571–72.

63. See Barsanti in Florence, 1986, pp.312–15, and Turner, 2003.

64. See for instance Rogers, 1778, Metz, 1798, Ottley, 1808–23, and Duval, 1829.

65. Byam Shaw, 1976, p.10, n.6; Fischer, 2001, p.24.

66. Tordella, 1996, p.79.

67. Fischer, 2001, p.22.

68. Turner in London, 1986, p.20.

69. Chappell, 1998.

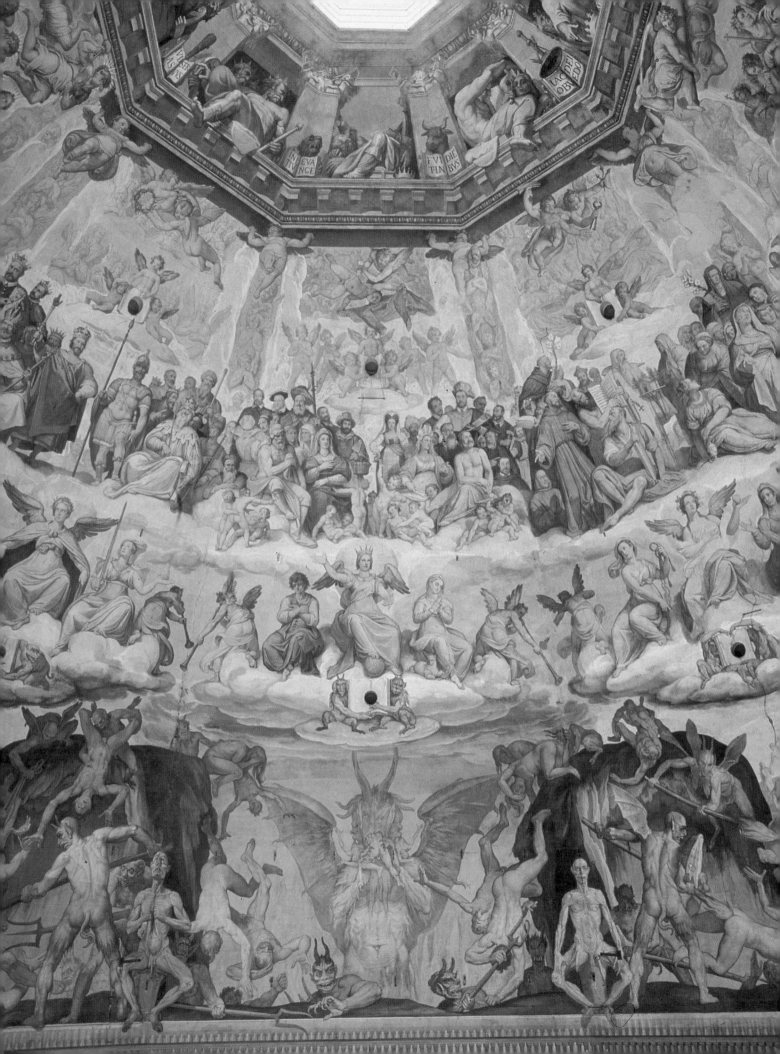

Drawing in Florence *c.*1600:
the studio and the city

Julian Brooks

'[Santi di Tito] was in youth, as in old age, much devoted to drawing, …. at which he spent all his spare time, especially in the evenings, when he was not able to work with colours. In those hours, when one could not draw from life in the public academy, which he frequented, along with every other first-rate master, and when he had nothing else to do, he drew in red chalk his wife, sons and daughters, the maidservant, the chairs, stools, and finally the cat.'[1]

S UCH ENTHUSIASM for drawing as that revealed by Baldinucci's anecdote of Santi di Tito pervaded Florentine art of the late sixteenth century. While it was stimulated by demand and necessity, the sheets produced in the period proclaim a passion for drawing well beyond the practical functions for which they were employed in the design process. New or vastly expanded genres such as landscape drawings made for sale, caricatures, drawn copies, designs for prints and book illustrations became extremely popular. These innovations were supplemented by the explosion in demand for religious works fuelled by the Counter Reformation, which particularly involved large cycles of cloister decorations, and altar-pieces for churches and private chapels. Ever-grander Medici celebrations of public events of increasing visual sophistication required much co-operation between artists, and a co-ordinating structure. Grandiose projects such as the decoration of the interior of the dome of Florence's cathedral (Duomo), the icon of the city, reflected an ambition and intention previously unknown in a painted project in the city, and whetted the appetite for large-scale ecclesiastical and secular decorative projects. All these types of project held drawing at their centre.[2] Yet there were two other factors which laid the groundwork for the graphic explosion in Florence at the end of the century: the presence of the Marchigian Federico Zuccari in the city between 1575 and 1579, and the establishment of the Accademia del Disegno in 1563.

The presence of Federico Zuccari in the city was particularly important because of his integration into Florentine artistic life and for the spontaneity and zeal with which he made drawings.[3] Having been in Rome a number of years and then travelled extensively, Federico won the commission to complete the decoration of the cupola of the Duomo (fig.5; cf. cat.80–84) after Vasari's death in 1574, much to the annoyance of Alessandro Allori, who coveted the commission.

Federico's mania for drawing, attested by the enormous number of surviving sketches, would have been a spur to young artists contemporary with, and perhaps even prior to, the ascendancy of the Santi studio (see below). A large team of artists worked on the enormous cupola project; Domenico Passignano in particular became a close associate, later travelling

Fig.5 Federico Zuccari, *The Blessed people of God; The punishment of the Proud by Lucifer.* Cupola of the Duomo (Santa Maria del Fiore), Florence (West section).

Fig.6 Federico Zuccari,
Portrait of Giambologna.
Black and red chalks,
261 × 188 mm, National
Gallery of Scotland,
inv.D.1951

with Federico to Rome and Venice. In turn Domenico's friendship with Cigoli, Pagani, Boscoli and others of a new generation would have influenced their art.[4] Many of Federico's drawings are spontaneous records of the everyday life he saw going on around him: mothers and children, workmen, friends, and landscapes. His portrait of his friend Giambologna (fig.6), taken from life, would later be used for placing his likeness in the cupola, close to a prominent one of Federico himself, and alongside other friends and family, all of whom the artist included among the representation of the 'blessed people of God'.[5] In contrast Federico declared in October 1577 that he intended to put a likeness of the engraver Cornelius Cort, with whom he had quarrelled, in *Inferno* with a copper plate around his neck. He probably abandoned this idea on Cort's death in March 1578.[6]

An example of a casual study from life made by Federico is a drawing of young artists making copies of Michelangelo sculptures in the New Sacristy (fig.2), which was at the time regularly frequented by artists.[7] The youths climb onto the architecture to get a better view, others are seated on a bench, resting, and reinforcing themselves with red wine. Throughout his life Federico showed an interest in the training of artists, and the drawing provides useful evidence that he was involved with them, whether in a formal or informal capacity. Federico would have encouraged the artists in making drawn copies, which he did himself extensively (cf. cat.82); he copied Mantegna, Titian, Giulio Romano, Holbein, Parmigianino, Pisanello, Palma Vecchio, amongst others. Further, they in turn would have seen him casually drawing them as a random genre scene.[8]

Making copies of other artists' work had long been acknowledged as a good way to learn to draw and paint.[9] Many artists learnt by copying the works of their master, such as

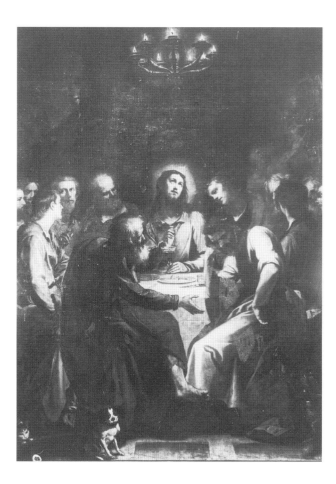

Fig.7 Lodovico Cigoli, *The Last Supper*, 1591, oil on panel, dimensions unknown, formerly Empoli, Church of Sant'Andrea Apostolo (destroyed in the Second World War) (cf. cat.36)

Balducci copying Naldini (cat.4). Often they would travel to other cities to copy other artists' work, including an almost-obligatory sojourn in Rome to study the works of Michelangelo, Raphael, and the antique. Yet there was not only interest in the old masters such as Raphael, Michelangelo or Correggio, but also in contemporary artists. We know that Cigoli and Pagani went to Arezzo in the 1580s to see Federico Barocci's *Madonna del Popolo* (1579).[10] In Cigoli's painting of the *Last Supper* (fig.7) Christ casts his eyes heavenwards in a Baroccesque touch; in turn, Rubens learnt from this picture (cf. cat.36). Cigoli also travelled with Passignano to Perugia to see Barocci's *Deposition* (1567–9).[11] Baldinucci records that Boscoli always travelled with a sketchbook in his belt, to record any view or work which might appeal to him, a practice that almost saw him executed as a spy when travelling in the Marches.[12] Through the practice of copying one can also see talent filtering down the generations; for example Jacques Callot copied the prints of Tempesta (cf. cat.27), and Stefano della Bella in turn learnt by copying the prints of Callot.[13] Copies held a different status then to that which they occupy in our world of mass-reproduction. They were used in a creative way as the basis of original solutions to artistic problems, and the late sixteenth-century outburst of drawn copies as a means of understanding the past was also crucial to formulating a new reformed style.

Beyond the triumvirate of Michelangelo, Raphael and Leonardo,[14] no Renaissance artist had a greater practical impact on late sixteenth-century Florentine art than Andrea del Sarto, whose works were copied widely, and which provided the springboard for numerous compositions of the time (e.g. cat.71, 76). The strength of interest in Andrea del Sarto's work is attested not only by an early anti-mannerist treatise in praise of his art, but

also by his status as a cult figure amongst artists.[15] Federico Zuccari bought Sarto's house and studio on 23 January 1577. Jacopo da Empoli possessed Andrea del Sarto's easel and is recorded as a keen copyist of his works. When Jacopo was studying the artist's frescoes in SS. Annunziata, Lucrezia, Andrea's aged widow, enjoyed sitting next to him, watching him work and telling stories of her husband, who had died years before in 1530.[16]

The Accademia del Disegno in Florence provided a focus for much artistic activity, while functioning as an instrument of Medici patronage and control. Its establishment in 1563, largely through the efforts of Giorgio Vasari (1511–1574) and Vincenzo Borghini (1515–1580), provided a single professional body to represent artists, a champion for the primacy of drawing, and an institution which could provide practical teaching, although the extent to which it did this has been a source of discussion. There is increasing evidence that the Accademia did provide lectures on mathematics and geometry, a forum for discussion, and some facility for study from life (cf. Baldinucci's account of Santi above), principally in the Cestello in Borgo Pinti. This evidence supplements long-standing views of the Accademia as an institution aimed at raising the status of artists.[17] Yet there was also a recognition by the late 1570s that improvements were needed to put the Accademia 'back on its feet', and Federico Zuccari was asked to provide some guidance for reforms. He suggested the provision of figure-drawing classes, instruction in the use of tools and materials, advice from older members to younger ones, and lectures in mathematics at least once a month.[18] There is no indication that these reforms were put into place until several decades later. In the end one of the principal roles of the Accademia seems to have been as a co-ordinating body. From the outset, the Accademia achieved prominence by organizing memorial ceremonies after the death of Michelangelo (14 July 1564), and this role was magnified through the grandiose public festivals and commemorations co-ordinated on behalf of the Medici over the coming decades, including a role in the 1589 wedding (see below). The Accademia also oversaw one of the first 'export bans' put in place, one of the reasons for which was given as the necessity to retain fine works for young artists to copy. The important regulation, passed on 6 November 1602, assigned to the Accademia supervision over the exportation from the Medici territories of works of art by masters of the previous hundred years.[19] Officials of the magistracy and the customs were ordered not to allow such paintings to leave Florence without a licence signed by the Luogotenente, countersigned by a leading painter and stamped with the official seal of the Accademia. The reasons cited for this were the prevention of fraud and the substitution of one painting for another; the only exemptions from this rule were portraits and landscapes of a small format, used as headboards for beds. Interestingly, the decree also included a list of artists whose paintings were completely unexportable; broadly the great Florentine masters, but also including 'foreigners' such as Titian, Correggio, and Parmigianino.[20]

The real engine-room of life drawing in Florence seems to have been the studio of Santi di Tito. Santi was an artist whose career straddled several generations and who contributed paintings to the decoration of the Studiolo, while working in a different idiom from the majority of the other painters represented there. In contrast to the densely-packed compositions, contorted poses, and rich colours of the other works (cf. fig.49), Santi set his scenes in a clear and comprehensible space, with realistic figures and landscape, and softer colours. Vasari believed that life drawing was only important in the early career of an artist and that thereafter intellectual and imaginative ideas were more important; in his time life

drawing was being practised less and less.[21] Instead Santi and his pupils re-asserted the earlier Renaissance practice of making studies for each of the figures in a painting, and furthermore regularly drew from life as an exercise. Hundreds of life drawings by Santi and his pupils Agostino Ciampelli, Gregorio Pagani, Andrea Boscoli, Lodovico Cigoli, and Cosimo Gamberucci, survive, principally housed in the Uffizi and Louvre (cf. cat.66).[22] Yet the sessions of life drawing in Santi's studio were fairly informal. It is recorded that Cigoli, while he was working with the architect Bernardo Buontalenti, went to Santi's studio 'every day to draw from life, benefitting in the rendering of poses'.[23] Chappell dates this to c.1584–5, when Cigoli was closely associated with Buontalenti and the project for the decoration of the Tribuna of the Uffizi; it seems likely that others such as Boscoli, Ciampelli, Empoli, Commodi, and Pagani drew in Santi's studio at this time.[24] This informal practice is reflected in Pagani and Cigoli subletting Girolamo Macchietti's light and spacious studio for the purpose of life drawing; they added a heater in order to be able to draw the nude during the winter months.[25] Although an artist such as Alessandro Allori did make studies from life, which seem to grow more natural in feeling later in his life (cf. cat.1), it is significant that his son Cristofano left his studio in order to join that of the more 'progressive' Pagani.[26]

Studying from life was one thing, but artists also studied anatomy from dead bodies or cadavers, as previous generations had, and this was seen as a core element of *disegno*.[27] Alessandro Allori had a room in the cloister of San Lorenzo where he made anatomy studies 'of many bodies', and in fact it is recorded that Cigoli was so assiduous in his study of these that he became extremely ill from the stench and lost his memory; he had to spend time in the countryside before recovering. Instead, Passignano, after his work with Federico Zuccari on the cupola, apparently went to Pisa to study anatomy.[28] It has been

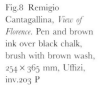

Fig.8 Remigio Cantagallina, *View of Florence*. Pen and brown ink over black chalk, brush with brown wash, 254 × 365 mm, Uffizi, inv.203 P

Fig.9 Cristofano Allori, *View of Florence*. Red chalk, 92 × 183mm Uffizi, inv.63 P

suggested that corpses were also propped up to enable life studies to be made from them. Although Stradanus's drawing of an artist's studio (fig.1) shows a system of pulleys to enable the easy study of écorché figures, it seems unlikely that this would be used regularly for making 'life' studies from corpses; live models were easily available, and most artists were aware of how quickly decomposition occurred.[29]

It is clear that some artists' private academies would also teach draughtsmanship to *dilettanti* gentlemen (just as other artists had taught drawing to junior members of the Medici family). Baldinucci singles out Jacopo da Empoli as someone who opened up his studio in such a manner. A number of drawings can be identified as some of the rather poor results of this, for example two studies of a standing gentleman on a single sheet (Uffizi, inv.3473 F) which Marabottini has identified as copies of Uffizi, inv.953 F.[30] The

Fig.10 French follower of Giulio Parigi, *c*.1615, *The Loves of the Gods*. Pen and brown ink over black chalk, brush with light blue wash. Squared in black chalk, 515 × 396 mm, National Gallery of Scotland, inv.D.1159

verso of another such study, Uffizi, inv.3457 F, contains a poor-quality copy of Empoli's Rijksmuseum study of a gentleman playing a lute, suggesting that drawings were also copied. This is also the case with a drawing at Lille of a young man with a pair of compasses, which is a copy of another drawing in the same location; the latter has underdrawing. The gourmand Empoli also acquired quail and partridge from the market to study still life with his students … and then promptly ate the subject matter. As a result Jacopo Ligozzi nicknamed him 'l'Empilo' ('the full-up one').[31]

Not all studio sessions were built around life, anatomical, or still-life drawing; in his house Giulio Parigi (1571–1635) taught mechanics, perspective, scenography, civil and military architecture, and 'a beautiful and new mode of making delightful landscapes in pen'.[32] Landscape artists such as Remigio Cantagallina (cat.28, 29; fig.8) learnt from Parigi, together with Ercole Bazzicaluva and Parigi's seven sons. The 'new mode' was influential for Jacques Callot and Stefano della Bella, while also creating a new genre in Florence, that of the finished landscape drawing intended for sale. These images were substantially different from Cristofano Allori's little sketches made in the countryside around Florence (fig.9), and from the highly-finished, yet also original, landscape scenes produced by Santi's pupils (cf. cat.30, 64). Artists and gentlemen from abroad also came to Parigi's school to study topics beyond landscape, with results such as an impressive scenographic design of the *Loves of the Gods* (fig.10). This is extremely close in style to Parigi, but is made on paper carrying the watermark Briquet 13.216, generally found on that produced in Narbonne 1604–11, and therefore is most likely to be by a French follower.[33]

For the month of May 1589 Florence became the centre of the courtly world, since the city was the stage for the most extravagant artistic productions and festivities ever held. Their purpose was to celebrate the wedding of Ferdinando de' Medici to Christine of Lorraine (figs.11, 12); Ferdinando was aware from precedents how such celebrations could convey the glory and power of a court far and wide. He had become Grand Duke two years previously on the death of his brother Francesco; his marriage was politically

right
Fig.11 Agostino Carracci,
Ferdinando de' Medici.
Engraving, 262 × 204 mm,
British Museum

far right
Fig.12 Agostino Carracci,
Christine of Lorraine.
Engraving, 261 × 205 mm,
British Museum

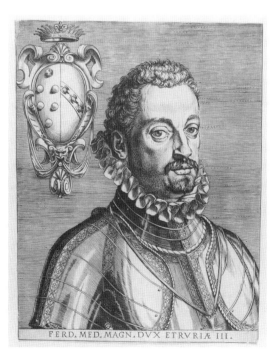
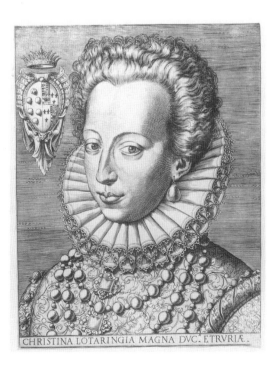

Fig.13 Orazio Scarabelli, *Second entry arch, Ponte alla Carraia*. Engraving, 250 × 342 mm, British Museum, inv.1897-1-13-47

motivated and arranged. Tuscan bankers supported the French economy, the alliance with a princess of Valois France would check the power of Habsburg Spain, and Christine brought with her an enormous dowry, largely provided personally by her grandmother Catherine de' Medici. To be acquainted with her likeness, Ferdinando had been sent a portrait of Christine from France (from which the engraving fig.12 is taken) and had been assured that 'her beauty will please you much more than her portrait'; we now know that the portrait was based on drawings made when the bride-to-be was ten years younger.[34] Yet in the event the marriage seems to have been a personal as well as a diplomatic success.

Derived from those made in 1565 for Francesco de' Medici and Giovanna of Austria, the month-long wedding celebrations were perhaps the most extravagant ever arranged. On 30 April 1589 the bride-to-be entered the city of Florence through a series of especially constructed triumphal arches (fig.13), each decorated with large pictures of events in the history – or supposed history – of her family painted by contemporary artists (cf. cat.5, 34, 56). During the following month the events included a mock sea battle staged using full-scale ships on the interior courtyard of the Palazzo Pitti, completely flooded for the purpose; a football match with 100 players on each side enacted in Piazza Santa Croce; ornate triumphal chariots with allegorical significance parading through the city (cf. cat.23), and a grand wedding feast for which Giambologna made statues of sugar to decorate the tables.[35] But the highlights of the celebrations were six musical spectacles, or *intermezzi*, interleaved with the acts of a production of the comedy *La Pellegrina* (*The Woman Pilgrim*) on 2 May (cf. cat.24, 25; fig.14). Self-contained units lasting about forty minutes, their theme was the power of ancient music, and their stories made use of elaborate stage machinery,

scenery and costumes.[36] These were all designed by Bernardo Buontalenti, whose principal assistants were Andrea Boscoli and Lodovico Cigoli.[37] The *intermezzi* were repeated three times after their original performance, twice between the acts of plays other than *La Pellegrina*. Eventually such *intermezzi* became more popular than the plays they were intended to complement, and their evolution is widely thought to have resulted in modern opera and ballet.

To help propagate the glory of the Medici wedding celebrations a carefully co-ordinated book was published by Raffaello Gualterotti and widely circulated; this is now our principal record of the event and its vast artistic organization (cf. cat.5, 34 and 56; R. Gualterotti: *Descrizione del Regale apparato per Le Nozze della Serenissima Madama Cristina di Loreno Moglie del Serenissimo Don Ferdinando III Gran Duca di Toscana*, Florence, 1589). This book was innovative for the richness of the illustrations and the prominence given to them; it also includes an acknowledgment of the artist who made each canvas. The book is in two parts, published separately. The first is a narrative, in the past tense, of the entry and the various ceremonies, and the second a catalogue with iconographical explanations of the various arches and canvases written in the present tense, which seems to have been intended for the use of Christine of Lorraine during the triumphal entry itself. The second part of the book is illustrated with etchings of all the temporary canvases. Philip Pouncey was the first to recognize Andrea Boscoli's distinctive hand in these etchings, and proposed that intermediary drawings by him had been used to make the prints.[38] In fact, given the nature of the etching technique, where the lines are drawn directly and relatively freely into the etching ground on the plate, it seems likely that Boscoli himself was the etcher. For example, it is difficult to imagine the lines in fig.15 being drawn by any artist other than Boscoli, given the very individual formation of the figures and emphasis on light and shade.

Fig.14 Epifanio d'Alfiano after Andrea Boscoli, *Inferno (Intermezzo 4)*. Engraving, 253 × 362 mm, Private Collection

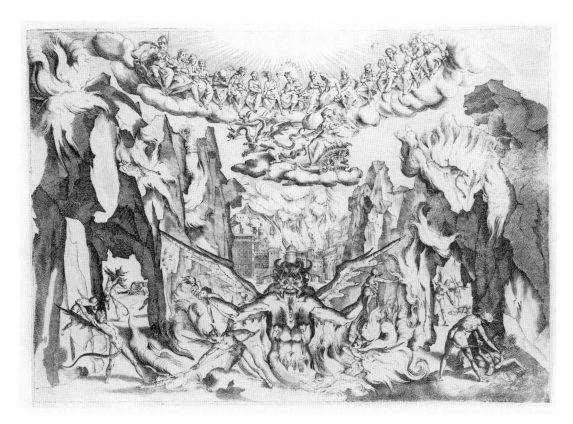

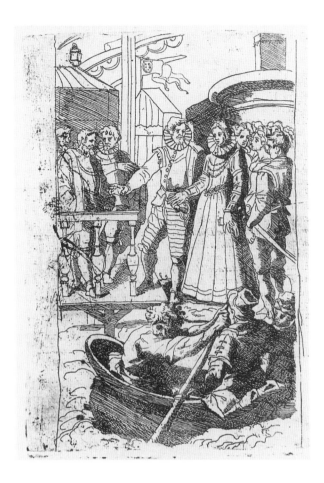

The hurried border lines and the fact that the imperfection in the plate at the centre-left was not corrected suggest that the etchings were prepared in haste. This is despite the fact that the book was planned some time before the entry, and that access was provided to the studios of the artists involved in decorating the arches so that the drawings for the etchings could be prepared as work continued on the large canvases.[39] The preparation of the etchings by a single artist would have ensured stylistic uniformity in the book, and obviated the need to co-ordinate with dozens of artists to provide drawings of each of their canvases; at the time it was an original compendium. Although most of the canvases are now lost, it is apparent from the one surviving arch painting (Giovanni Balducci's *Don Pietro de' Medici welcomes Christine aboard the Capitana in Marseilles*, Florence, Pitti Palace, inv. 1890.7760) that the tall, thin, composition has been modified better to fit the size of the book page (a vertical rectangle; fig.15), and this has also happened with Ligozzi's horizontal canvas (cf. cat.56 and fig.44). The book was illustrated much more lavishly than the one, also by Gualterotti, commemorating the wedding of Francesco de' Medici to Bianca Cappello ten years before, showing the growth in the importance of the images relative to the text. There was also an increasing visual sophistication; whereas his 1579 book was illustrated with woodcuts, Gualterotti's 1589 work was adorned with etchings.[40]

The six *intermezzi* are also now known principally through a series of etchings with engraving made after the event, two by Agostino Carracci (1557–1602; figs.25 and 26), four by Epifanio Parrini d'Alfiano (1564–1616; e.g. fig.14).[41] These were made from intermediary drawings by Boscoli, who, as Buontalenti's assistant, would have had access to the stage designs, as is confirmed by Boscoli drawings of two of the scenes, of the same size and

incised for transfer to the plates.[42] Noticeable in fig.14 is the way in which the design has telescoped the action of the whole *intermezzo* into a single moment in time; the reliance of this depiction of the *Inferno* on Federico Zuccari's painting of Lucifer in the cupola of the Duomo is also very apparent (cf. fig.5; cat.80). This set of *intermezzi* prints were unprecedented, and proved extremely influential in their genre: they set the standard in format and style for subsequent artists treating theatrical themes, including Giulio Parigi and the widely-distributed work of Jacques Callot, who also followed the logical and innovative technique of telescoping the temporal action.

Almost the entire membership of the Accademia del Disegno was involved in some way or another with the wedding decorations, while the programme for the triumphal entry and overall responsibility for the arches fell to Niccolò Gaddi, officer, and former Luogotenante, of the Accademia. As Gianvittorio Dillon has pointed out, the wedding provides a perfect picture of the artistic scene in Florence at the time.[43] Subsequent weddings, funerals, and public events were celebrated in similar or more fitting ways (cf. cat.16, 40), and Florentine international primacy in the planning and execution of such spectacles during this period is attested by Inigo Jones' desire to replicate them in England.[44]

Towards the end of the sixteenth century in Florence a wider range of materials and techniques were used in drawing than ever before. This was probably inspired by the search for new effects, an increasing pride in drawings as works of art in themselves, and the increasing availability of such materials. Blue paper had been used in Venice from the late fifteenth century by artists such as Vittore Carpaccio and Giovanni Bellini, probably reflecting the Venetian primacy in dyeing technology and acquaintance with decorated Middle Eastern papers.[45] By the end of the sixteenth century it was widely employed in Florence, providing a useful mid-tone from which the artist could easily excavate shadows and raise highlights with the use of black, red, and white chalks (cf. cat.4, 38). In early Florentine drawing, coloured grounds were frequently applied to paper for the use of metalpoint. Although the use of the often laborious and indelible metalpoint technique had died out by the end of the sixteenth century, broadly-applied coloured grounds lived on, producing not only a mid-tone but also an effective high finish which could be shown to a patron (cf. cat.76). Empoli and Poccetti often used grounds for figure studies (cf. cat.70), and Cigoli sometimes used a dark brown wash background to study effects of light (cf. cat.37, where the preparation also covers up indistinct red chalk workings). Red chalk, popularised by Leonardo, was the most common medium for life drawings and academies, which were suited to the chalk's warm skin-tone hue, and black chalk was often also used. Federico Zuccari frequently mixed them to provide a two-chalk technique (cf. cat.82, 83), and this was influential particularly on Cigoli, Biliverti, and Cristofano Allori, and was often used later in the seventeenth century, including by Cecco Bravo (cf. cat.61, 63). Black and red chalks are frequently found individually as underdrawing for the rough sketching-out of compositions on sheets which were then worked up in pen and ink. Brown washes were easily made and commonly used; more colourful ones were added to drawings for a finished pictorial effect (cf. cat.7, 8, 18). While the white of the paper was often left in a drawing to depict the areas with most light (cf. cat.19–22), if necessary highlights could be added roughly or precisely in white lead, applied either with a brush or pen, or as white chalk (cf. cat.54–55, 75). From here it was only a short step to applying those highlights in

real gold for an extra-rich effect, as frequently used by Ligozzi (cf. cat.57), and to comic effect by Baccio del Bianco (cf. cat.8).

The majority of drawings presented here are designs for paintings of religious subjects; beyond Medici commissions, the large altar-pieces in the bigger churches were some of the most prestigious and desirable. During the final session of the third period of the Council of Trent (3–4 December 1563), designed to unite the church and declare its doctrines and ideals, a new pietistic zeal was emphasised, and guidelines were laid down for paintings commissioned for churches. Principal among these was the precept that paintings in churches should present histories, people, and sacred mysteries clearly, accurately and persuasively. The representation of the nude figure should be controlled. Although these demands took time to filter through, there is no doubt that for artists such as Santi di Tito they went hand-in-hand with a reform of painting and a new emphasis on the study of nature and clarity of treatment.[46] The necessity and desire for clarity meant that pictures had to be planned to an even greater degree, and so preparatory compositional drawings became even more important. Santi's preferred working method of making careful studies of individual figures contributed to their accurate and realistic depiction in paint. Drawings of all sorts were further required to ensure the correct setting in space of the narrative, and to establish a clear relationship between the viewer and the scene represented. These aspects are visible even more clearly in the work of Santi's pupils and followers, among whose patrons there seems to have been a desire not only to follow church doctrine but also the 'new' artistic style, as with patrons such as Giuliano di Francesco Serragli (1548–1611) and his Cappella del SS. Sacramento in San Marco, decorated with paintings by Tiberio Titi, Cigoli, Passignano and Jacopo da Empoli.[47] The reformed style is manifested in the iconic simple figures and gestures of Cosimo Gamberucci's work (cf. cat.53), Pagani's symmetrical composition of the Madonna in a rose garden (cf. cat.65), Cigoli's *Last Supper* (fig.7; cf. cat.36), Empoli's *Presentation in the Temple* (cf. cat.50), and the closely observed naturalism of Ciampelli's *Birth of the Virgin* (fig.29; cf. cat.31). Often the choice of subject matter also reflected Counter Reformation tendencies, for example with the emphasis on penitence exemplified by Mary Magdalene (cf. cat.1, 13, 44), or the newly popular figure of St Thomas Aquinas (cf. cat.26). The clarity, simplicity, piety, and naturalism of these works was in contrast to the artificial *maniera* of the majority of works by the previous generation of artists in the circle of Vasari, exemplified in the painted works of the Studiolo and elaborate altar-pieces often featuring contorted nudes.

Intriguingly, the demand of the Counter Reformation church for clear religious subject matter seems to have been counterbalanced by a secular demand for a much wider range of subject matter and the growth of book illustrations. Some of this was in a curious way linked to the enthusiasm for memorials to recent victories over the Muslim Turks in church decorations such as Ligozzi's *Return from the Battle of Lepanto with spoils* (fig.45; cf. cat.57). The Counter Reformation struggle provided fertile territory for Torquato Tasso's epic *Gerusalemme Liberata* (1581; cf. cat.19–22), a dramatized account of the First Crusade by Godfrey of Bouillon to recapture Jerusalem. The epic quickly gained currency, as shown by the fact that it was the subject of a number of the military scenes on one of the arches for Christine's triumphal entry into Florence only a few years later in 1589; Godfrey was a distant antecedent of Christine.[48] Yet Tasso fills the epic with complex amorous idylls, and it was these that particularly caught the imagination of artists, and became popular and

standard subject-matter throughout the seventeenth century and well beyond. In this regard, the series of Andrea Boscoli drawings which extracted the amorous scenes from Tasso's epic (cf. cat.19–22) are extremely significant. Dante's *Divine Comedy*, as the ultimate Florentine literary subject, also attracted the attention of patrons of the period, no doubt stimulated by the debates on the text in the Accademia degli Alterati; Ligozzi's precise sheets, gone over with a stylus, betray the intention to reproduce them as prints (cf. cat.54, 55).

Although Florence did not have a strong printing or publishing industry during the period in question, drawings were often made for prints to be produced elsewhere (cf. cat.78). The presence of Callot and Stefano della Bella, however, must have been a spur to the Florentine printing industry in the early decades of the new century. The artists were also important in the defining of new genres, such as caricatures and small-scale *capricci*. Two drawings for prints represented here both depict the expensive and courtly activity of hunting (cf. cat.78,79), long popular with the Medici. Poccetti's richly detailed allegorical design for a tapestry (cf. cat.72) with a figure returning from the hunt is in stark contrast to Baccio del Bianco's lowly servant trudging home with laden horses (cf. cat.7). Boscoli's hunting scene shows the durability of conception in Federico Zuccari's 1565 celebrated drop-curtain of a similar subject (cf. cat.18).

The new age of the revival of a close and questioning study of nature was exemplified in Florence in the early seventeenth century by the mathematician and astronomer Galileo Galilei, and it is significant that Galileo matriculated into the Accademia del Disegno in 1613. In fact, he shared a mathematics teacher with Lodovico Cigoli: Ostilio Ricci, who himself became a member of the Accademia del Disegno in 1593, and who taught perspective in the house of Buontalenti. Cigoli and Galileo developed a close friendship and shared many mutual interests, as shown by their correspondence after Cigoli's move to Rome (1604).[49] The letters discuss aspects such as the surface of the moon, sunspots, and the debate on the superiority of painting or sculpture (Galileo rated painting more highly). Cigoli also noted that Domenico Passignano, his fellow Tuscan in Rome, was equally involved in observing sunspots. Raffaello Gualterotti, author of the books celebrating the 1579 and 1589 Medici weddings, was also an astronomer and writer of numerous works on such subjects, and claimed to have invented the telescope before Galileo. Gualterotti was a correspondent of Sigismondo Coccapani and Michelangelo Buonarroti the Younger.[50]

Cigoli, Ciampelli, Passignano, and Boscoli all moved to Rome in the last decade of the sixteenth century or first decade of the seventeenth, to take advantage of the new opportunities opened up there by the taste of Pope Clement VIII (elected 1592, d.1605) for Tuscan art. With the deaths of Santi di Tito, Pagani, Ligozzi, and Alessandro Allori, Florentine patrons employed Poccetti, Empoli, Cristofano Allori, Biliverti and the new generation of artists who had trained in the studios of Santi's followers: Cecco Bravo, Matteo Rosselli, Francesco Furini, Sigismondo Coccapani, and Giovanni da San Giovanni.

A showpiece of the period is the *galleria* in the Casa Buonarroti (1615–22), built by Michelangelo Buonarroti the Younger (1568–1647) to honour the memory of his famous namesake (cf. cat.11).[51] Michelangelo Buonarroti the Younger was a well-known writer, *letterato*, and composer, and a friend of many of the artists whom he paid to produce canvases for the project, some of whom were already working in Rome. The scheme was designed and planned by Buonarroti himself, representing incidents from Michelangelo's

life; the principal scenes around the walls were painted by Anastasio Fontebuoni (1572–1626), Biliverti, Empoli, Rosselli, Valerio Marucelli (1533–*c.*1628), Filippo Tarchiani (1576–1645), Boschi, Passignano, Cristofano Allori/Zanobi Rosi (d.1633), Gamberucci, Ciampelli, Nicodemo Ferrucci (1574–1650), Sigismondo Coccapani, Francesco Curradi (1570–1662), and Tiberio Titi (1573–1627). Significantly, and ironically, all the works are in a thoroughly reformed style, and the one artist of whom there is little stylistic trace is Michelangelo himself. Other parts of the house were decorated with frescoes by Baccio del Bianco and Cecco Bravo.

One of the most intriguing issues of Florentine art of the period is that of the relationship with the work of Caravaggio in Rome. While the Florentines practised and celebrated drawing at every opportunity, Caravaggio apparently never made a drawing in his life. Obviously for those artists who had moved to Rome there was a much greater exposure to Caravaggio. Cigoli's nephew, Giovanni Battista Cardi, asserted that a certain Monsignor Massimi held a secret competition between Cigoli, Passignano and Caravaggio for a painting of an *Ecce Homo*, and liked that of Cigoli best. Research in the archives of the Massimi family suggests that this story is most likely a colourful invention.[52] Nevertheless, Cigoli sometimes went to taverns in Rome with Passignano and Caravaggio, apparently, says Baldinucci, so as not to fall foul of the tempestuous Caravaggio.[53] Cigoli's painting of *Joseph and Potiphar's wife* (cf. cat.39) certainly shows the influence of Caravaggio in the clear light, dramatic treatment of the subject, and the composition of the scene close to the picture plane. Yet what of Jacopo da Empoli, who travelled little and composed works with a clear light based on a close study of reality? In many ways it seems as if the groundwork for a number of the innovations made famous by Caravaggio had been laid in Florence and in the work of Florentine artists in Rome. Such aspects as the strong light and shade (apparent in the studies of Cigoli and Boscoli in the 1580s, cf. cat.17, 35), the clear compositions with strong narrative, the use of realistic figure types, the interest in the close observance of life and nature can all be seen in Florentine art of the period, but stated in an elegant, courtly form, and lacking the violence and strength of Caravaggio. Cristofano Allori's famous *Judith* sits firmly in a Caravaggesque tradition. Whether Empoli's still-lifes of the 1620s also reflect his influence is debatable.[54]

On a sojourn in Florence, Artemisia Gentileschi (1593–1652/3), daughter of Orazio, the close follower of Caravaggio, painted a canvas with a female personification of *Inclination* on the ceiling of the *galleria* of the Casa Buonarroti. For this work she was paid three times the standard rate. Later, Lionardo, Michelangelo the Younger's son, had the nude figure covered with drapery by Baldassare Franceschini, il Volterrano.[55] There were few works by Caravaggio in Florence. His *Head of Medusa* was sent to Florence as a wedding present for Grand Duke Cosimo II de' Medici in 1608 by Cardinal del Monte, and the *Bacchus* was also in the Medici collections at an early date. The *Sleeping Putto* was in Florence by 1608, and Giovanni da San Giovanni paraphrased it on the facade of the Palazzo Antella in Piazza Santa Croce in 1619–20.[56]

Ferdinando de' Medici had died in 1609, but his reign of peace and prosperity was continued by his son Cosimo II de' Medici (1590–1621), guided by his mother Christine of Lorraine. Cosimo II married Maria Maddalena of Austria in 1608 (cf. cat.40), and remodelled the Villa Poggio Imperiale for her (cf. cat.74). On the early death of Cosimo II, Christine and Maria Maddalena acted as co-regents during the minority of Ferdinando II;

their economizing reformed the Medici workshops in the Uffizi (Biliverti walked out of his studio and thereafter worked at home), and forced many artists to leave Florence.[57] Although the decoration of the Palazzo Pitti and other projects gave work to the talented Giovanni da San Giovanni, Francesco Furini, and Cecco Bravo, amongst others, in the following decades, there remains a sense that the golden age of Florentine *disegno* had passed, replaced by a new grandeur centred in Rome, partly based on the work of the Tuscans who had moved there. In 1637 Ferdinando II commissioned Pietro da Cortona (1596–1669) to work on the Stanza della Stufa in the Palazzo Pitti, having met him in Rome and seen his frescoes at the Palazzo Barberini.[58] Ferdinando invited the most senior artists in Florence, Matteo Rosselli and Francesco Curradi (1570–1661), to witness the unveiling of the frescoes: Matteo said nothing to the Grand Duke but turned to Curradi in despair, saying "Oh Curradi! Oh Curradi! How tiny we others are!"[59]

What survives of drawing in Florence from around 1600 is extraordinarily impressive. The range and quality of the sheets produced in the period reflect the richness and diversity of a strong tradition, and the way in which innovation thrived within it. Even when many of the artists who were the source of this innovation and reform had gone to Rome, artists such as Giovanni da San Giovanni and Cecco Bravo demonstrate the talent and originality remaining in Florence, particularly in their drawings (cf. cat.59,63). Baldinucci's writings, though incomplete, provide a vivid account of the atmosphere within which the drawings were produced. Over the span of several decades each side of the year 1600, the casual studies, life drawings, rapid compositional sheets, highly finished presentation drawings, caricatures, landscapes, designs for prints and theatrical performances all reflect the diversity of the requirements of contemporary patronage and the artistic thought that went into satisfying it. Yet the vigour and brio of the drawings, and the unusual techniques used by the various artists of the time, tell a story of their own.

Footnotes

1. 'Fu si da giovane, come da vecchio, tanto innamorato di questa bella facoltà del disegno …. v'impiegò sempre tutti gli avanzi del tempo, nel quale non eragli permesso il colorire, particolarmente l'ore di quelle veglie, nelle quali non facevasi tornata a disegnare il naturale alla pubblica accademia, la quale egli insieme con ogn'altro maestro di primo nome era solito frequentare, ed allora quando altra cosa non gli dava fra mano, disegnava di matita rossa la moglie, i figliouli e figliuole, la fante, le sedie, gli sgabelli e fino la gatta.' Baldinucci, II, p.551.

2. For overviews of the period in Florence see particularly the exhibition catalogues Florence, 1980 (Primato), Florence, 1986, Oberlin, 1991, Florence, 1997, and Florence, 2002.

3. His influence discussed most recently by Gregori, 1998, pp.9–45; see also Heikamp, 1967 and Acidini Luchinat, 1999.

4. Wazbinski, 1987, I, pp.316–7. There is also the intriguing suggestion that Lodovico Carracci was associated with Federico at this time, see the summary in Gregori, 1998, pp.25–6.

5. See for example Acidini Luchinat, 1999, figs.36, 39, 40, 72–73, 75; Heikamp, 1967, pp.49–51.

6. Acidini Luchinat, 1999, p.95.

7. Wazbinski, 1987, pp.75–103.

8. Heikamp, 1967, p.54.

9. As by Leon Battista Alberti, book 3 (ed. 1956, p.94), and Cennino Cennini, (ed. 1933), pp.13–15. Cennini recommended that the young artist should copy alone, or in company that will not disturb him. Also that the artist should not 'indulge too much in the company of women' lest his hand become unsteady.

10. Chappell in Florence, 1992, p.4, under no.2.

11. Petrioli Tofani in Florence, 1980 (Primato), p.103.

12. Baldinucci, III, pp.75–6.

13. Forlani Tempesti in Florence, 1986, Biografie, p.78.

14. There was considerable interest in Leonardo, whose works and unpublished treatise on painting were copied and widely known; see for example Barone, 2001.

15. Williams, 1989, pp.111–140.

16. Heikamp, 1967 (Casa), pp.3–34; Baldinucci, III, pp.15, 11, 6.

17. Pevsner, 1940, pp.39–66. See Dempsey, 1980, pp.552–69, Wazbinski, 1987, I, pp.267–303, and Barzman, 2000, pp.60–79.

18. Barzman, 2000, pp.67–8.

19. Reynolds, 1974, pp.200–2.

20. As listed: Michelangelo, Raphael, Andrea del Sarto, Beccafumi, Rosso, Leonardo, Franciabigio, Perino del Vaga, Pontormo, Titian, Francesco Salviati, Bronzino, Daniele da Volterra, Fra Bartolomeo, Sebastiano del Piombo, Filippo Lippi and Correggio.

21. In his life of Titian, Vasari says:– '…Besides which, it is necessary to give much study to the nude, if you wish to comprehend it well, which you will never do, nor is it possible, without having recourse to paper, and to keep always before you, while you paint, persons naked or draped, is no small restraint, whereas, when you

have formed your hand by drawing on paper, you then come little by little with greater ease to carry your conceptions into execution, designing and painting together. And so, gaining practice in art, you make both manner and judgement perfect ….' Vasari, *Lives*, vol .IX, ed. G. de Vere, London, 1911–15, p.106. As argued by Florian Härb in a paper given at a conference in Chicago 23 November 2002.

22. Many of these studies remained in the artists' studios; at his death Santi's studio contained 196 life studies, 280 compositional studies, 144 studies of *teste di morti*, a bundle of architectural studies, and a sketchbook; see Brooks, 2002, p.281.

23. Cardi, as quoted by Matteoli, 1980, p.21.

24. Chappell, 1971, pp.51, 263, n.40.

25. Baldinucci, III, pp.37–8.

26. Chappell in Florence, 1984, p.15.

27. Wazbinski, 1987, pp.179–96.

28. Matteoli, 1980, p.20; Baldinucci, III, p.433.

29. Ciardi and Lecchini Giovannoni in Florence, 1984 (Anatomiche), pp.22, 96, no.51. The example given is a drawing by Boschi in which the model does indeed appear dead; either this was a one-off, or perhaps the model had been asked to 'play dead'.

30. Baldinucci, III, p.15; Marabottini, 1988, p.157, figs.XC and XCI.

31. The Rijksmuseum sheet, inv. 1947.357, repr. Forlani Tempesti in Florence, 1980 (Primato), p.114–6, no.209, fig.209; Lille, invs. W.1191 and W.1157, Brejon de Lavergnée, 1997, p.86, nos.197–198 (as both by Jacopo da Empoli); Baldinucci, III, pp.15–6.

32. Baldinucci, IV, p.141.

33. Baldinucci, IV, p.141; Before the analysis of the watermark, the sheet was believed by Tim Clifford, Julien Stock, and the present author, to be from Giulio's hand on stylistic grounds; Annamaria Petrioli Tofani called it 'not Florentine and probably not Italian'. The sheet was brought to my attention by Catherine Monbeig Goguel, and Christopher Baker kindly communicated details of the watermark.

34. Langedijk, 1981, I, p.654–5, no.5, fig.31.5.

35. For the wedding, see Saslow, 1996, from which the present details are taken.

36. The six were: *The Harmony of the Spheres, The Contest between the Pierides and the Muses, Apollo and the Python, The Inferno, The Triumph of Amphritite, and The Descent of Apollo, Rhythm, Harmony and the Muses to Earth.*

37. Saslow, 1996, p. 45.

38. As first recognized by Philip Pouncey; Pouncey, 1951, p. 323, n.3. Two Boscoli drawings at Genoa have recently been identified with the project, one of which copies the painting by Valerio Marucelli of *The Marriage of Duke Charles III of Lorraine and Claudia of France*, and another Cigoli's *Charles of Anjou at the Battle of Benevento* (Genoa, Palazzo Rosso, invs. 1813, 1822). Discussed by Bastogi in Florence, 1997, p.296, under no.243. The two drawings were attributed to Veronese until recognized as Boscoli by Bert Meijer and Nicholas Turner independently. These drawings were presumably two of the *ricordi* from which Boscoli worked on the etchings.

39. Saslow, 1996, pp. 24–25.

40. A series of drawings at Lille, sometimes used to define the styles of almost unknown draughtsmen (e.g. Gamberucci, Thiem, 1974, p.385, and Lecchini Giovannoni, 1982, p.6), seem in fact all to be copies after the prints in Gualterotti's book; Brejon de Lavergnée, 1997, p.400, under no.1081. They are of the same size and copy the etchings identically. Gualterotti intended Andrea to illustrate another of his books, the *Polemidoro*, which was never done; see Bastogi, 1994, p.13. Gualterotti recounted that he gave Andrea money for the illustrations which were never provided, and claimed pictures from the artist's estate when he died.

41. One of the prints (of the second *intermezzo*) is dated 1592, but their manufacture was presumably driven by the 'hype' during and following the wedding. Examples of the two Carracci prints are found in the British Museum (invs.U 2-111, U 2-112). The four Epifanio prints are included in two albums of prints concerning the Medici wedding, one of which is in New York, Metropolitan Museum of Art, inv. The Dick Fund 1931, 31.72.5, the other is discussed in Hanover, 1980, p.17. The second state of all six prints bear the address of the otherwise unknown Sienese publisher Filippo Suchielli. Epifanio Parrini d'Alfiano was a Vallombrosan monk (see Savioli & Spotorno, 1973, pp.61-4. He was never the Prior of Santo Spirito, Florence (an Augustinian church) as claimed by the *Allegemeines Künstler-Lexikon*, 1986, II, p.53.). At the time of the wedding he was based at the Badia di Passignano, where a year earlier documents record that he received mathematics lessons from Galilei Galileo (Vasaturo, 1973, p.132, n.193).

42. Uffizi, inv. 15115 F; Louvre, inv. 866; figs.41-42. Although these two Boscoli drawings have for some time been associated with the series of six prints, the idea that the other four were also after drawings by Boscoli has been demonstrated independently by Bastogi (in Florence, 1997, under no.244) and the present author (in a paper given at the study day 'Drawings by the Carracci from British Collections' held at the Ashmolean Museum, Oxford, 18 March 1997).

43. 'un parfait tableau de la situation artisistique en cette annee 1589' (Dillon in Nancy, 1992, p.147). In Francis Douce's copy of Gualterotti's book in the Bodleian (Douce G.580), he copies a note apparently in Mons. Mariette's handwriting 'inserted in Mr Lloyd's edition of the work' listing the illustrations and asserting 'On ne peut voir sans admiration qu'à la même epoque il se trouva tant d'habiles artistes dans la Ville de Florence'.

44. Explored by Pellegrini in Florence (Potere), 1980, pp.375-79.

45. Brückle, 1993, p.74.

46. Hall, 1979, pp.79-83.

47. See literature noted in Brooks, 2002, pp.282-3. For patronage in the period see Goldberg, 1988.

48. Saslow, 1996, p.192.

49. Kemp, 1990, pp.92-98; Chappell, 1975, pp.91-8.

50. Gamurrini, 1685, V, p.185; Casa Buonarroti, Archivio, 48, fol.1020-1030, letters of between 1591-1623, one speaks of the *argomento* of Gualterotti's *Polemidoro*.

51. Vliegenthart, 1976, pp.22-52.

52. Cardi (Matteoli, 1980, p.31); the issues are summarized by Brown in London, 2001, pp.260-63.

53. Baldinucci, III, p.277.

54. See Chappell in Florence, 2002, pp.140-2, no.5; Moir, 1967, p.213.

55. Vliegenthart, 1976, pp.170-73.

56. Moir, 1967, p.214; Sebregondi Fiorentini, 1982, p.122.

57. Barocchi, 1975, VII, p.68. The studio was retained by his students.

58. Acanfora, 2001, p.149. For the interior decoration of the Palazzo Pitti see Acanfora, 2001, pp.147-54.

59. Baldinucci, IV, pp.173-4. 'O Curradi O Curradi, quanto noi altri siamo piccini! Che dite che dite, non siamo noi ben piccinini?'.

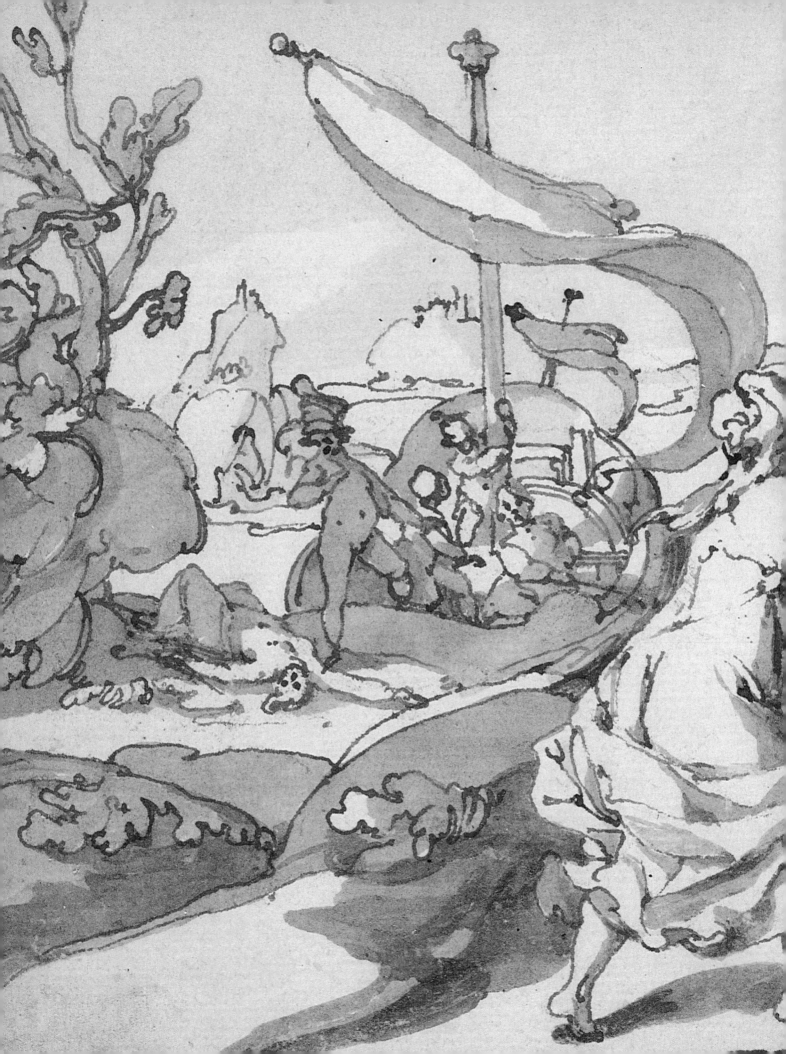

A pupil and adopted son of Bronzino, he assisted with a number of Medici projects before a sojourn in Rome in the 1550s. In 1564 he was involved in the commemoration of Michelangelo's death, and he also made two paintings for Francesco's Studiolo. For the last quarter of the century he was court painter to the Medici, with a studio as important as that of Santi di Tito, if ultimately less influential. The works produced over his long life remained rooted in a Bronzinesque style, although showing more naturalism towards the end of his career.

Study for the figure of Mary Magdalene (recto); A stooping figure (verso)

Black chalk. Inscribed by an early hand in brown ink on the *verso*: *Alessandro Allori*[1]
363 × 245 mm

The Trustees of the British Museum

This accomplished drawing is deceptive; it seems highly finished and yet has been created with rapid, fluent, but finely judged, lines. While the lower part of the figure is left relatively unfinished (resulting in some spatial uncertainties in the depiction of the open book), attention has been concentrated on the rendering of the face and the hair. Since the Magdalen is traditionally identified with the woman who anointed the feet of Christ and dried them with her hair, this detail is extremely important (cf. cat.47). Long chalk strokes are used to convey texture, in contrast to the tiny criss-cross patterns modelling the Magdalen's face.

In the tradition of the early Renaissance model-book, Allori seems to have retained this drawing in his studio in order to use the pose again and again, over a long period of time. He used it first for a figure in the painting of *Christ in the house of Martha and Mary* in the chapel of the Palazzo Salviati, Florence (1578); for the same figure in the *Resurrection of Lazarus* now in Sant'Agostino, Montepulciano (1593); for the *Resurrection of Lazarus*, Pistoia (1595); for the *Penitent Magdalen*, Museo Stibbert (1601); and in reverse in *Christ in the house of Martha and Mary*, now in Vienna (1605).[2] Such frequent and straightforward re-use reflects a successful solution, and an efficient workshop practice.

A rapid study of a stooping figure on the *verso* was connected by Heikamp with that of a man lifting a sack in a preparatory drawing for a lost tapestry of *The provision of grain*

Fig.16 Verso of cat.1

(1595–7). Turner suggested that the figure seems instead to be lifting platters, and that the sketch might have been made earlier and re-used for that commission.[3] However, the object being lifted in the right hand looks suspiciously like a three-legged stool, suggesting that the drawing was made from life for a generic lifting pose, and indeed probably re-used a number of times, like the *recto*.

Provenance: Nicholas Lanier (L.2885); (?) Samuel Woodburn; Lord Breadalbane; his sale, Christie's, London, 4 June 1886, lot 14 (as Domenico Fetti); purchased by the British Museum, inv.1886-6-9-33

Exhibited: London, 1986, no.155

Select literature: Heikamp, 1956, p.139; Lecchini Giovannoni in Florence, 1970, p.47, under no.57; Turner in London, 1986, p.208, no.155, ill.p.207; Lecchini Giovannoni in Florence, 1986 (Maddalena), pp.99–101, under no.25; Lecchini Giovannoni, 1991, under no.69, fig.143

1. Turner has noted that this is the same hand as in a similar inscription on inv.5237-87.
2. Lecchini Giovannoni, 1991, nos. 69, 132, 133, 159, 171.
3. Heikamp, 1956, p.139, espoused in Lecchini Giovannoni, 1970, p.48; Turner in London, 1986, p.208.

Trained by his father Alessandro, Cristofano argued with him about art and left to join the studio of the younger reformer Gregorio Pagani. Cigoli, Passignano and Boscoli were also strong influences. No doubt through his close Medici connections he won a series of significant commissions, including a painting for S. Stefano dei Cavalieri, although he was not always efficient in completing them. His *Judith with the head of Holofernes* (*c*.1610–18; several versions) remains one of the most widely appreciated works of the period. Cristofano's softly-decorative and intense style is also found in his chalk drawings. Owing to his illness from 1618, many of his paintings were finished by his pupil Zanobi Rosi.

Portrait of Christine of Lorraine, Grand Duchess of Tuscany (1565–1637)

Red and black chalks
328 × 232 mm

The Visitors of the Ashmolean Museum

As an important and powerful figure in Tuscany, Christine's features are recorded in a number of portraits, many of them copies of the famous images by Giusto Suttermans (1597–1681) and Santi di Tito, whose studios no doubt made a good trade in them.[1] Baldinucci recounts that Christine disliked long portrait sittings and that after her arrival in Florence she wanted to be painted only by a French artist.[2] Nevertheless, Santi di Tito successfully managed to capture her likeness in half an hour, probably by simply updating the earlier marriage portrait sent from France (cf. p.30). This drawing dates from 1615–20, when Christine would have been aged fifty to fifty-five. The likeness is most similar to that in a portrait by Tiberio Titi, Santi's eldest son and collaborator, in Poggio Imperiale, of which there is a copy dateable to 1618 by Francesco Bianchi Buonavita.[3]

Although Christine is recorded as disliking Cristofano, he painted a number of portraits of her at this time, none of which can now be identified.[4] While the attribution of the sheet to Allori is relatively recent, it accounts well for the soft yet structured handling of the chalk, similar to that found in Cristofano's less formal portrait of his father (Uffizi, inv.7939 F).[5] The red and black chalks are mixed with great sensitivity, and shadows (for example in the ear) created by Cigolesque blocks of shading. Her transparent widow's hood is particularly delicately conveyed.

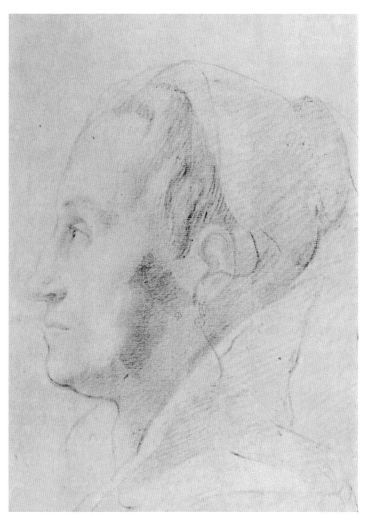

Fig.17 Follower of Cristofano Allori, *Portrait of Christine of Lorraine in profile*. Red and black chalks, 278 × 201 mm, Courtauld Institute Galleries (Witt Collection), inv.3960

A drawing in the Courtauld Institute Galleries (inv.3960; fig.17) seems to be a study of Christine in profile. Macandrew links it stylistically to the present drawing, however, it seems somewhat flat and less well formed.[6]

Provenance: Purchased by the Ashmolean Museum, 1960, inv.WA1960.54 (M.784 A.)

Exhibited: Oxford, 1992, no.29

Select literature: Ashmolean Museum Annual Report, 1960, p.57; MacAndrew, 1980, p.90, no.784A, pl.XLVIII; Whistler in Oxford, 1992, p.82, no.29, fig.29

1. Langedijk, 1981, pp.660–65, nos.21 and 24.
2. Baldinucci, II, p.544.
3. Langedijk, 1981, pp.666–7, nos.25, 25a, figs.31.25, 31.25a.
4. Pizzorusso, 1982, pp.11, 120–21; Langedijk, 1981, I, p.654.
5. Chappell in Florence, 1984, p.40, no.7.2, fig.7.2. Some rubbing of the chalk in cat.2 has resulted in a slightly less forceful image. However, Annamaria Petrioli Tofani (in conversation 21 February 2003) doubts the attribution to Cristofano, and believes the drawing to be closer to an artist such as Giovanni da San Giovanni. The sheet bears a watermark of an *agnus dei* derived from Briquet no.47 (Venice 1484); the paper of cat.2 is clearly later than that.
6. Macandrew, 1980, p.90, under no.784A.

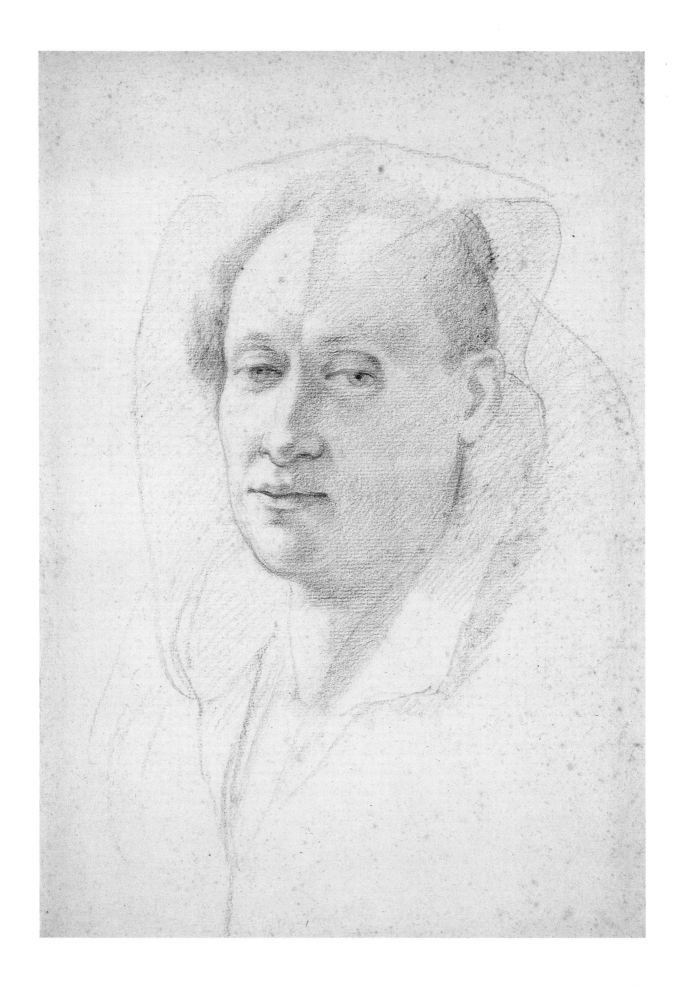

Studies of a young man and other figures

Black chalk. Inscribed in black chalk: *per di uno ½ b*[raccia] and with other measurements
390 × 280 mm

The Visitors of the Ashmolean Museum

This dynamic, yet little-studied, sheet includes sketches for three figures. The principal youth, drawn first, sits on a low box on the left, with a subsidiary study of his head in the centre of the drawing, followed by another, extremely cursory. Behind him is a standing figure leaning over, while another pose of a figure kneeling on one knee is studied in the centre background and on the right. It is difficult to imagine a subject that would include these three poses, and the drawing cannot be conclusively linked with any known painting. Yet each of the figures has some affinities with poses painted by Cristofano.

Seen in isolation, the seated figure resembles the reading figure of Joseph in a drawing in the Uffizi, who sits on a low rock with his weight on his right arm, his left arm extended holding a book.[1] The standing figure is instead similar to those found overlooking the table in, for example, a picture of the supper at Emmaus, and some sort of dining theme is supported by the subsidiary study at the bottom of the sheet, of a hand – presumably that of the seated youth – pouring from a flask. The third, kneeling, figure is particularly interesting because of its links to Allori's kneeling study of St Benedict (Uffizi, inv.911 F; fig.18) for his painting for the Compagnia di San Benedetto Bianco (*c.*1608–10).[2] The figure holds a similar pose, with left arm outstretched to the side (visible in the painting), and right arm lower in front. Interestingly, the box by which he kneels, with a distinctive metal

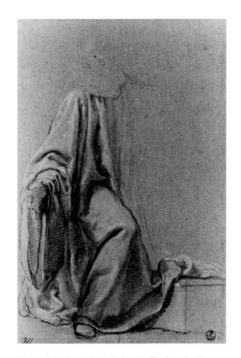

Fig.18 Cristofano Allori, *St Benedict*. Black and white chalks on blue paper, 392 × 260 mm, Uffizi, inv.911 F

upper rim, is strikingly similar to that in the Ashmolean drawing.

Whether the figures were conceived as a group or not, they seem to have been drawn in the same session and deliberately placed within the same space. The triangle measured out at the feet of the seated figure is swept upwards in an arc with some curved light black chalk strokes to an angled horizontal line three-quarters up the page, leading from the top of the head of the seated figure. A similar line travels to the left of the head of the standing man. The purpose of these lines is difficult to

ascertain, but they presumably aid the construction of space, and possibly relate to the carefully-measured dimensions on the box. Such details particularly bring to mind the work and interests of Cigoli (cf. cat.42), and indeed this drawing seems stylistically in his debt, with similarly constructed forms and shorthand heads and hands. Yet it seems to have greater affinities with the work of Allori – Cigoli's most gifted pupil – than with that of Cigoli, being close, for example, to a late drawing by Cristofano in the Uffizi, inv.7923 F (*c.*1610).[3]

Provenance: Purchased by the Ashmolean Museum, 1938, inv.WA1938.83 (P.II 783)

Not previously exhibited

Select literature: Ashmolean Museum Annual Report, 1938, p.35 (as ?Jacopo da Empoli); Parker, 1956, p.413, no.783 (as Cristofano Allori)

1. Uffizi, inv.7929 F, repr. Thiem, 1977, p.334, no.95, fig.95.
2. Discussed by Chappell in Florence, 1984, pp.58–60, fig.16.1. In the note on the mount of this drawing in the Uffizi Miles Chappell further relates it to a sheet formerly with Paul Prouté, Paris, Spring 1987.
3. Repr. Chappell in Florence, 1984, p.88, fig.28.2. Annamaria Petrioli Tofani has stated she believes cat.3 to be either 'late Cigoli or early Allori' (in conversation 21 February 2003).

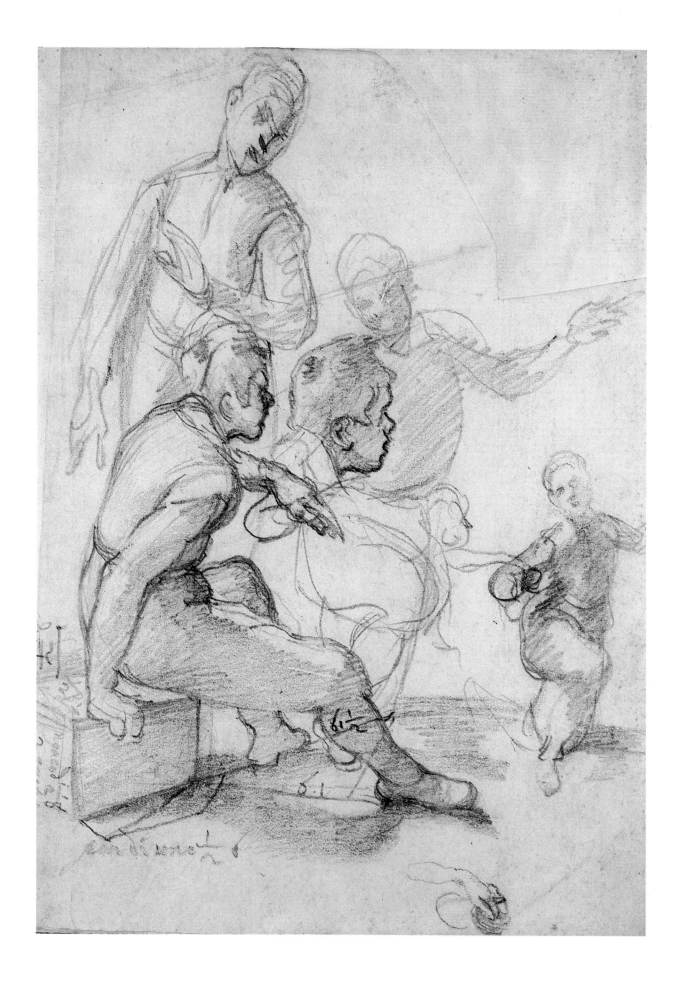

4 GIOVANNI BALDUCCI, CALLED IL COSCI (Florence c.1560 – after 1631 Naples)

Called Cosci after the paternal uncle by whom he was raised, Balducci was the pupil of and spiritual heir to Giovan Battista Naldini (c.1537–1591). He worked with Federico Zuccari on the decoration of the Duomo cupola, assisted Alessandro Allori in the decoration of the Uffizi, and undertook work for the 1589 wedding. Principal among a number of Florentine works was the Oratorio dei Pretoni (1588–90), commissioned by Cardinal Alessandro dei Medici, for whom he moved to Rome with Agostino Ciampelli in 1594. A subsequent move to Naples in c.1596 in the retinue of Cardinal Alfonso Gesualdo, and his marriage and settlement there, ensured the spread of Balducci's attractively simple and iconic, though undynamic, art.

The Lamentation

Pen and brown ink over black chalk, brush with brown wash, white heightening, on blue paper. Inscribed in brown ink lower centre-right: *FP*
359 × 222 mm

The Trustees of the British Museum

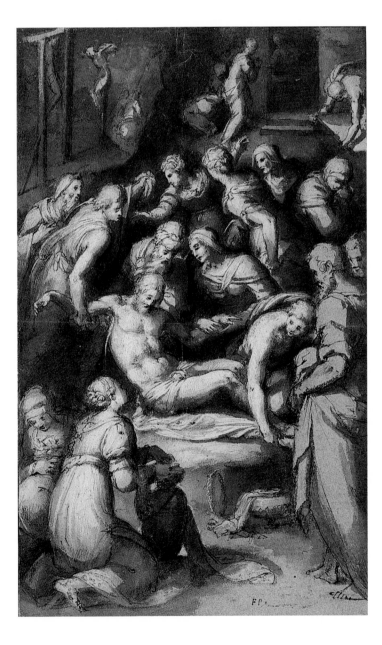

Early in his career Balducci made this copy of Giovan Battista Naldini's painting of 1572 in Santa Maria Novella, rated Naldini's best work by Raffaello Borghini.[1] Baldinucci described Giovanni Balducci as Naldini's 'first and principal pupil'.[2] While copies made for learning were generally rapid – and often clumsy – affairs, this is an extraordinarily highly finished example in rich media, lacking the sense of two-dimensionality often found in copies. The high finish reflects the desire of the young artist to do more than record and discard the composition of the painting as an exercise; the drawing was probably intended for careful retention or presentation.

If it were not for Balducci's distinctive style – with its flat, shovel-shaped, faces and long upper bodies – this is the sort of drawing which would normally be considered a preparatory *modello*.

Provenance: Purchased by the British Museum, inv.1950-4-1-5

Exhibited: Florence, 1980 (Primato), no.62; London, 1986, no.178

Select literature: Petrioli Tofani in Florence, 1980 (Primato), p.68, no.62, fig.62; Turner in London, 1986, p.229, no.178, fig.178 on p.230

1. Hall, 1979, p.102, pl.54.
2. Baldinucci, III, pp.517, 519.

Christine of Lorraine taking leave of Catherine de' Medici

Pen and brown ink over black chalk, brush with brown wash, white heightening, on blue paper. Inscribed in grey ink lower left: *Santi de Titi*
322 × 244 mm

The Trustees of the British Museum

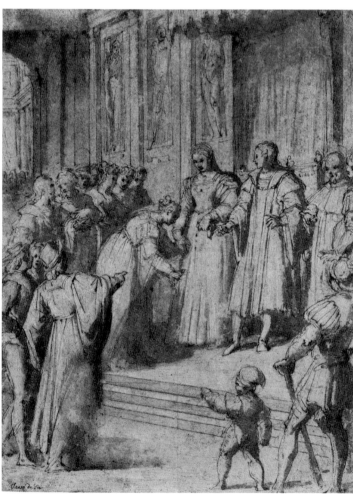

Prior to her marriage in 1589 to Ferdinando de' Medici, Christine of Lorraine made a grand ceremonial entrance to Florence on April 30 through a series of especially erected triumphal arches featuring painted canvases on a particular theme.[1] This drawing is an early study for Balducci's painting on the arch adjacent to the Ponte alla Carraia, the theme of which was previous marriages of the Medici and Lorraine dynasties, and episodes in Christine's journey to Florence. Balducci's canvas represented Christine's farewell to her family, and in particular her beloved grandmother Catherine de' Medici (1519–1589). Yet in fact such an event never took place, since Catherine died on 5 January, and Christine left for Italy in late February, as James Saslow has pointed out.[2] The news of Catherine's death reached Florence on 17 January; it seems that by then arrangements for the canvas and arch were too far advanced to change them, or else it was decided to leave the composition as a tribute; the leavetaking would have had an added poignancy. The pictures were to a large extent symbolic and iconic in any case, and were interspersed with painted allegories (cf. cat.56).

The final painting, like most of these ephemeral decorations, is now lost, but the composition is shown in the contemporary etching made for Gualterotti's book (fig.19), and is also visible *in situ* on the engraving in fig.13.[3] Balducci made a number of changes to the composition shown in this drawing; in particular he turned the figure of Christine to make her face more visible, and rearranged the steps to focus better on the farewell. These pictorial solutions to such scenes of contemporary 'history' were extremely influential in future ephemeral decorations thanks to their circulation through the etchings in Gualterotti's book. Rubens, for example, clearly followed them in his Marie de' Medici cycle.

Provenance: W.Y. Ottley; his sale, T. Philipe, London, 17 June 1814, lot 1206, as Santi di Tito; Sir Thomas Lawrence (L.2445); John Malcolm (L.1489); purchased by the British Museum, inv.1895-9-15-572

Exhibited: London, 1986, no.181

Select literature: Robinson, 1876, no.135 (as Santi di Tito); Pouncey, 1951, pp.323f.; Turner in London, 1986, pp.229, 234, no.181, fig.181; Saslow, 1996, p.191

1. Saslow, 1996, pp.24–5, 141, 190–1, with previous literature.
2. Saslow, 1996, pp.24–5.
3. Gualterotti, p.66.

Fig.19 Andrea Boscoli after Giovanni Balducci, *Christine of Lorraine taking leave of Catherine de' Medici.* Etching, 225 × 165 mm. Warburg Institute

6 STEFANO DELLA BELLA (Florence 1610 – 1664 Florence)

An autodidact who learnt to draw by making copies, particularly of the prints of Jacques Callot, della Bella initially trained as a goldsmith. He was soon acclaimed as an etcher and draughtsman, and was extremely prolific in the production of prints of festivities, public occasions, caricatures, decorative motifs, landscapes, and portraits. Stefano had a sojourn in Rome in the 1630s, and in 1639 left Florence to enjoy fame as a printmaker and scenographer in Paris, with a trip to Holland, where he perhaps met Rembrandt, in 1647. In 1650 he returned to Florence, undertaking Medici commissions until his death.

Design for a sepulchral monument

Pen and brown ink, brush with brown wash. Truncated inscription by the artist in pen on the right: *In ogni …/ In ogni …/ In ogni …/ In ogni …* 196 × 105 mm

The Visitors of the Ashmolean Museum

The dashing and liberal penwork of this drawing reflects the freedom of the artist's imagination. A screaming skeleton has the world in his hands, and is about to roll it like a wheel. A single simple stroke of the brush has been used to fill in the patch of shade under the globe. The drawing cannot be related to a known print or funerary monument but it most likely connects to the funerary decorations for Francesco II de' Medici of 30 August 1634. Presumably this particular design was rejected, since Stefano has crossed out the Medici coat of arms at the top of the drawing. While most of the decorations were made by Alfonso Parigi, some of them were recorded by Stefano in a contemporary commemorative volume.[1] Given the architectural framework in the drawing, it may have been intended for a funerary monument, and not simply as an *impresa*, which generally occupy cartouche-like or armorial designs.

Death and the *memento mori* were subjects to which Stefano returned some years later, with his prints *The Five Deaths c.*1648, and *Death on the Battlefield*.[2] A very similar shouting skeleton to that featured in the Ashmolean drawing, although instead beating a drum, occurs in one of his series of prints of ornaments and grotesques (*c.*1653).[3] On the right of the sheet is a truncated inscription, a verse of four lines, with each beginning *In ogni* …('In every..') Panofsky believes that the third and fourth lines of this can be completed:

In ogni te[mpo], in ogni lo[co] ('In every time, in every place'). This probably records a contemporary saying, but in any event, the message is as clear as the illustration: Death is master of all.

An unpublished drawing on a similar theme, rather weaker and probably from Stefano's circle, shows a *vanitas* with skeletons crowning a skull over a cartouche with the inscription: *Un hombra un sognio, anzi dell'sognio un ombra / un nombra un sognio anzi dell' sog* …(blotches of ink).[4]

Provenance: Prof. Jacob Isaacs, Esq., London; purchased by the Ashmolean Museum, 1942, inv. WA1942.84 (P.II 787)

Not previously exhibited

Select literature: Parker,1956, p.415, no.787; Panofsky, 1964, p.96, fig.445

1. A.Cavalcanti, *Esequie del Serenissimo Principe Francesco*, Florence, 1634; the volume included a view of the interior of the Florentine church of San Lorenzo (D.V.M.74; discussed Caen, 1998, p.42, no.6), a portrait of Francesco (D.V.M. 36), and a series of eight *stemmi* (D.V.M. 971–8), featuring emblems surmounted by simple skulls.
2. D.V.M. 87–91; see Viatte, 1972, pp.198–209, 283–286. Caen, 1998, no.23 with previous literature; D.V.M. 93, Caen 1998, no.24 with previous literature.
3. D.V.M. 1014.
4. Florence, Biblioteca Marucelliana, inv.D 33.

7 BACCIO DEL BIANCO (Florence 1604 – 1657 Madrid)

Placed at the age of eight in the workshop of Biliverti, Baccio also frequented the academy of Giulio Parigi, where he formed an important friendship with Stefano della Bella. In the early 1620s he travelled to Vienna with the military engineer Giovanni Pieroni, and also worked in Prague; on his return to Florence he established a school of perspective and architecture. Baccio was involved with Medici ephemeral decorations and stage productions, and painted genre scenes in villas and houses, including Casa Buonarroti. In 1651 he was called to the Spanish court by Philip IV, occupying himself with ephemeral decorations and scenography until his death.

Studies of a figure kneeling before another, horses returning from the hunt and cavorting children

Pen and brown ink, brush with blue, red, and brown watercolour. Numbered and inscribed in brown ink lower right: *92 Baccio del Bianco*
310 × 213 mm

The Courtauld Institute Galleries, London (Witt Collection)

A gentleman kneels before another seated in a chair, surprising a dwarf and servant behind him; an earthy figure leads two horses laden with a stag, a boar, and some birds back from the hunt; three caricatured dwarves dance while one bangs a tambourine: these elements make for a curious mixture of subject matter. There is no indication of the purpose for which this sheet was made, but it fully displays Baccio's amused and closely observant nature as described by Baldinucci. The unusual layout of the drawing and its horizontal emphasis might suggest that he had in mind three short frieze designs, or three projects for vignettes. The simple genre nature of the figure returning from the hunt can be contrasted with Poccetti's courtly depiction of the same subject (cat.72), while the dancing dwarves are subjects regularly found in the work of Baccio's contemporary Jacques Callot.

Numerous folds on the sheet of a certain size indicate that it may at some time have been included with a letter.

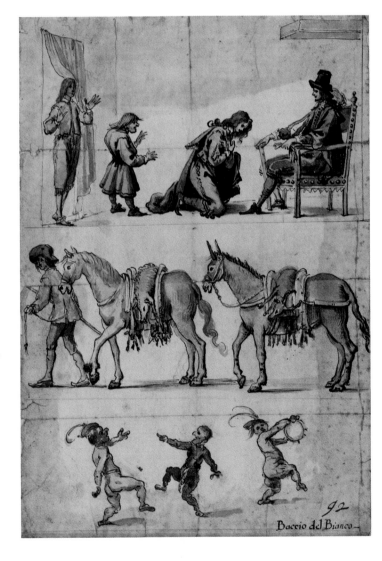

Provenance: Col.Sir Willoughby Rooke; Miss Williams, London, 1926; Sir Robert and Lady Witt (L.2228b), by whom bequeathed to the Courtauld Institute of Art, 1952, inv.2258

Not previously exhibited

Select literature: Thiem, 1977, p.383, no.179, pl.179

Caricature of alchemists at work

Pen and brown ink over traces of black chalk, brush with brown, blue, pink and green washes, gold heightening
200 × 279 mm

The Visitors of the Ashmolean Museum

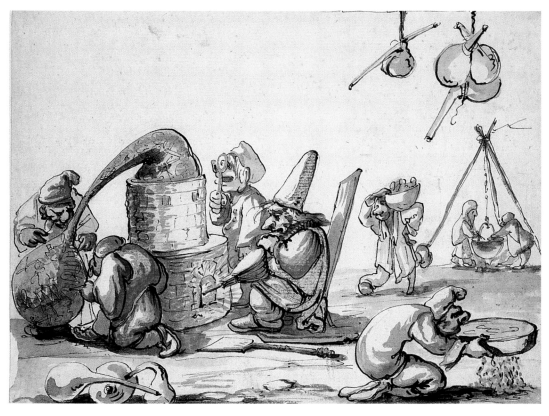

Provenance: Francis Douce, by whom presented to the Bodleian Library, 1834; transferred to the University Galleries in 1863, inv.WA1863.696 (P.II 799)

Not previously exhibited

Select literature: Parker, 1956, p.420, no.799 (as Faustino Bocchi (?)); Olivari, 1990, p.250, no.C45, fig.C45 (as not by Bocchi); Kahn-Rossi, 1993, p.267, fig.10 (as Baccio del Bianco)

1. Formerly attributed to Faustino Bocchi, they were first noted as del Bianco by Marco Chiarini (note on files, 1989), and independently by Kahn-Rossi.
2. Magl. CL.XVIII, cod.6; Kahn-Rossi, 1993, p.267
3. 'Quello però, in che Baccio del Bianco fu eccellente, e forse anche singolare, in materia di finire, fu l'inventare e toccar di penna storiette piacevoli, caramogi, e ritratti di persone con disegno caricato, in genere di che gli sovvenivano cose da fare altrui morir dalle risa'. Baldinucci, V, p.31.

In stark contrast to the serious treatment of cat.77, this drawing pokes fun at a team of alchemists, the principal of whom blows with bellows the furnace of an alembic, while others study the retorts (products) and prepare materials over a fire. In a comic touch the artist has placed two groups of flasks and alembics hanging *trompe l'oeil* from the top of the sheet of paper. Furthermore, as a twist, he has used a thick wash of powdered gold to heighten the drawing, thus mocking the seekers after gold in the caricature, or perhaps mocking the viewer. This drawing comes from a group of three sheets in the Ashmolean recently attributed to Baccio.[1] The other two are scenes of an artist at work, and a patron of the arts. The three sheets have similar dimensions, and, as Kahn-Rossi has pointed out, are the same size and in a very similar format to studies in a sketchbook in the Biblioteca Nazionale, Florence.[2] This contains caricatures of different professions, reminiscent of the street-sellers of the *Arti di Bologna* (published 1630 after Annibale Carracci's drawings of *c.*1580), but in a more wicked vein and focusing on more elevated professions. Such drawings as these caricatures are particularly difficult to date, but seem relatively mature. According to Baldinucci, Baccio was particularly celebrated for his caricatures, which made people 'die of laughter'.[3]

A crowd watching a staged performance

Pen and brown ink over black chalk, brush with watercolours. Inscribed in brown ink lower right: *Calotti*
198 × 276 mm

The Trustees of the British Museum

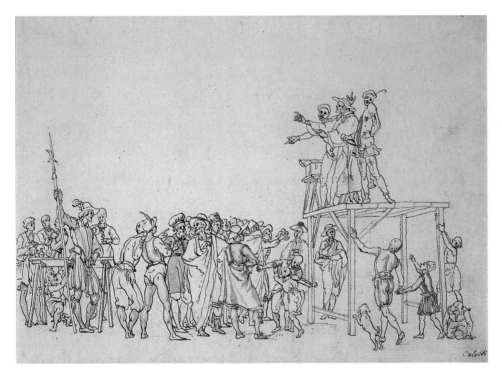

Provenance: Purchased by the British Museum, 1850, inv.1850-3-9-8

Not previously exhibited

Select literature: Hodges, 1968, p.122, no.22, pl.22; Feinberg, 2000, p.119

1. For introductions to *commedia dell'arte* see Molinari, 1985 or Lawner, 1998.
2. I am grateful to Dr Peg Katritzky for pointing this out, and providing details on literature related to the drawing. For further information on mountebanks, see Katritzky, 2001, pp.121–53
3. Ternois and Cairns in Nancy, 1992, pp.210–31.
4. For example in Uffizi, inv.3326 F, where the space between figures is particularly unclear.

In contrast to the much rehearsed and precisely-planned play *La Pellegrina* and its *intermezzi* (cf. cats.24, 25), this drawing gives an idea of the *commedia dell'arte* performances of the time, played on a temporary stage, reliant on improvization and a mix of stock characters.[1] In fact, here we see a group of three mountebanks, itinerant tradesmen who used *commedia dell'arte* sketches to gather crowds, and then had, literally, commercial breaks when they would sell them quack medicines, kept in the chest on stage.[2] The central figure is playing Pantalone, a rich old man who is probably bragging of his love conquests; he is being disrespectfully mocked by his two servants, one of whom is making the cuckold sign behind him (implying that Pantalone's wife is sleeping with someone else). Yet the artist who made this drawing encourages us, the viewer, to watch the audience. There is a mass of anecdotal detail: beside a table at the left with drinkers, an unattentive soldier has his pocket picked, two youths fight in front of the stage, and another tries to climb up onto it with the help of a friend.

The drawing is close to the style of Baccio del Bianco, but also has affinities with that of Jacques Callot, hence the old attribution at lower right, understandable given Callot's interest in *commedia dell'arte* figures.[3] While the application of the watercolour washes is highly accomplished, the perspective of the table on the left-hand side is inconsistent with that of the stage; it can be noted that Baccio del Bianco often had trouble with keeping a consistent space in drawings.[4] The ink lines are carefully drawn but there is no indication that this is a copy of another design; it could perhaps have been intended for the manufacture of a print.

Son of the Delft-born goldsmith Jacques Bijlivert (1550–1603), who was head of Francesco I de' Medici's workshops, Biliverti trained with the Sienese painter Alessandro Casolani (1552/3–1607) before entering the studio of Lodovico Cigoli. Cigoli's influence on Biliverti was overarching in terms of both composition and draughtsmanship, and Biliverti benefitted from numerous Florentine private commissions. The success of and demand for his elegant and emotionally-charged domestic paintings led Biliverti and his workshop, which included Orazio Fidani and Agostino Melissi, to produce plentiful replicas. His often-Cigolesque drawings are relatively numerous, and are sometimes confused with those of Cristofano Allori.

Study for a putto flying

Black, red, and white chalks on green-blue paper. Inscribed in ink lower centre: *Bilivelti 175* (over *174* in black chalk), and numbered *117* lower right
297 × 182 mm

The Governing Body, Christ Church, Oxford

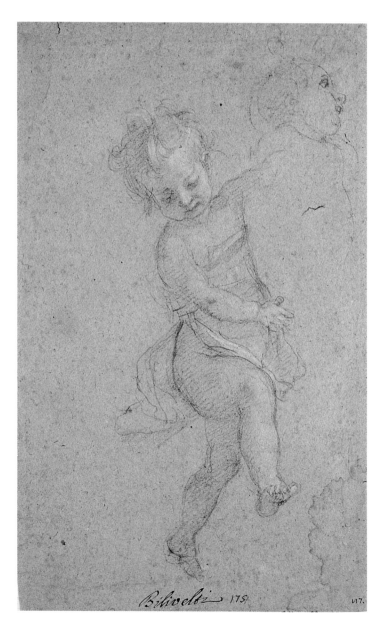

While this softly-handled study of a *putto* does not seem to relate to any currently known painting, the motif is typical of Biliverti, whose paintings often include such flying *putti*.[2] Given the downwards-looking glance and truncation of the right-hand side of the figure, it is probable that the *putto* was intended to hold a piece of drapery, attribute, or coat of arms, or else might have been obscured by a cloud. Wingless, he wears a tunic delineated in all three chalks which billows around his waist. At the top right corner of the sheet is a subsidiary study of a head in lost-profile, most likely conceived for that of a kneeling figure on the ground in the same painting. The early inscription at the base – *Bilivelti* – records an alternative spelling of the artist's name often found in contemporary documents.

Miles Chappell has attributed this drawing to Lodovico Cigoli and linked it to a *putto* in the painting of *Charity* in the Palazzo Pitti, and to its preparatory drawing in the Uffizi.[3] Yet the *putti* there are all unclothed whereas the one in this drawing wears a tunic. Furthermore it is difficult to see this sheet as by the same hand as cat.38; the handling of cat.10, while Cigolesque, is less structured, and is softer and rather less competent in the construction of space.

Provenance: Brandini stamp (L.2736),[1] *verso;* Filippo Baldinucci; General John Guise; Christ Church, Oxford, inv.0252 (JBS 271)

Not previously exhibited

Select literature: Bell, 1914, p.29, G.31 (as Biliverti); Byam Shaw, 1976, p.97, no.271 (as Biliverti); Chappell, 1989, p.203 (as Cigoli); Chappell in Florence, 1992, p.164, under no.97 (as Cigoli)

1. Cf. p.14.
2. For example see particularly the *San Carlo Borromeo adoring the Crucifix* or the *Assumption of the Virgin with Saints*, repr. Contini, 1985, plates 2 and 31.
3. inv.9013 F; Chappell, 1989, p.203; Chappell in Florence, 1992, p.164, under no.97. The pose is instead similar to the left-hand *putto* in Uffizi, inv.433 Orn., repr. Chappell in Florence, 1992, p.93, no.54, fig.54, but this is presumably a generic similarity, or else reflects a Biliverti derivation from Cigoli.

Michelangelo and the Turkish ambassadors

Black chalk, pen and brown ink, brush with light grey wash, oxidized white heightening. Faded inscription in brown ink at top centre: *angiolo*
346 × 231 mm

The Trustees of the British Museum

This is a study for the painting made by Biliverti *c*.1616–20 (fig.20) for the gallery constructed by Michelangelo Buonarroti the Younger (1568–1647) to commemorate the virtue and honour of his famous great-uncle.[1] It represents an episode where Michelangelo (on the right) was commissioned by the Turkish Sultan to build a bridge between Constantinople and Pera. After consulting Piero Soderini, *gonfaloniere* of the Florentine Republic, Michelangelo is said to have refused on the grounds that he could not work for a non-Christian patron.[2] We see here various stages of Michelangelo myth-making in progress, for in fact the Sultan made his offer through some Franciscan monks, yet in this drawing Michelangelo holds a letter of commission directly from the Sultan, and in the finished painting Biliverti includes the Sultan personally pleading, as assistants pull plans from a tube. The main composition in the drawing is made within a carefully delineated border, outside of which are subsidiary studies of the conversing heads on the right, and of the standing Michelangelo holding the letter. At the bottom of the sheet a measured scale is marked out.

A quick sketch in the Uffizi – made before this drawing – shows Biliverti attempting various resolutions of the composition, also principally with Michelangelo holding a letter.[3] Other Uffizi sheets are related studies of turbanned figures, while a finished and squared compositional drawing in

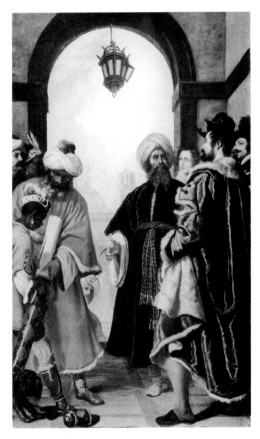

Fig.20 Giovanni Biliverti, *Michelangelo and the Turks*, *c*.1616–20, oil on canvas, 236 × 141 cm, Florence, Casa Buonarotti

Berlin with affinities to the subject is difficult to place in what we know of the scheme.[4] The rather generic agglomeration of buildings seen in the background of this drawing have been replaced in the finished painting by a view of the rooftops and the campanile of Santo Spirito. Two intriguing drawings reproduce almost exactly this panorama, one in the

Uffizi, stylistically close to Cecco Bravo, proposed by Masetti as Biliverti and given by Petrioli Tofani and Contini to Cecco Bravo, and a drawing in the Louvre, proposed as Biliverti by Del Bravo and retained by Contini, but which fits rather well with the group of Cristofano Allori drawings amongst which it is housed.[5]

Provenance: Malcolm Collection (add.103), bequeathed to the British Museum, inv.1934-10-13-1

Not previously exhibited

Select literature: Thiem, 1977, p.326, no.85, ill.; Contini, 1985, p.78, ill. no.105b

1. Viegenthart, 1976, pp.108–111; the drawing first published by Thiem, 1977, p.326, no.85.
2. Vliegenthart, 1976, p.108.
3. Uffizi, inv.1094 F; Procacci, 1965, pp.11, 173; Vliegenthart, 1976, p.109; Contini, 1985, p.78. Contini – rightly to this author – denies another sheet, 2158 S, proposed by Lauriol.
4. Uffizi, inv.9599 F *verso*, 2140 F, Berlin KK 15771; Contini, 1985, p.78.
5. Uffizi, inv.91772, Louvre 36; Contini, 1985, p.79.

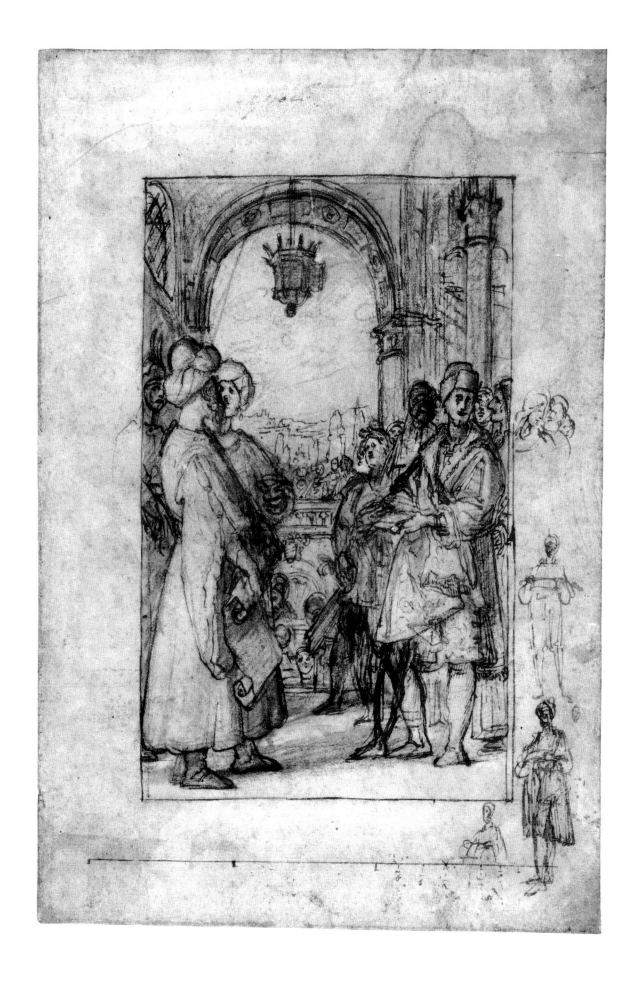

Portrait of Neri Corsini

Pen and brown ink over black chalk, brush with brown and grey/blue washes. Squared in red chalk. Inscribed along lower edge in brown ink:
del Biliverti il quadro e nel Palazzo Corsini in Fiorenza
214 × 145 mm

Private Collection

A drawing of extraordinary interest in Biliverti's oeuvre, this is a study for his portrait of Neri Corsini of *c.*1624, formerly in the Galleria Corsini, Florence and now known only through a photograph (fig.21).[1] Neri di Corsino Corsini (1244–1325) was a *gonfaloniere* (literally, flag-bearer) of the Florentine Republic in 1295; consequently the portrait is an imagined one, and the purpose would have been to glorify the family.[2] It was possibly commissioned by his namesake descendent Neri di Bartolommeo Corsini, born in 1577, who assumed the title Marquis of Sismano in 1629, and who was on the prestigious Council of *Dugento* Florentine city leaders.[3] Corsini is depicted seated at his desk, surrounded by books, and with a pen and red *gonfaloniere's* cap in front of him. Interestingly, while the drawing shows a full length portrait, with a decorative curtain at the top, and is fully squared for transfer, the Alinari photograph records only a three-quarter length figure. Since the figure is also depicted closer to the picture plane, it seems that the artist settled on a more intense, focused solution than the traditional full-length shown in the drawing.

As was first observed by Mina Gregori, the pose is strikingly similar to that used by Cristofano Allori and Zanobi Rossi for that of Michelangelo in the picture of *Michelangelo with Poetry* (1615–22) in the *galleria* of the Casa Buonarroti.[4] Of course, Biliverti had also worked on a commission for the *galleria* (cf. cat.11) so would have been

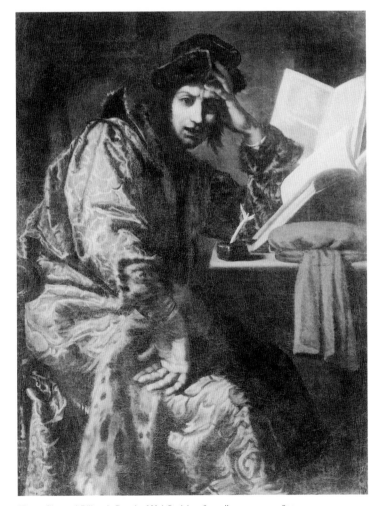

Fig.21 Giovanni Biliverti, *Portrait of Neri Corsini*, *c.*1624, oil on canvas, 138 × 100 cm, location unknown

familiar with this image. Nevertheless, Corsini's pose, with his hand on his forehead rather than his cheek, is much more alert – and less 'melancholic' – than that of

Michelangelo.

In 1752 Sir Joshua Reynolds made a copy of the Corsini portrait (then believed to be by Cristofano Allori).[5]

Provenance: Sotheby's, Monaco, 2 December 1989, lot 109, ill.

Not previously exhibited

Unpublished

1. The painting is discussed by Contini, 1985, pp.84–5, pl.17.
2. For Corsini see Passerini, 1858, pp.13–14.
3. Passerini, 1858, p.142.
4. Gregori, 1961, p.109. The Allori, finished by his pupil Zanobi Rosi, is discussed by Vliegenthart, 1976, pp.138–42, no.9, pl.18; Chappell in Florence, 1984, pp.108–110, no.38, fig.38.
5. British Museum 1752 sketchbook, no.201a.10, p.33; published by Miles Chappell in 1991, p.203.

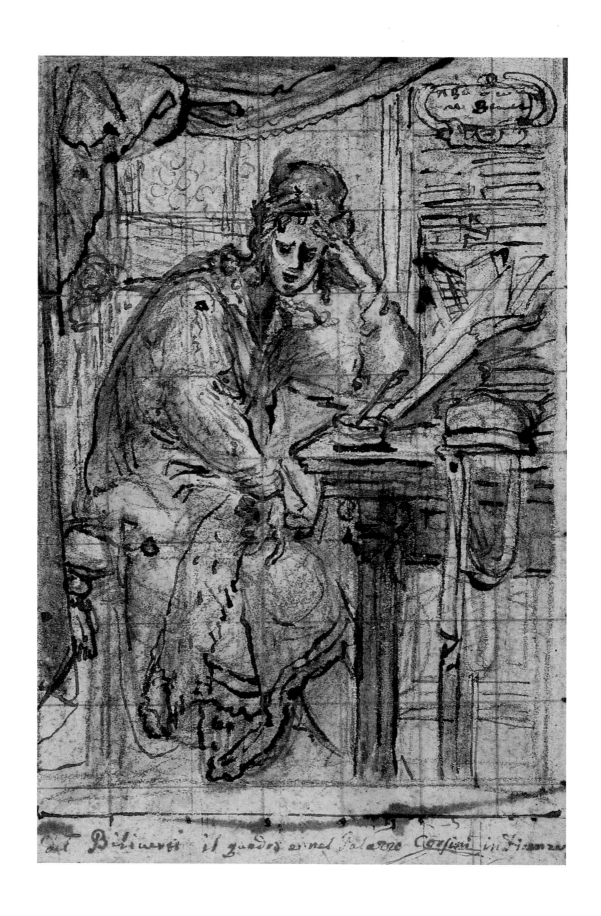

Del Biliverti il quadro e nel Palazzo Corsini in Firenze

The Magdalen at the tomb with angels (recto); Studies of the Magdalen at the tomb (verso)

Black chalk, brush with grey wash, white heightening *(recto)*; Black chalk *(verso)*; Inscribed in pencil, upper right, *verso*: 8
260 × 208 mm

The Syndics of the Fitzwilliam Museum, Cambridge

Mary Magdalene is shown lost in grief at the deserted tomb of Christ; this episode is not recorded in the Bible but was popular with the Counter Reformation church, for whom the penitent Magdalen was a central figure. The drawing is a preliminary study for a painting now in the Bigongiari Collection, Florence (fig.22), and recorded in the biography of Biliverti written by his pupil Orazio Fidani.[1] It was commissioned by Marchese Luca degli Albizzi and paid for on 22 December 1627; Fidani says that 'nothing better in this genre can be seen today', and the painting quickly became famous and was much copied, by Confortini amongst others.[2]

Fidani records that Biliverti executed the painting very quickly, and this drawing is one of six extremely rapid drawings known for the composition, which seem like a brainstorming sequence. The earliest drawings show very different resolutions, with the Magdalen looking into the tomb (Louvre, inv.13928), and talking to one of the angels (Uffizi, inv.2026 S).[3] The composition of Uffizi, inv.10340 F is extremely close to the solution in our sheet, but is probably earlier since the Magdalen does not rest her head on her hand, a motif which does occur in our drawing and the finished painting. This motif recurs in another sheet in the Uffizi, inv.9582 F, also close in composition, but probably made just after the Fitzwilliam drawing. In that sheet the Magdalen holds her drapery up to the tomb as in the finished

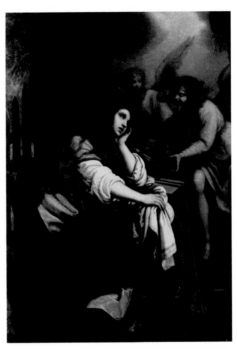

Fig.22 Giovanni Biliverti, *The Magdalen at the tomb with Angels*, 1627, oil on canvas, 200 × 150 cm, Florence, Bigongiari Collection

painting (and unlike cat.13), and the positions of the hands of the principal angel are resolved from the numerous *pentimenti* (minor changes) of our drawing. The *versi* of both Uffizi, inv.9582 F and the Fitzwilliam drawing show quick black chalk ideas for the Magdalen almost prone on the tomb.

All five of these sheets are in reverse to the composition as Biliverti painted it. The final compositional drawing – current whereabouts unknown – is almost identical to the painting, in the same direction, and includes details such as the tree stump in the foreground and fence in the background, as well as being squared in chalk for transfer.[4] The Magdalen is also shown with her eyes open rather than in the trance of the Fitzwilliam drawing. The rapid sequence of sheets shows Biliverti's willingness to study the same composition again and again with relatively minor differences, as opposed to Cigoli's technique of dramatically changing figures on the sheet through forceful reworking (cf. cat.36), or Stradanus's use of paper patches (cat.77).

Provenance: Sotheby's, London, 11 December 1980, lot 27; bought by the Fitzwilliam Museum with Grant-in-Aid from the Victoria and Albert Museum, 1981, inv.PD.13-1981

Not previously exhibited

Select literature: Goguel in Paris, 1981, p.94, under no.52; Bigongiari, 1982, repr. pl.15, p.59; Thiem, 1983, p.275ff., pl.40; Contini, 1985, pp.89–90, ill. under no.22, ill.no.22

1. Barocchi, 1975, p.70, after Matteoli, 1970.
2. Contini, 1985, pp.89–90.
3. Giglioli (1923) first discussed Biliverti's Uffizi drawings of this subject; the Louvre sheet was recognized by Catherine Monbeig Goguel and published by her in Paris, 1981, pp.93–4, no.52, fig.no.52. Bigongiari and Contini both discuss the drawings and omit Giglioli's Uffizi, inv.9657 F, which instead shows Hagar and Ishmael, with her water bottle and the angel in flight.
4. The sheet was formerly in the collection of Loriano Bertini, Prato; the Pouncey/Stock fototeca contains a photograph.

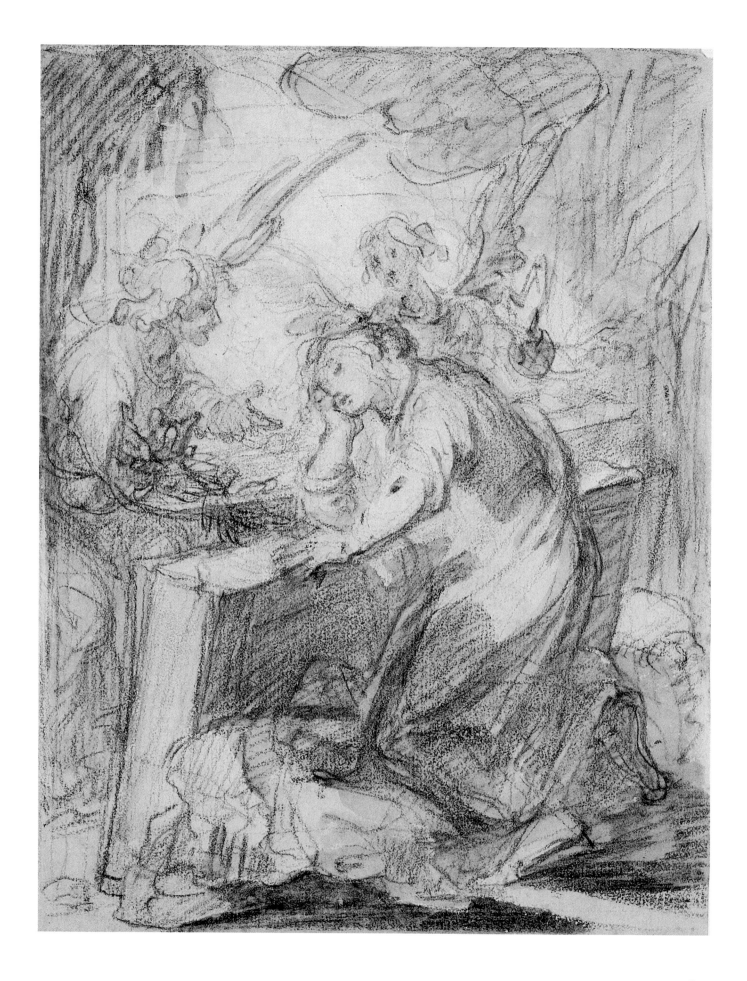

Diana and a nymph surprised by Actaeon

Pen and brown ink over black and red chalk
235 × 202 mm

The Board of Trustees of the Victoria and Albert Museum

Although this scene has been traditionally identified with that of Diana and a nymph (or nymphs) surprised by the young prince Actaeon while bathing in a grotto (Ovid, *Metamorphoses* 3: 138–253), there are some strange aspects to the iconography. Unusually, Actaeon has no hunting equipment or dogs, and instead seems to be holding a *tazza* in his left hand. The nymph seems to be placing a crown on Diana's head, although this might be the goddess's traditional crescent-moon head adornment, and there is no sign of water or a grotto.

With its delight in the elegant forms of the figures and their exaggerated expressive gestures, this drawing sits firmly within the Baroque tradition of mythological figure subjects. Unrelated to a painting, it is characteristic of a number of drawings by Biliverti where the chalk underdrawing seems extremely lively, and the pen tracing of the lines less animated.[1] The drawing probably dates from the early 1630s, during which time Biliverti particularly worked on a number of mythological subjects. From 1636 until his death he painted almost exclusively religious subjects, apparently the result of a religious conversion brought on by a serious illness during the painting of a St Francis receiving the stigmata.[2] Two lightly drawn red chalk lines – one horizontal and one vertical – which intersect in the centre of the sheet, are presumably a reduced form of squaring for the transfer of the composition.

A small drawing in the Uffizi (inv.9649 F) of a half-length Diana prepared for the hunt has been linked to Biliverti's treatment of this subject by Anna Matteoli.[3] Contini has doubted the attribution to Biliverti, and in fact the drawing is a study for a painting of identical composition, formerly attributed to Annibale Carracci, noted in the Collection Hanfstaengl, Munich, and unlike the work of Biliverti.[4]

Provenance: Miss Georgiana Lornlin, by whom presented, 1880, inv.8641.C

Not previously exhibited

Select literature: Ward-Jackson, 1980, p.25, no.637, fig.no.637; Contini, 1985, p.165

1. Other good examples are Uffizi, inv.9639 F or 2202 S.
2. Contini, 1986, p.48; Biliverti's illness and operation are described in great detail by his pupil Orazio Fidani, see Barocchi, 1975, p.76.
3. Matteoli, 1970, p.357, no.73.
4. Contini, 1985, p.165; A photograph is in the Kunsthistorisches Institut, Florence (as Biliverti); the mount is inscribed with an attribution to Ottavio Vannini, and one to Matteo Rosselli by Anna Matteoli.

15 GIOVANNI BOLOGNA, called GIAMBOLOGNA (Douai 1529 – 1608 Florence)

Born and trained in Flanders, Giambologna travelled to Italy in 1550 to study antique and Renaissance sculpture. Gaining an increasingly elevated position in the Medici court, he executed a series of lively marble groups particularly well-suited to a Medici desire for allegorical propagandistic sculpture. These were matched by highly sought-after bronzes on a small scale. His technical skill combined with a close study of nature brought him international renown.

Design for a fountain of Oceanus

Pen and brown and black inks over black chalk and stylus indications. Inscribed with measurements in the artist's hand: the height of the principal figure *figoura b 5 1/2*; the diameter of the bath *bracio dondice incerco*; the radius from the edge of the bath to the outer edge of the pavement *b 8 incerco*; the height of the parapet around the basin *b 2*
202 × 330 mm (upper left and right sections removed)

The Visitors of the Ashmolean Museum

Several painters from the Accademia del Disegno were noted as working with Giambologna in the design of the prominent equestrian monument of 1587–93 to Grand Duke Cosimo I in Piazza della Signoria.[1] Although only Cigoli and Pagani were specified in that case, Giambologna's studio was often frequented by the young artists of the reform tradition, as well as powerful patrons, international figures, and friends such as Federico Zuccari (cf. p.24, fig.6).

One of very few drawings by Giambologna known to us today, cat.15 is an indicative preliminary sketch with measurements for the fountain now in the Gran' Vasca

dell'Isolotto in the Boboli Gardens behind the Palazzo Pitti, Florence.[2] The project was originally commissioned from Niccolò Tribolo (1500–1550) following his excavation of the large granite bowl on Elba, but was transferred to Giambologna on his death. Four blocks of marble were ordered for the fountain in 1571, and it was put in place on the Prato Grande in 1575 (it was moved close to the Grotto della Madama in 1618, and to its present location in the 1630s).

Oceanus was in mythology the son of Uranus (Sky) and Ge (Earth), and father of the Oceanids and river gods. Although not often represented,

he generally takes the form of a benign old man, somewhat at odds with the active and vigorous figure shown in this drawing and that sculpted in marble for the fountain. Nevertheless the sculpture is traditionally known as the fountain of Oceanus. Cat.15, a simple line drawing with little hatching or modelling, conveys the nature of the design and taut poses of the figures: the standing central figure, and three river gods crouching below, here re-arranged to provide a view of each of them. The choice of viewpoint for the projection also shows the hexagonal nature of the basin with monster-spouts which was never executed.

Provenance: Henry Oppenheimer; his sale; Christie's, London, 10 July 1936, lot 35; purchased by the Ashmolean Museum, 1954, inv.WA1954.29 (P.II 118)

Exhibited: Edinburgh, 1978, no.205; Florence, 1980 (Primato), no.235; Florence, 2002, no.171

Select literature: Popp, 1927, p.23, pl.27; Parker, 1956, p.65, no.118, pl.xxxvi; Avery in Edinburgh, 1978, p.206, no.205; Gaeta Bertelà in Florence, 1980 (Primato), p.124, no.235; MacAndrew, 1980, p.254; Avery, 1987, p.273, no.168, pl.242; Campbell, 1991, pp.89–106; Wardropper in Florence, 2002, pp.313–4, no.171, fig.171

1. Baldinucci said that he knew some of the drawings for the commission, and Chappell points out that they must have been made between Autumn 1587 when the statue was ordered and 28 September 1591 when it was ready to be cast (Chappell, 1971, p.267, n.59).
2. First connected by Popp, and most completely discussed by Campbell, 1991, pp.89–106.

16 FABRIZIO BOSCHI (Florence 1572 – 1642 Florence)

Having grown up within a family of artists, Boschi trained and worked in the studio of Passignano, with whom it seems he spent four years in Rome from 1602. He then spent his career in Florence, painting dramatic altar-pieces such as the *Martyrdom of St Sebastian* in Santa Felicità (1617), and secular works such as a canvas in the *galleria* of Michelangelo Buonarroti the Younger (1615–17), of whom he was a close friend. His graphic style derives substantially from Passignano and Cigoli.

The entry of Margaret of Austria into Ferrara

Pen and reddish-brown ink over red chalk, brush with brown wash. Inscribed in ink in an old hand lower right: *Passignano*
325 × 410 mm

The Trustees of the British Museum

To commemorate the death of Margaret of Austria, wife of Philip III of Spain, Cosimo II de' Medici ordered a grand memorial service in the church of San Lorenzo, held on 6 February 1612.[1] The church facade was temporarily covered with skeletal emblems, and the interior decked out with twenty-six canvases showing significant scenes from her life, painted in a striking golden-yellow chiaroscuro. This drawing is a study for the canvas showing Margaret's triumphal entry with two cardinals into Ferrara, where she was to meet the Pope. Margaret was the sister of Maria Maddalena, Cosimo's wife, giving good reason for the Florentine commemoration, but Cosimo would also have been aware of the benefit it could bring him in his political relations with the Spanish.

Unlike many contemporary Medici events, the preparations for these exequies are poorly documented, and it is not known which artist was allocated to paint this canvas. Recently, after conservation, it has been attributed convincingly on stylistic grounds to Fabrizio Boschi, together with this drawing.[2] This attribution makes sense of the stylistic proximity of the sheet to Passignano, Boschi's master, and it compares well with drawings by Boschi in the Uffizi.[3] Cosimo had the ceremonies recorded in a book by Giovanni Altoviti, and Antonio Tempesta was recalled from Rome to oversee the production of illustrations for it.[4] Of the twenty nine etchings in the book, Callot made fifteen (including that of cat.16),

Tempesta six, Raffaello Schiaminossi five, and Giulio Parigi one; two are anonymous. As Monica Bietti has pointed out, the prints were made from intermediary drawings, in turn made directly from the canvases.[5] The intermediary drawing for the present composition, now in Edinburgh, is generally attributed to Antonio Tempesta. Yet the sheet lacks the strength and sense of volume of Tempesta's drawings, even those made for prints, and seems more likely to have been made by an associate.[6]

Provenance: Sir Joshua Reynolds (L.2364); G.T. Clough, by whom presented to the British Museum in 1912, inv.1912-2-14-1

Exhibited: London,1986, no.204

Select literature: Popham & Wilde, 1949, p.292, under no.676 (as Passignano); Vitzthum, 1968, p.93; Andrews, 1968, p.117, under no.D.4890/4 (as Tempesta); Gaeta Bertelà and Petrioli Tofani in Florence, 1969, p.140; Thiem, 1977, p.280 (as Tempesta); Turner in London, 1986, pp.260, 262, no.204 (as Attributed to Passignano), fig.204; Bietti in Florence, 1999, pp.141, 154, under no.6, fig.p.154 (as Boschi)

1. Gaeta Bertelà and Petrioli Tofani in Florence, 1969, pp.138–141; Testaverde and Bietti in Florence, 1999, pp.132–91.
2. Bietti in Florence, 1999, p.154. Laura Lucchesi has confirmed the attribution.
3. For example 9462 F of the *Judgement of Solomon*, which has similar figure types and handling of wash.
4. Giovanni Altoviti, *Essequie della Sacra Cattolica, e Real Maestà di Margherita d'Austria Regina di Spagna, celebrate dal Serenissimo don Cosimo II, Gran Duca di Toscana III*, Florence, 1612; Bietti in Florence, 1999, p.141.
5. Bietti in Florence, 1999, pp.141, 154.
6. D.4890/4. The sheet is not a copy after the print; it has some slight variations, including one in Margaret's hat plume, unlikely to have been made by a copyist.

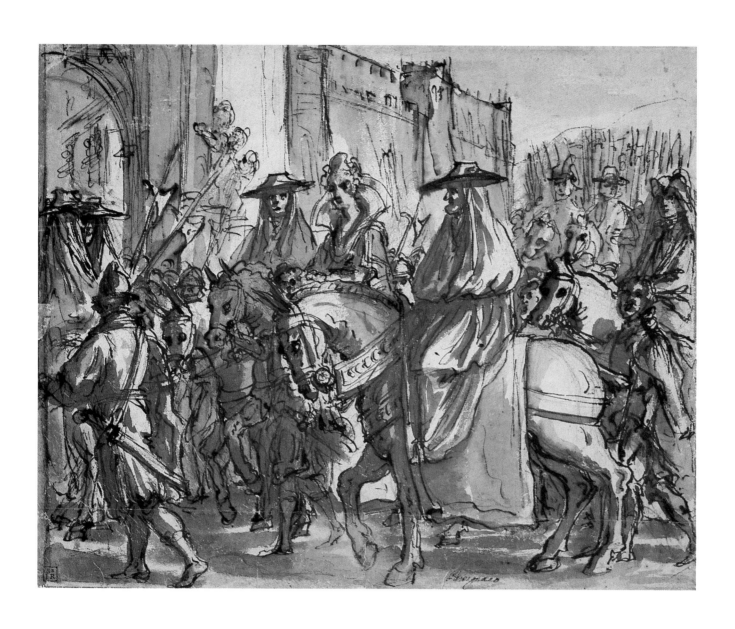

17 ANDREA BOSCOLI (Florence? *c.*1560 – 1608 Rome)

Learning largely by making copies – a practice he continued throughout his life – Boscoli frequented the studios of Santi di Tito and Bernardo Buontalenti. His academies reveal a dramatic handling of light and shade, and his clear narrative style lent itself well to his involvement with printmakers and publishers. Masterpieces such as his fresco cycle for the villa of Corliano near Pisa (1592) show an inventive and playful painted style of high quality. He travelled widely, settling in the Marches between 1600–05; his last three years were spent between Florence and Rome. Federico Zuccari was a clear influence, and probably friend, throughout his life. Boscoli was one of the most original and talented draughtsmen of his generation.

The Supper at Emmaus

Red chalk. Inscribed in brown ink lower centre-left: *Taliarino*; numbered *85* in red chalk lower left; truncated pagination at top right
220 × 305 mm (corners cut)

The Royal Collection

Provenance: King George III; Royal Library, Windsor Castle, inv.RL 3817 (P&W 142)

Not previously exhibited

Select literature: Popham & Wilde, 1949, pp.200–01, no.142, fig.40 (as 'Attributed to Andrea Boscoli'); Forlani, 1963, p.155, no.195; Brooks, 1999, pp.391–2

1. Petrioli Tofani, 1991, p.345, no.813 F, ill.; Other counterproofs are: Edinburgh, inv.D.1515v.; Louvre, inv.675; Uffizi, invs.2261 S, 5736 Sv., 8189 F, 8195 F, 825 Orn, 4713 S; Vienna, inv.13521; Pierpont Morgan Library, inv.1993.192v.: although some of these could possibly have been made after the artist's death, many appear on the reverse of other drawings by him.

A fine example of the dramatic red chalk drawing style which Andrea used throughout his career but particularly in the late 1580s, the composition does not relate to any known painting. Andrea leaves the white of the paper for the highlights by building up intense areas of parallel-hatched shading, creating powerful contrasts of light and shade, something for which he would become known. The subject seems to be that of the Supper at Emmaus, with Christ seated on the left; after journeying anonymously with two disciples, Christ revealed himself to them during a meal (Luke 24: 28–32). A slight blurring of the chalk in this drawing is the result of a counterproof being taken, whereby a damp sheet of blank paper is laid on top of the drawing which, when removed, then contains a weaker, reversed, version of the composition. A drawing in the Uffizi (inv.813 F) is the counterproof taken from cat.17. It was almost certainly taken by the artist himself, and has architectural studies by Andrea on the *verso*; a number of counterproofs exist within his oeuvre.[1] Counterproofs were used regularly at the time; they facilitated reversing a composition (e.g. cf. cat.39), and were an easy way to obtain two figure studies for the effort of one.

The cryptic inscription in ink at the base – *Taliarino* – must have been added after the counterproof was taken; there is no trace of it on the Uffizi sheet.

A stag hunt within an architectural surround

Pen and brown ink over black chalk, brush with brown, pink and green washes
182 × 138 mm (arched top)

The Governing Body, Christ Church, Oxford

Here a scene of a stag hunt is given a decorative frame coloured by the artist with pink and green washes, and surmounted by a portrait of an unknown man. The use of colour in Boscoli's drawings is quite rare, and otherwise only features on sheets in Lille (inv.Pl.665) and Berlin (inv.23585).[1] In the Oxford drawing the colour is used in the architecture, but not in the central stag hunt design; the reverse is the case in the Berlin sheet, a study for a picture within an architectural surround.

As has been pointed out by A.E. Popham and John Gere independently, the composition, with the tree and figures on the left-hand side and hunting-scene vista on the right, is based on a famous drop-curtain made by Federico Zuccari for the theatrical celebrations of the wedding between Francesco I de' Medici and Giovanna of Austria in 1565.[2] The purpose of Boscoli's drawing is not clear, but it was most likely intended for the manufacture of a similar loose wall-hung decoration or for fictive architecture. It is unlikely to represent a real architectural project, since the *putto* holding the portrait would have been difficult to execute, and the colour impractical; Boscoli did not use it on the architectural designs that are known to us.[3] Forlani Tempesti has suggested that this drawing may have been intended for a frontispiece, but this would seem strange (as she points out) given the lack of space for an inscription.[4] Federico Zuccari was a strong influence on Boscoli

throughout his career, and the drop-curtain had a major impact on the production of hunting scenes by Florentine artists of the next generation.[5]

The light and feathery decorative style with elongated figures of this sheet is very similar to a group of drawings by Boscoli of subjects from Ovid's *Metamorphoses*.[6] This group has been dated to the first half of the 1590s by Bastogi on the basis of stylistic similarities with other sheets, a dating confirmed by a rough black chalk sketch found on the *verso* of the

Fall of Phaeton sheet in the Biblioteca Marucelliana (inv.AB 18), with two kneeling figures.[7] This study can be tentatively linked with kneeling figures in the foreground of a painting of *The Miracle of St Nicholas of Bari* by Boscoli in the church of San Lorenzo delle Rose, near Impruneta, which is mentioned by Andrea in his Libro in August 1596.[8] Although the figures do not correspond exactly, the beard and unusual hat worn by the principal supplicant, and the specific direction in which he kneels, render the link likely.

Provenance: Guillaume Hubert (L.Suppl.1160); General John Guise; Christ Church, Oxford, inv.0933 (JBS 233)

Exhibited: U.S.A., 1972–3, no.7; Florence, 1986, no.2.44; Tokyo, 1994, no.62; Oxford, 2001, no.28

Select literature: Bell, 1914, p.57, CC.11 (as Italian School, 1600–50); Byam Shaw in U.S.A., 1972–3, pp.18–20, no.7; Byam Shaw, 1976, p.89–90, no.233, pl.155; Pignatti, 1977, unpaginated, no.54, fig.54; Forlani Tempesti in Florence, 1986, II, p.102, no.2.44, fig.2.44; Whitaker in Tokyo, 1994, pp.204–5, no.62, fig.62; Brooks, 1999, pp.72, 358; Elam in Oxford, 2001, p.11, ill.

1. Forlani Tempesti in Florence, 1986, no.2.50; Brooks, 2003, pp.3–5.
2. Tordella in Florence, 1997, pp.246–7, no.196.
3. Bastogi, 1996, pp.128–141.
4. Forlani Tempesti in Florence, 1986, p.102, no.2.44.
5. Pezzati in Florence, 1997, p.247, under no.196.
6. Forlani Tempesti in Florence, 1986, p.105, nos.2.45–2.47; Bastogi in Florence, 1997, p.299, under no.246.
7. Bastogi in Florence, 1997, p.299, no.246.
8. Heikamp, 1963, p.187; Arrigo in Florence, 1998, p.11.

Armida with the sleeping Rinaldo

Pen and brown ink over traces of red chalk, brush with brown wash
150 × 214 mm

The Courtauld Institute Galleries, London (Witt Collection)

Cats.19 to 22 tell the story of Rinaldo and Armida (*canti* XIV and XVI) from Torquato Tasso's epic *Gerusalemme Liberata* (*Jerusalem Delivered*), the first complete edition of which was published in 1581. They are part of a series of drawings which also covered the stories of Olindo and Sophronia (*canto* II), and Erminia and Tancred (*canto* VII), and were highly innovative in the way in which they extracted the romantic episodes from Tasso's martial epic; these subjects would become extremely popular in the seventeenth century.[1] Of the twenty sheets mentioned in an early Marchigian inventory (*c.*1611), only fifteen are now known.[2]

The wicked sorceress Armida vowed to capture and torture the Christian knight Rinaldo, who had freed a group of knights she had imprisoned. Armida conjured up a beautiful singing nymph, seen on the right, who lulled Rinaldo into a deep sleep. When she saw him, Armida fell in love with Rinaldo and is shown here soothing his brow on the verdant shore. Their figures are characteristic of Boscoli's solid yet curvaceous doll-like forms, with their navels visible even through their clothes.

Provenance: Luca Fei, Filottrano (Macerata, *c.*1611); G. Reynst; Charles Rogers (L.625); his sale, T. Philipe, London, 15 April 1799, part of lot 83; Sotheby's, Morritt sale, 22 March 1923, lot 84 (as Nicholas Poussin); Sir Robert and Lady Witt (L.2228b), by whom bequeathed to the Courtauld Institute of Art, inv.1517

Not previously exhibited

Select literature: Voss, 1928, pl.29 (as of *Angelica and Medoro*); Brooks, 1999, pp.251, 347; Brooks, 2000, p.449. fig.1; Bastogi in Florence, 2001, p.92, fig.10

1. Brooks, 2000, pp.448–59; Bastogi in Florence, 2001, pp.85–96.
2. Bastogi in Florence, 2001, p.93. Two sheets of Sophronia and Olindo recently came to light in Paris, and are now on the London art market.

The spellbound Rinaldo is placed in Armida's chariot

Pen and brown ink over traces of red chalk, brush with brown wash
150 × 223 mm

The Visitors of the Ashmolean Museum

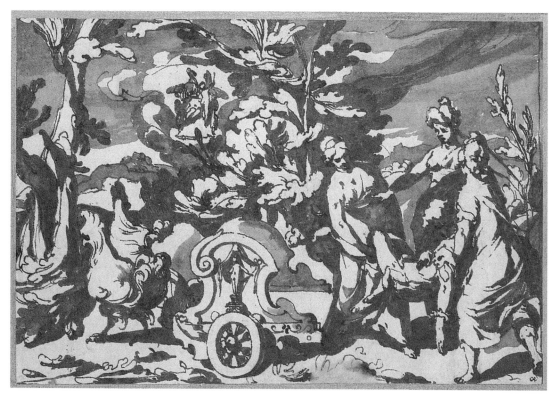

Provenance: Luca Fei, Filottrano (Macerata, *c*.1611); G. Reynst; Charles Rogers (L.625); his sale, T. Philipe, London, 15 April 1799, part of lot 83; Professor Francis Haskell; presented to the Ashmolean Museum by Mrs Larissa Haskell in honour of Professor Francis Haskell, 2003, inv.WA2003.98

Not previously exhibited

Select literature: Brooks, 1999, pp.251, 384–85; Brooks, 2000, p.449. fig.2; Bastogi in Florence, 2001, p.92, fig.11

1. Bastogi in Florence, 2001, p.93.

Continuing the Tasso series of cat.19, we see here how Armida has the spellbound Rinaldo chained with flowers and placed in her chariot by her attendants. In the centre-left background the chariot can be seen flying away to Armida's palace in the Fortunate Islands. Tasso's text does not specify which creatures pull Armida's chariot, and artists have variously imagined dragons, serpents, and horses. Boscoli, instead, has – somewhat strangely – depicted outsized cockerels, adding to the sense of dream-like unreality.

In this sheet Boscoli takes to bravura extremes the rich and schematic effects of light and shade for which he was well-known. Variously dense pools of brown wash create the effect of a scene bathed in strong sunlight; it is easy to understand why the drawings in this series were recorded as *storiette di chiaro scuro* ('little stories in light and shadow') in an inventory of *c*.1611.[1]

Armida pursuing Rinaldo

Pen and brown ink over traces of red chalk, brush with brown wash
149 × 223 mm

The Visitors of the Ashmolean Museum

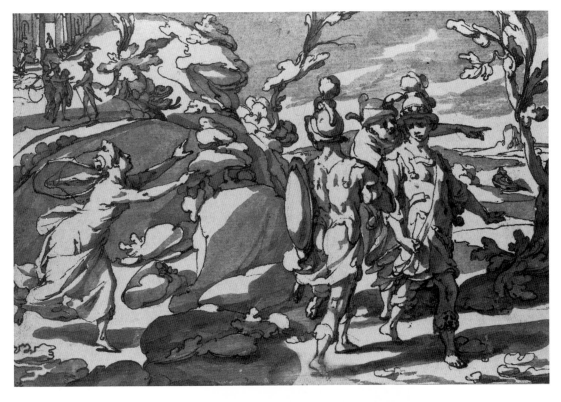

Provenance: Luca Fei, Filottrano (Macerata, *c.*1611); G. Reynst; Charles Rogers (L.625); his sale, T. Philipe, London, 15 April 1799, part of lot 83; F. Abbott (L.970) (as Tempesta); purchased by the Ashmolean Museum, 1941, inv.WA1941.149 (P.II 123)

Not previously exhibited

Select literature: Parker, 1956, pp.67–8, no.123; Brooks, 1999, pp.251–65, 357; Brooks, 2000, p.449. fig.4; Bastogi in Florence, 2001, p.92, fig.13

After abducting the spellbound Rinaldo (cat.20), the sorceress Armida kept him as her prisoner and lover in the beautiful enchanted garden of her palace, a scene shown in a drawing in a private European collection (fig.23). Two Christian knights, Carlo and Ubaldo, were dispatched to rescue Rinaldo. Equipped with a crystal shield by the Magician of Ascalon, they entered the palace garden and, when Rinaldo was alone, showed him his reflection in the shield. The shield broke Armida's spell, and Rinaldo saw clearly his situation; they ran from the palace. This is the scene shown in cat.21; in the left background lies a guard slain in their escape, while their subsequent flight to the shore, pursued by Armida, can be seen in the centre.

Fig.23 Andrea Boscoli, *Rinaldo and Armida in the enchanted garden.* Pen and brown ink over black and red chalks, brush with brown wash, 150 × 218 mm, Private Collection

Armida bidding Rinaldo to stay

Pen and brown ink over traces of red chalk, brush with brown wash
151 × 220 mm

The Visitors of the Ashmolean Museum

On the shore, Armida begs Rinaldo to stay with her, saying that she will reform. Rinaldo's dismissive gesture – possibly borrowed from contemporary sculpture – indicates clearly his reply.[1] In the background he can be seen stepping onto the ship which will return him to the Christian camp; Armida faints on the shore. Reinforcing the poetic nature of the series a further, unpublished, drawing in the Milwaukee Art Museum (fig.24) shows Armida abandoned on the shore, and about to destroy her palace in grief.[2] The arrangement of figures on the sheets demonstrates their iconic theatricality.

The purpose of the set of Boscoli drawings taken from Tasso subjects is

not clear; they might conceivably be related to a series of designs of 'tales of love' which Boscoli made to decorate his bedroom towards the end of his life. Alternatively they could have been made as designs for a series of prints, or as presentation sheets for

one of Boscoli's numerous literary friends.[3] That Lodovico Cigoli saw them and praised them *grandemente* suggests that they were made or at least known in Florence or Rome; they certainly date to the last few years of Boscoli's short life.[4]

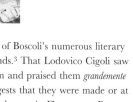
Fig.24 Andrea Boscoli, *Armida abandoned on the shore.* Pen and brown ink over red chalk, brush with brown wash, 148 × 215 mm, Milwaukee Art Museum, inv.M1954.13

Provenance: Luca Fei, Filottrano (Macerata, *c.*1611); G. Reynst; Charles Rogers (L.625); his sale, T. Philipe, London, 15 April 1799, part of lot 83; F. Abbott (L.970) (as Tempesta); purchased by the Ashmolean Museum, 1941, inv.WA1941.150 (P.II 124)

Not previously exhibited

Select literature: Parker, 1956, p.68, no.124; Brooks, 1999, pp.251–65, 357; Brooks, 2000, p.449. fig.5; Bastogi in Florence, 2001, p.92, fig.14

1. Brooks, 2000, p.449.
2. Milwaukee Art Museum, Max E. Friedmann-Elinore Weinhold Friedmann Bequest, inv.M1954.13; Miles Chappell kindly brought this drawing to my attention. This is the last sheet of the seven listed as formerly in the Rogers collection, Brooks, 2000, p.449.
3. Brooks, 2000, pp.453–6; Bastogi in Florence, 2001, pp.93–5.
4. Bastogi in Florence, 2001, p.93.

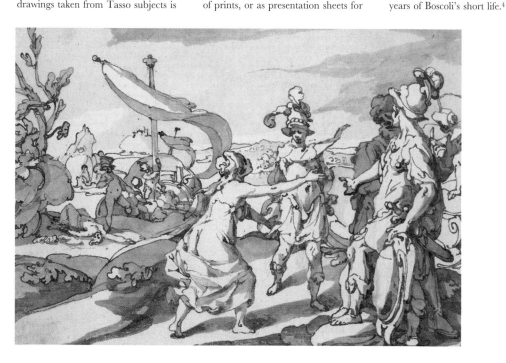

23 BERNARDO BUONTALENTI (Florence 1531 – 1608 Florence) and ANDREA BOSCOLI

One of the most extraordinary figures of the second half of the sixteenth century, Buontalenti was an architect, sculptor, painter, engineer, scenographer, and inventor of great capacity. Taken on in childhood by the Medici court, he gave lessons aged only sixteen to the young Francesco, later Grand Duke (1541–1587). He spent his life in the service of the Medici court, employed on construction and design projects, and responsible for all ephemeral celebrations and commemorations between the exequies for Grand Duke Cosimo in 1574 until the wedding of Maria de' Medici in 1600. Buontalenti's wide range of interests and capacities inspired Cigoli, his one-time assistant, and bred Giulio Parigi, his successor at the court.

Design for a festival chariot

Pen and brown ink over traces of black chalk, brush with brown wash. Incised with a stylus
112 × 219 mm

The Board of Trustees of the Victoria and Albert Museum

This is the only surviving drawing for the series of elaborate allegorical chariots, made of wood and papier-mâché, which processed into the Palazzo Pitti courtyard on the evening of 11 May 1589 before a packed audience, as part of Ferdinando and Christine's wedding celebrations (cf. p.29–33). Most of the chariots carried figures who then engaged in foot combat, although this one was the first to enter and carried the tournament referees, Don Pietro, Ferdinando's brother, and his nephew Vincenzo Gonzaga.[1] As chief supervisor and designer of the visual and mechanical *apparati* for the wedding, Buontalenti was aided principally by Andrea Boscoli and Lodovico Cigoli.[2] This design reveals how closely together they worked: the dragon and devils pulling the chariot, drawn in a darker shade of brown ink than the chariot itself, show the distinctive attenuation and doll-like character of Boscoli's figures, while the architectural conceits and wash-application of the chariot show that this part was by Buontalenti.[3]

The drawing was used by Orazio Scarabelli to produce one of his series of twelve etchings of the chariots, for which the lines were traced with a stylus.[4]

Provenance: Purchased by the Victoria and Albert Museum, 1938, inv.E.1731-1938

Not previously exhibited

Select literature: Dearborn Massar, 1975, p.21, pl.4; Saslow, 1996, pp.166–7, 249–50, no.73, pl.16

1. Saslow, 1996, pp.166–7, p.249.
2. Saslow, 1996, pp.90–1.
3. Saslow, 1996, p.149, no.73, following Massar, concludes exactly the opposite.
4. Dearborn Massar, 1975, p.21.

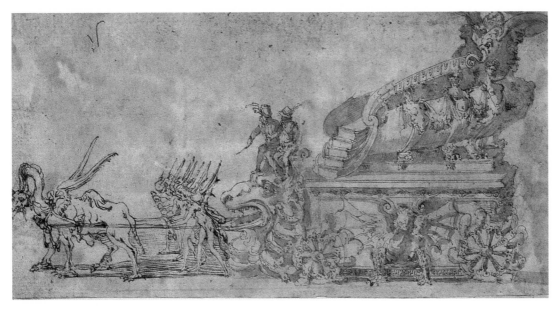

The Harmony of the Spheres

Pen and brown ink, brush with brown wash and watercolour
379 × 556 mm

The Board of Trustees of the Victoria and Albert Museum

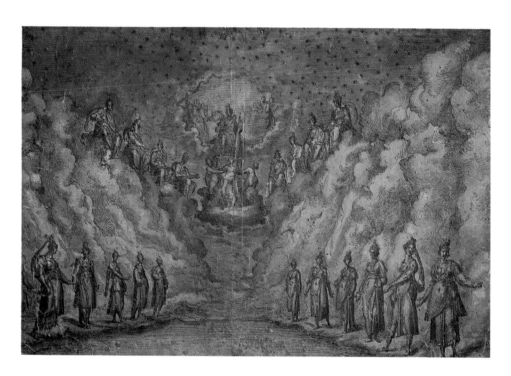

Provenance: Purchased by the Victoria and Albert Museum, 1931, inv.E.1186-1931

Exhibited: Florence, 1975, no.8.10; Florence, 1980 (Potere/Spazio), no.5.13a

Select literature: Warburg, 1895, pp.109,169–71, 415n; Laver, 1932, pp.294–300; Jacquot, 1964, p.81; Fabbri in Florence, 1975, p.111, no.8.10; Borsi in Florence, 1980 (Potere/Spazio), p.358, no.5.13a; Strong, 1984, fig.88; Blumenthal, 1986, pp.91–3; Saslow, 1996, pp.197–8

1. Saslow, 1996, pp.30–2, 151–3, 197–8.
2. Saslow, 1996, p.115.
3. Gaeta Bertelà and Petrioli Tofani, in Florence, 1969, pp.78–80, no.37.

The highlight of the month of wedding celebrations occurred on the evening of Tuesday 2 May 1589 with the premiere of the comedy *La Pellegrina,* and its six interspersed *intermezzi* (or musical interludes), on which a greater effort had been expended (cf. p.29–33). This drawing is Buontalenti's design for the second part of the first *intermezzo* of the Harmony of the Spheres, associating planetary and musical harmony with the happy union of the newly married couple. At the centre of the scene sits Mother Necessity, holding a giant diamond spindle joining the poles of the Universe; just visible behind her are groups of Virtues, six on either side. Below her are her daughters, the Three Fates. Seated in the clouds on the left and right are eight female personifications of heavenly bodies, and on the lower clouds stand Sirens. All of these, lit by lanterns with perfumed smoke, sang madrigals praising Ferdinando and Christine and welcoming the new 'golden age', while their clouds moved up and down in turn. The backdrop was a starry night, simulated by a thick canvas pricked with holes to emit light from lanterns behind.[1] In addition to the performers, mostly men in female costume, the complex stage mechanics of this *intermezzo* required eighty-two stagehands; another fifty were needed to tend to

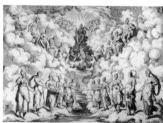

Fig.25 Agostino Carracci after Andrea Boscoli, *The Harmony of the Spheres.* Etching and engraving, 237 × 345 mm. British Museum

the hundreds of oil lamps and candles.[2]

The scene was engraved by Agostino Carracci (fig.25) from an intermediary drawing by Andrea Boscoli (cf. p.32–33).[3]

Apollo and the Python

Pen and brown ink over black chalk, brush with brown wash and watercolours
375 × 564 mm

The Board of Trustees of the Victoria and Albert Museum

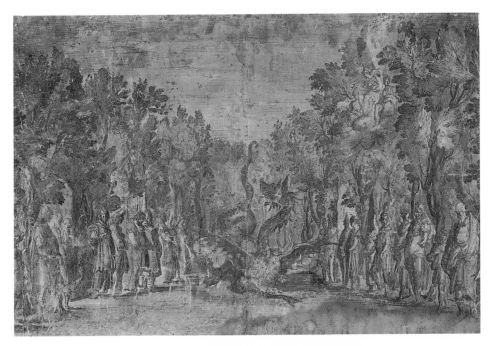

Provenance: Purchased by
the Victoria and Albert
Museum, 1931,
inv.E.1188-1931

Exhibited: Florence, 1975,
p.113, no.8.14; Florence,
1980 (Potere/Spazio),
p.360, no.5.13e

Select literature: Laver,
1932, pp.294–300; Fabbri
in Florence, 1975, p.113,
no.8.14; Borsi in
Florence, 1980
(Potere/Spazio), p.360,
no.5.13e; Blumenthal,
1986, pp.94–5; Saslow,
1996, pp.214–5, no.33,
fig.33, plate 9

1. Saslow, 1996, pp.32,
153–5, 214–32.

Buontalenti's design for the third *intermezzo* represents the story of Apollo and the Python. The monstrous dragon (in classical accounts a serpent or Python), wheeled around on stage by men inside, breathes fire and terrorizes the people of the forest of Delphi, who stand singing, mock-terrified, on either side. Innovations such as dragons breathing real fire were a speciality of the ingenious and talented Buontalenti. As shown in Carracci's print (fig.26, cf. p.32–33), Apollo then swooped to the rescue of the Delphic citizens from the sky. The flying figure was a cardboard mock-up in real clothes, replaced immediately on landing by a similarly dressed dancer.

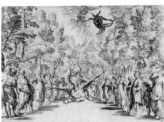

Fig.26 Agostino Carracci after Andrea Boscoli, *Apollo and the Python*. Etching and engraving, 237 × 345 mm. British Museum

His dance was then in five parts, firstly surveying the scene and baiting the dragon, fighting it in iambic rhythm, then spondaic rhythm, killing the dragon, and finally a victory dance. The figure of Apollo was

intended to represent, and flatter, Grand Duke Ferdinando.[1]

The three female figures surveying the scene from the trees on the right do not occur in any written account of the drama, and must have been eliminated.

The six *intermezzi* were repeated three times during the month of celebrations, and their fame was widespread. The condition of drawings cats.24 and 25 shows that they were much used in the studio; cat.25 has further suffered water damage at the lower left corner at some stage. Despite its poor condition, perspective lines for the delineation of space are still visible in the lower part of the drawing.

26 Attributed to LODOVICO BUTI (Florence 1555 – 1611 Florence)

Trained by his cousin Domenico in the circle of Vasari, and then in the studio of Santi di Tito, Buti painted several lunettes in the large cloister of Santa Maria Novella, Florence. His subsequent career, apparently spent entirely around Florence, saw him working on decorative fresco projects, reform-style religious works, portraits, and designs for optical games.

The vision of St Thomas Aquinas

Pen and brown ink over black chalk, brush with blue wash, on blue prepared paper
265 × 200 mm

The Governing Body, Christ Church, Oxford

St Thomas Aquinas (*c*.1225–74) was a Dominican philosopher and theologian whose writings and reputation were given a new impetus by the Council of Trent; in 1567 Pius V declared him a Doctor of the Church, and ordered the first complete printed edition of his writings. This drawing shows an episode in which, while Thomas was praying in front of a crucifix, he was seen to levitate, and the voice of God was heard to approve his writings. The study was presumably made in preparation for an altar-piece, now not known. It reflects the importance of such clear and pietistic devotional images for both the Counter Reformation church and the artists of the Florentine reform. The composition is deliberately organized so as to draw the viewer into the picture space, and involve them with the scene. As Byam Shaw pointed out, this particular image is substantially derived from a similar subject, similarly posed, by Santi di Tito formerly in the Oratorio di San Tommaso, Florence (1569) and now on deposit in the Cenacolo di San Salvi.[1]

Lodovico Buti was a close follower of Santi di Tito, and a great imitator of his style.[2] Thiem first attributed this sheet to him on the basis of similarities between the background angel and one in a documented work by Buti, but the attribution is far from secure and Petrioli Tofani believes a more generic one to the school of Santi di Tito preferable.[3] The sheet is carefully and tidily drawn within a neat brown ink line border; there are no signs of *pentimenti*.

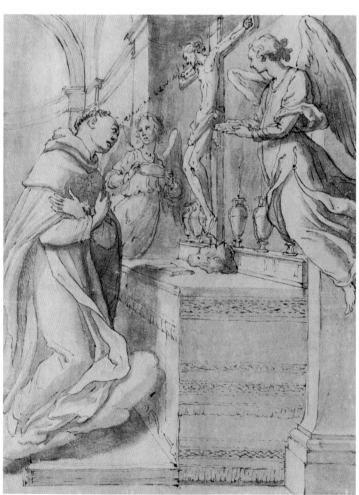

Provenance: General John Guise; Christ Church, Oxford, inv.0197 (JBS 267)

Not previously exhibited

Select literature: Byam Shaw, 1976, p.97, no.267 (as Tuscan, *c*.1600); Thiem, 1977, p.278, no.23, fig.23 (as Attributed to Buti); Petrioli Tofani, 1979, p.78 (as Florentine School, *c*.1600, follower of Santi di Tito)

1. Collareta in Florence, 1986, p.82, no.1.1, fig.1.1.
2. Baldinucci, III, p.420.
3. Petrioli Tofani, 1979, p.78. This is also followed by Forlani Tempesti, 1992, p.256, note 19.

27 JACQUES CALLOT (Nancy 1592 – 1635 Nancy)

Trained as a goldsmith in Nancy, Callot moved to Rome between 1608–11, lodging with and assisting the print publisher Philippe Thomassin, and becoming acquainted with Francesco Villamena and Antonio Tempesta. With Tempesta, Callot went to Florence in 1611, and thereafter worked under Medici patronage, producing numerous vigorous etchings of historical and ephemeral subjects, as well as popular caricatures. He spent time in Giulio Parigi's academy and befriended Filippo Napoletano; he returned to Nancy after the death of Cosimo II in 1621, and continued his work there with great success.

Studies of horses and horsemen

Pen and brown ink, brush with brown wash. Inscribed in brown ink, lower right: *559*
235 × 174 mm

The Board of Trustees of the Victoria and Albert Museum

In this sheet of exercises made for study, Callot integrates the work of another artist with his own ideas. The principal study of a horse, the first to be made on the sheet, is a copy of one in AntonioTempesta's print *Romanus Equus* (fig.27), and the head has been studied further in particular.[1] Then Callot's imagination seems to have taken over, and the other rapid sketches anticipate those made on a tiny scale with very few lines for which he would become famous. At the top of the sheet are a

Fig.27 Antonio Tempesta, *Romanus Equus*. Engraving and etching, 138 × 164 mm, British Museum

number of studies of a rearing horse; in the one on the right he has added a rider and, evidently dissatisfied, crossed it through. The scene at the lower right of the sheet within an ink line border shows how the young artist was anticipating using such studies as the rearing horse within a composition. He places the horse on high ground on the left, as part of an army attacking lower ground on the right. Other drawings show him developing these ideas.[2]

The drawing was clearly cut at the left side and laid onto another sheet before entering Sir Joshua Reynolds' collection, since his collector's stamp at the lower left corner extends over both sheets.

Provenance: Sir Joshua Reynolds (L.2364); Rev. Alexander Dyce (L.Suppl.711 bis); by whom bequeathed to the museum in 1869, inv.Dyce 559

Exhibited: Nancy, 1992, no.42

Select literature: Catalogue Dyce, 1874, p.83, no.559; Laver, 1927, pp.80–85; Ternois, 1962, pp.49, 111–113; Ternois in Nancy, 1992, p.158, no.42, ill. no.42

1. The Illustrated Bartsch, 17 (36), 946 (161).
2. Choné in Nancy, 1992, p.158. Another Callot drawing after the same Tempesta print is in the National Gallery of Art, Washington, inv.1981. 51.1b; Choné in Nancy, 1992, p.159, no.43, fig.43.

28 REMIGIO CANTAGALLINA (Borgo San Sepolcro *c.*1582 – 1656 Florence)

An associate of the set-designer and architect Giulio Parigi and of Jacques Callot, Cantagallina specialized in etchings and drawings of landscape subjects. In particular he showed a lively interest in humble scenes of everyday life; this may have been spurred by a tour of the Low Countries in 1612–13. While his known etchings are dated between 1603 and 1635, in later life he seems to have concentrated on producing independent drawings, some of a large scale, such as his meticulous views of Siena and Pisa.

A street on the outskirts of a town

Pen and brown ink, brush with brown wash. In ink on the *verso*: *By Cantagallina*
250 × 400 mm

The Governing Body, Christ Church, Oxford

Provenance: General John Guise; Christ Church, Oxford, inv.1021 (JBS 284)

Not previously exhibited

Select literature: Bell, 1914, p.33, no.EE.18 (as Cantagallina); Byam Shaw, 1976, p.99, no.284, pl.185; Veldman, 1977, p.45, fig.21

1. Veldman, 1977, p.45.

Unusually, Cantagallina has here included in one of his characteristic genre scenes the depiction of a proverb, The Idol on the Ass.[1] The ass, being walked on a street with an idol on his back, to which passers-by kneel, assumes that the reverence is being paid to him and not to the idol. This subject was treated in a print by Coorhert after Heemskerck (1549), and it was perhaps Cantagallina's travels in the Low Countries which stimulated his desire to represent it. Whether the motif of the man on the right in a doorway throwing out some food to a barking dog is also related, or is solely an additional genre detail, is not known. Cantagallina's specific mode of drawing bushes can clearly be seen here; first he made a jagged circular outline, then filled it in with regular horizontal strokes, and finally created shadows around the outlines with short vertical marks.

A street scene in Tuscany

Pen and brown ink over black chalk, brush with brown wash. Inscribed by the artist, top centre, in ink: *1614*
194 × 262 mm

The Visitors of the Ashmolean Museum

Provenance: From a portfolio containing 105 drawings attributed to Ligozzi, first recorded in the possession of Dr Henry Wellesley; his sale, Sotheby's, London, 30 June 1866, lot 954; Sir David Kelly; his sale, Hodgson's, London, 26 November 1954, lot 596; purchased by the Ashmolean Museum, 1955, inv.WA1955.14 (MAC802-2)

Not previously exhibited

Select literature:
MacAndrew, 1980, pp.98–99

1. MacAndrew, 1980, pp.98–99.
2. The Brussels sketchbook is slightly smaller (200 × 152 mm) and was acquired by a collector in Florence in 1866 (Chiarini in Florence, 1986, p.179, no.2.127, and III, p.48).

While two men inspect meat hanging under cover on the right, two coopers construct a large barrel in the street outside a workshop. The scene is carefully composed, with the prominent structure in the foreground and view down the street, but was probably drawn from life. Since Cantagallina is not recorded as having made paintings, such precise drawings as this were presumably made as finished products for sale, or were intended to be made into etchings. Nevertheless it is significant that this drawing came from a sketchbook with 105 leaves which was only broken up on the art market in 1954 and which therefore the artist must have kept or sold as an entire unit. In Hodgson's sale the album was described as 'Original sepia and wash drawings of scenery, antiquities, buildings etc. of Tuscany by Jacopo Ligozzi, Remigio Cantagallina and others, including three large views *La Corsa dei Barbari in Firenze*' (it was noted at the time that the drawings were in fact almost entirely by Cantagallina).[1]

Another sketchbook, also with 105 leaves, now in the Musées Royaux des Beaux-Arts, Brussels includes drawings dated by the artist in 1612 and 1613, and seems to have functioned as a pocket sketchbook.[2]

30 AGOSTINO CIAMPELLI (Florence 1565 – 1630 Rome)

Trained in the studio of Santi di Tito, whose influence is visible in his art throughout his career, Ciampelli aided Ligozzi in the decoration of the Uffizi Tribuna in 1586–88 and painted a canvas for the 1589 Medici wedding. After a number of successful commissions in Florence, including that for San Michelino Visdomini and the palazzo of Cardinal Alessandro de' Medici, Ciampelli moved to Rome to work on Alessandro's new titular church, Santa Prassede, in 1594. There, with occasional but substantial visits to Florence, he remained as a successful artist for the rest of his life. Ciampelli's known graphic oeuvre recently doubled with the emergence of about sixty drawings in Olomouc, Czech Republic.

A gypsy encampment in a landscape

Pen and brown ink over black chalk, brush with brown wash, white heightening, on blue paper
254 × 412 mm

Private Collection

While figures are engaged in a variety of domestic activities in the camp – drawing water, preparing food – a woman keeps a young traveller talking and her accomplice picks his pocket. In the background an ass grazes on the slopes, and a bridge leads away to no fewer than two fantastical cities set in a rich landscape. This drawing and cat.64 show artists from Santi di Tito's studio approaching landscape subjects and filling them with genre interest. A pickpocket also appears in cat.9, and in the seventeenth century such details would become increasingly prominent, often involving a moralizing message.

Ciampelli follows his master's choice of media for such subjects (cf. cat.75), using rapid and precise penwork to build the composition and white heightening and brown wash to produce chromatic effects on the blue paper. The slender figure types reflect those of both Santi and Federico Zuccari, suggesting that this is a relatively early work.

Landscape drawings are not common in Ciampelli's oeuvre, and in his painted work landscape is used only occasionally as a rich backdrop to narrative subjects in secular locations, for example in his Old Testament scenes with the story of Cain and Abel in the Palazzo Corsi, made for Cardinal Alessandro de' Medici in the early 1590s.[1]

Provenance: Sotheby's, London, 3 July 1980, lot 33

Not previously exhibited

Unpublished

1. Buoncristiani,1986, pp.22–23.

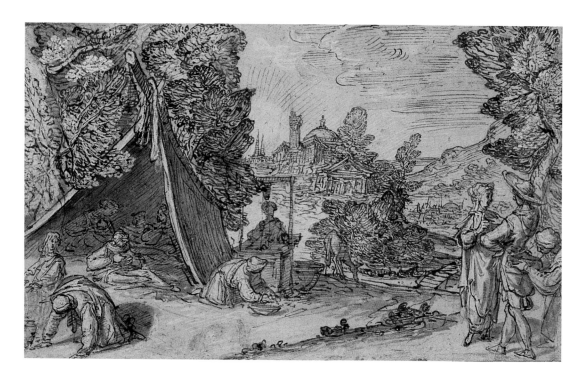

Study of a crouching woman (verso); *Studies of standing male figures, one with a bowl, one with a lamb* (recto)

Black and white chalks on blue paper
262 × 364 mm

The Visitors of the Ashmolean Museum

Formerly attributed to Santi di Tito, this sheet was recognized as Ciampelli by K.T. Parker on comparison with cat.32, and then connected by Pouncey with his painting of the *Birth of the Virgin* in San Michelino Visdomini, Florence, signed and dated 1593 (fig.29).[1] The drawing is one of Ciampelli's finest studies. Powerfully conceived and graceful, the woman acts as a repoussoir figure, directing the viewer's attention into the pictorial space. That the artist considered the pose succesful is indicated by the fact that he used a similar figure in his scene of *Esther fainting before Ahasuerus* in the Palazzo Corsi of *c.*1590–93, leaning forward to give support. Of the three studies on the *recto* of the sheet only the right hand study of a youth carrying a bowl relates to the Visdomini painting, as

Fig.29 Agostino Ciampelli, *The Birth of the Virgin*, 1593, oil on panel, dimensions unknown, Florence, San Michelino Visdomini

noted by Parker; the figure is just visible in the background behind the bed. The other two studies have not yet been related to paintings. Two sheets in the Uffizi also contain figure studies for the Visdomini painting: Uffizi, inv.7174 F, for the little child kneeling behind the central seated woman holding the Virgin, and Uffizi, inv.7178 F, a rough study for the old man seated on the right.[2]

In an unpublished document Agostino's brother Lorenzo alleged that between 1592–1601 he was owed for various duties while Agostino 'was in Rome without any thought for such bothersome matters', which indicates that the artist had already spent significant periods of time in Rome before the execution of the Visdomini altar-piece (1593).[3]

Provenance: Purchased by the Ashmolean Museum, 1952, inv.WA1952.112 (P.II 826)

Exhibited: Florence, 1980 (Primato), no.166

Select literature: Parker, 1956, pp.430–31, no. 826; Thiem, 1971, p.360, *recto* pl.2, *verso* pl.1; Prosperi Valenti Rodinò, 1973, p.7 n.21, fig.7 (*verso* only); MacAndrew, 1980, p.295, no.826; Petrioli Tofani in Florence, 1980 (Primato), p.103, no.166; Togner in Olomouc, 2000, p.96, no.B55

1. Repr. Cantelli, 1983, no.137.
2. Thiem, 1971, p.360, pls.3a and 3b.
3. 'mentre che Agostino suo fratello è stato a Roma senza pensieri alcuno di detti fastidi', ASF, Archivio Notarile Moderno, Camillo di Stefano Ciai, Prot.7593 (1610–11), fol.79, one of an interesting series of documents.

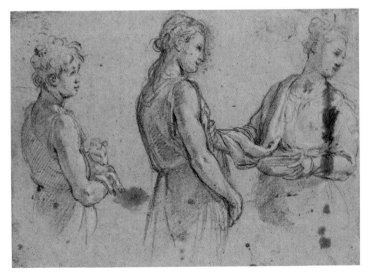

Fig.28 *Recto* of cat.31

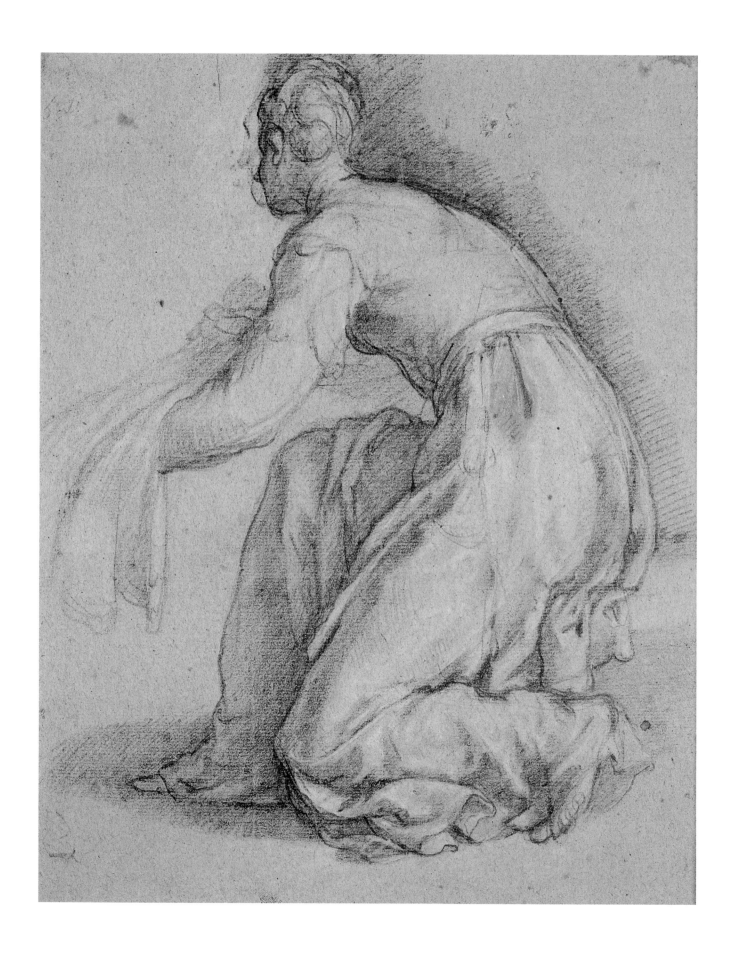

Study of a standing draped figure

Black and white chalks on blue paper
251 × 168 mm

The Visitors of the Ashmolean Museum

Ciampelli here studied the figure of the kneeling angel who holds Christ's garment during his baptism in a painting of *c.*1605 formerly in the Corsini Gallery, and now in a Florentine private collection (fig.30).[1] The painting is still stylistically very close to Santi, to whom it was traditionally attributed, particularly in the composition and facial types. However, this drawing shows how Ciampelli has moved beyond his master's graphic style; it is freer in handling and the figure is more solidly set in space. The recession of the figure is particularly studied in this

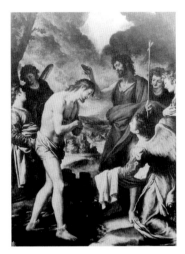

Fig.30 Agostino Ciampelli, *The Baptism of Christ, c.*1605, oil on panel, 250 × 182 cm, Florence, Private Collection

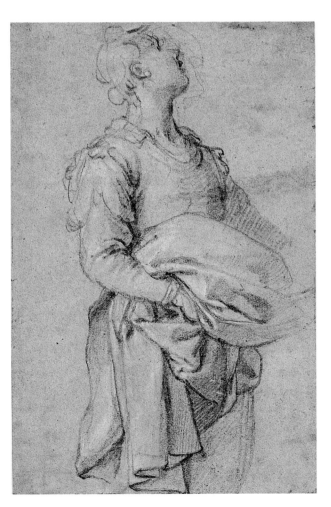

drawing, and the more distant side of the body and left arm are left incomplete since they are not required for the painting. The angel's clothes are also simplified in the final work and those of Christ, which he carries, are made more copious and rich, probably for reasons of decorum.

Two further figure studies for the composition are known, one for the kneeling angel on the right hand side, and one for St John the Baptist himself.[2] A rapid *primo pensiero* or first idea for the whole composition (Farnesina, inv.F.C. 127628) has been published by Prosperi Valenti Rodinò; it is not a strong sheet and has been rejected by Togner, but seems plausible as an initial idea, especially since it includes a foreground angel in a similar pose but in reverse.[3]

Provenance: Purchased by the Ashmolean Museum, 1943, inv.WA1943.68 (P.II 825)

Exhibited: Florence, 1980 (Primato), no.168

Select literature: Parker, 1956, p.430, no.825, pl.clxxix; Thiem, 1971, p.362; Prosperi Valenti Rodinò, 1973, p.12 n.42, fig.23; MacAndrew, 1980, p.295, no.825; Petrioli Tofani in Florence, 1980 (Primato), p.103, no.168; Togner, 1998, p.106; Togner in Olomouc, 2000, p.96, no.B54

1. Repr. and disc. Petrioli Tofani in Florence, 1980 (Primato), p.100, no.163, fig.163. The painting was formerly attributed to Ciampelli's master Santi di Tito until recognized by Giuliano Briganti in 1938, Briganti, 1938, p.xvii, note.
2. Museo Civico, Bassano del Grappa, riva 53 (Thiem, 1971, no.4, pl.9); Olomouc, inv. I./125 (Togner in Olomouc, 2000, p.72, no.A48, fig.A48r.).
3. Prosperi Valenti Rodinò in Rome, 1977, p.47, no.69, ill.; Togner in Olomouc, 2000, p.100, no.B68, fig.B68 bis.

God the Father with music-making angels

Pen and brown ink over traces of black chalk, brush with brown wash, traces of oxidized white heightening. The backing scraped away to reveal the number *11* in ink, struck through, and *10* written below.
350 × 555 mm (lunette shape, lower corners cut)

The Trustees of the British Museum

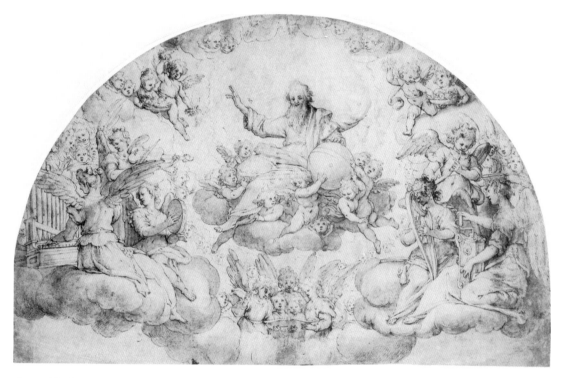

Provenance: C.R. Rudolf; his sale, Sotheby's, London, 19 May 1977, lot 12; purchased by the British Museum, 1979, inv.1979-7-21-63

Exhibited: London, 1986, no.209

Select literature: Gere & Pouncey, 1983, p.51, no.62, pl.58; Turner in London,1986, p.266, no.209, ill.209; Turner, 1999, p.220, under no.344; Togner in Olomouc, 2000, p.94, no.B45

1. Repr. Acanfora, 2001, p.49, fig.7.
2. Togner in Olomouc, 2000, p.94, no.B45.

As noted by Gere and Pouncey, the shape of this composition, the viewpoint, and the rounding of the lower left and right corners, indicate that it is a design for a semi-dome above a chapel. God the father sits with his orb in glory, surrounded by angels playing a variety of musical intruments, and others below, singing. The idea of featuring musical angels in such a composition was a common one, and is reflected in works by Ciampelli's contemporaries, for example Passignano's cupola for the cathedral in Pistoia.[1] Although the over-riding influence visible in this sheet is that of Ciampelli's master Santi di Tito, there are also derivations in the figure types and poses from Federico Zuccari, to whom the drawing was once attributed. These affinities suggest a relatively early dating; however, Togner has pointed out that this drawing is 'more Baroque than Mannerist', in feeling, and prefers a dating after Ciampelli's move to Rome.[2]

Named after his home town, Cigoli was first apprenticed to Alessandro Allori, but studied to greater effect with Santi di Tito and Buontalenti. He established his reputation in Florence in the 1590s through a series of dynamic altar-pieces with clear and dramatic narrative, rich Venetian colour, and careful spatial manipulation. From 1604 until his death Cigoli divided his time between Florence and Rome, winning great success in the papal city. Also an architect, poet, and musician, Cigoli had extensive intellectual interests. Drawing was at the root of Cigoli's art, and well over a thousand sheets survive. He had numerous pupils and followers, and his impact on Florentine and Roman seventeenth-century art should not be underestimated.

Charles of Anjou defeating Manfred at the battle of Benevento

Pen and brown ink over black chalk, brush with brown wash, touches of body-colour. Squared in black chalk
540 × 412 mm

The Visitors of the Ashmolean Museum

As Philip Pouncey was the first to point out, this drawing is a compositional study for one of Cigoli's paintings in the 1589 Medici wedding festival decorations (cf. cats.5, 56).[1] The painting decorated the first structure on Christine of Lorraine's route into Florence near the Porta al Prato. While decked out as a triumphal arch, this structure was actually a temporary theatre in which Christine was crowned Grand Duchess; the theme of the decoration was significant events in Florentine military history up to the fourteenth century.[2] The vigour of Cigoli's draughtsmanship is apparent in the numerous *pentimenti*; for example one can see several brief trials for the positions of the shields of the two principal protagonists.

Compositions such as this, set in a space with receding planes, and with a visible and powerful narrative, marked a clear break with the traditional format developed by Vasari and Stradanus for battle scenes. This tended to follow the model of antique sarcophagi and kept the action in a single frieze-like space at the front. Chappell has credited this innovation to the particular influence of Santi di Tito.[3] The etching in Gualterotti's book (fig.31), in reverse orientation as a result of the printing process, shows a number of changes to the finished painting: the prominent tree is omitted and replaced with more banners, and the respective slashing and thrusting sword movements of the principal mounted warrior and corner foreground figure are exchanged. Despite this, the principal figures are broadly similar, and the substantial size of the sheet used suggests that the artist was at an advanced stage in the design process; the large-scale black chalk squaring was presumably added by him for the final transfer to canvas.

Andrea Boscoli's drawn copy after the present work, used as an *aide-memoire* for his etching for Gualterotti's book, is in Genoa (cf. p.31–32).[4] Cat.35 is a preliminary study for the figures in the lower right-hand corner.

Provenance: Richard Houlditch (L.2214); Sir Joshua Reynolds (L.2364); purchased by the Ashmolean Museum, 1942, inv.WA1942.96

Exhibited: Cambridge, 1985, no.17

Select literature: Parker, 1956, p.92, no.196; Carman, 1978, p.31; Chappell, 1981, pp.92–3; Chappell, 1982, p.333, fig.4; Stock & Scrase in Cambridge, 1985, n.p., no.17, ill.; Chappell, 1989, pp.196–7, pl.2; Chappell in Florence, 1992, pp.5–6, under no.3; Saslow, 1996, p.189, under no.1.28

1. Gualterotti, p.28. The drawing was formerly attributed to Giuseppe Salviati, but was related to the Gualterotti print by Pouncey.
2. Saslow, 1996, pp.189–90.
3. Chappell, 1989, p.197.
4. Palazzo Rosso, inv.1822; Bastogi in Florence, 1997, p.296, no.243, ill.p.296.

Fig.31 Andrea Boscoli after Lodovico Cigoli, *Charles of Anjou defeating Manfred at the battle of Benevento*. Etching, 225 × 165 mm, Warburg Institute

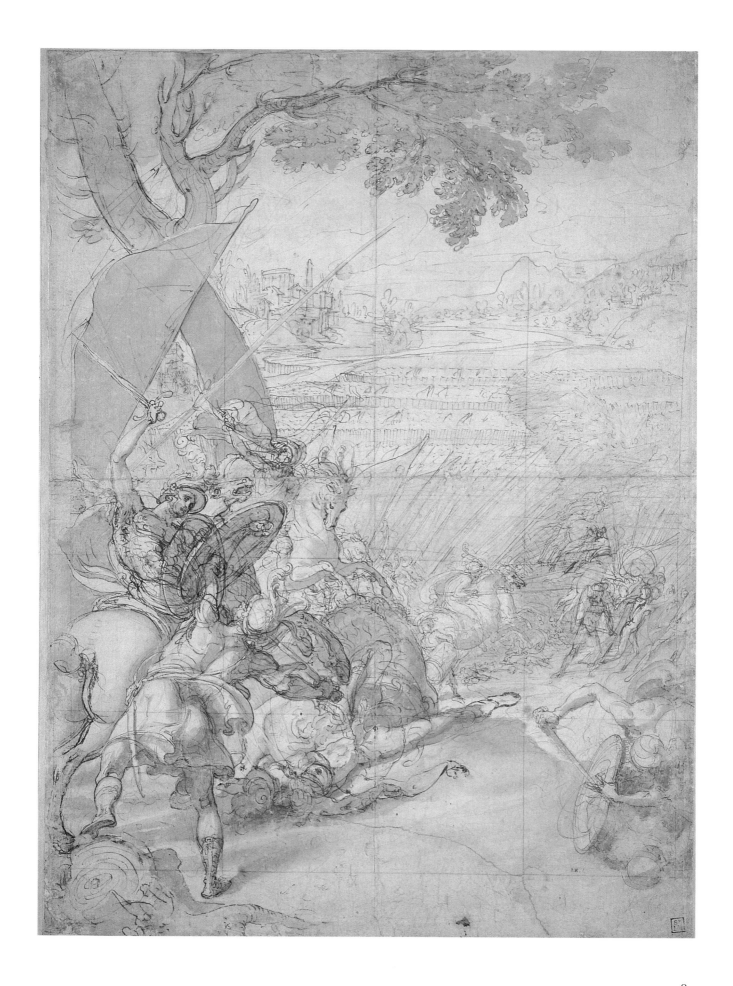

Study of a nude warrior about to kill another (verso); *A man seated at a table* (recto)

Black and white chalks on blue paper *(verso)*; Brush with brown wash heightened with bodycolour *(recto)*. Inscribed in brown ink in a contemporary hand lower right on *verso*: *Cigoli. R.26* in black chalk lower left *(verso)*. Price marks of William Gibson *2.3* and *8.1* lower right *(verso)* 420 × 249 mm

The Governing Body, Christ Church, Oxford

This rapid black chalk drawing is a life study for the two figures in the lower right-hand corner of Cigoli's *Battle of Benevento* (cf. cat.34).[1] A swiftly sketched warrior is prone on the ground, while the other figure, of principal interest to the artist, prepares to despatch him. Following a longstanding workshop practice, perhaps most famously employed by Raphael, Cigoli here makes a study of the figure in the nude so as to understand fully the form; a further sketch would then have been made with helmet and armour. A drawing in the Uffizi, made principally with brush and wash on blue paper, shows a figure in an almost identical pose with one knee on a studio box; no weapons or further figures are sketched in.[2] It seems less exploratory than the Christ Church sheet, and was most likely made to study the fall of light and shade on the figure.

An interesting parallel can be made with a drawing by Andrea Boscoli (fig.32) of a very similar group, and certainly the two artists were very close at this time. Boscoli's warrior wears full armour, and the figure on the ground is face down, but nevertheless the similarity between the

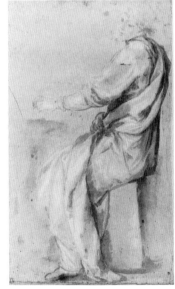

Fig.33 *Recto* of cat.35

groups is striking. The source followed by these artists might be a group in this attitude in the lower right-hand corner of Taddeo Zuccari's fresco of the *Siege of Tunis* in the Sala Regia in the Vatican, of which Boscoli made a copy.[3] As Byam Shaw noted, the study of a seated figure on the other side of the sheet (fig.33) relates to Cigoli's painting of the *Last Supper* of 1591 formerly in Empoli (see cat.36 and fig.7).[4] As in the present case, Cigoli often used one side of a sheet of paper for quick chalk or pen studies, and then several years later returned to the sheet, sometimes giving the other side a coloured preparation for another drawing. Which side is the *recto* and which the *verso* is then decided by later generations.[5]

Provenance: Sir Peter Lely (L.2092); William Gibson (L.Suppl.2885); General John Guise; Christ Church, Oxford, inv.0229 (JBS 259)

Not previously exhibited

Select literature: Bell, 1914, p.38, G.9 (as Cigoli); Byam Shaw, 1976, pp.94–5, no.259, pls.167, 168; Chappell in Florence, 1992, p.6, under no.3 (for the *verso*) and p.22, under no.12 (for the *recto*)

1. Chappell in Florence, 1992, p.4.
2. 9036 F; connected to the Christ Church sheet by Chappell in Florence, 1992, pp.5–7, fig.3a.
3. Uffizi, inv.2180 F; the copy after Taddeo sold Sotheby's, London, 17 April 1980, lot 5, ill..
4. Byam Shaw, 1976, pp.94–5.
5. Another example is Uffizi, inv.8970 F (Chappell in Florence, 1992, pp.133–36), where one side contains brief pen studies for a picture of 1597, and the other a figure study on a grey preparation for one of 1605. In the case of the present Christ Church drawing, Byam Shaw presumably chose the current *recto* on the basis of the higher level of finish.

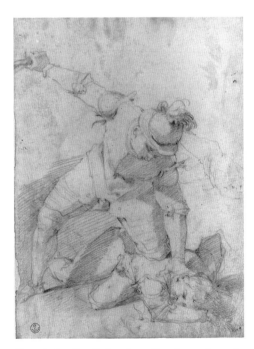

Fig.32 Andrea Boscoli, *A warrior attacking a figure on the ground.* Red chalk, 284 × 212 mm, Uffizi, inv.2180 F

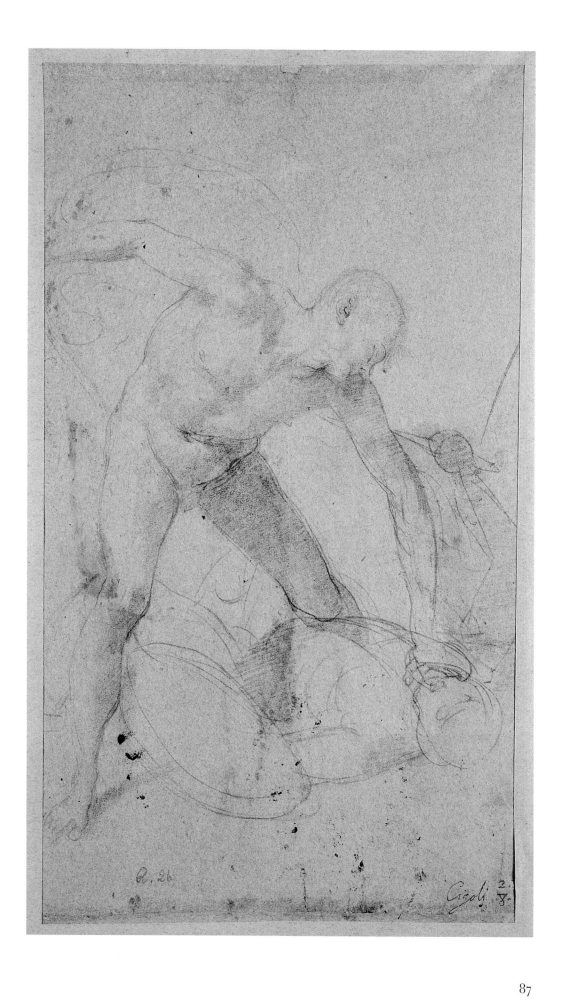

The Last Supper (recto); *Studies for disciples at the Last Supper; architectural studies* (verso)

Black chalk, pen and brown ink, brush with brown wash, heightened with white *(recto)*; Black and red chalk, pen and brown ink *(verso)*
325 × 239 mm

The Syndics of the Fitzwilliam Museum, Cambridge

This is a compositional study for the painting commissioned from Cigoli for the altar of the Confraternita del Corpus Domini in the church of Sant'Andrea in Empoli (1591).[1] Destroyed in 1944, the altar-piece is recorded in a photograph (fig.7). The sheet shows the whirl of draughtsmanship from which Cigoli extracted his compositions, in some places so intense as to make the sheet illegible. Chalk was used first for some early ideas, which were then firmed up by numerous rapid pen lines. Brush and wash and white heightening were added to give some idea of the fall of light in the composition. As David Scrase has pointed out, Cigoli further enclosed the composition around Christ in the completed painting by lowering the ceiling and moving the foreground figures closer together. Significantly,

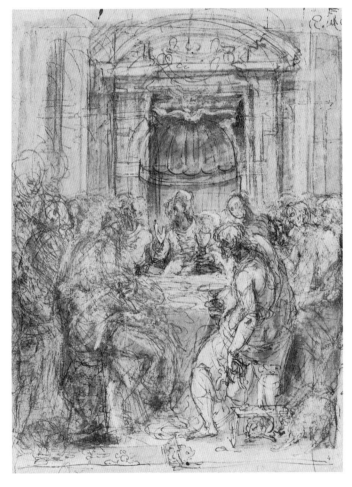

Fig.34 *Verso of cat.36*

the artist also turned the figure of the traitor Judas in the right-hand foreground further away from Christ, and raised Christ's eyes piously skywards. Although this is the only known compositional study for the painting, Chappell has identified a number of related figure studies, particularly for that of Judas; the *recto* of cat.35 was linked to the picture by Byam Shaw.[2] The painting was remarkable in depicting the subject as a night scene, and the composition had a profound influence on Rubens.[3] On the *verso* of the drawing are brief alternatives for the two foreground figures and several architectural studies.

Provenance: Christie's, London, 30 March 1976, lot 38; purchased by the Fitzwilliam Museum, 1977, inv.PD.13-1977

Exhibited: U.S.A., 1989, no.82

Select literature: Munro in U.S.A., 1989, no.82; Chappell, 1989, pp.197–98, pls.3,4; Chappell in Florence, 1992, pp.20–3, under no.12

1. Chappell, 1989, pp.197–8; Chappell in Florence, 1992, pp.20–3.
2. Chappell in Florence, 1992, pp.20–3.
3. Gregori, 1983 (Rubens), p.51.

Study of a kneeling acolyte

Brush drawing in body-colour and a little brown pigment on a dark brown preparation
397 × 283 mm

The Visitors of the Ashmolean Museum

Cigoli often used a dark preparation in conjunction with white wash, something he perhaps developed thanks to his study of the works of Federico Barocci, and Venetian prototypes. This sheet is an excellent example of the technique. The paper has been brushed with a thick dark brown ink – the brushstrokes are clearly visible – and allowed to dry. Then the elements of the rich robe of the figure have been quickly outlined with a brush in white wash. Such media allowed the artist to express fully the intense chiaroscuro effects he was seeking, and to plan where the highlights would fall; the dark preparation also replicated the background and relatively dark cloth of the vestments in the final painting. The study was preparatory for the dramatic robes of a repoussoir figure in Cigoli's picture of *Cosimo I receiving the robes of Grand Master of the Order of St Stephen* painted for the ceiling decoration of the church of Santo Stefano, Pisa (1605). Cigoli was originally commissioned to paint all six pictures in the decorative scheme, but referred five of them to other artists; two to Ligozzi (cf. cat.57), two to Empoli, and one to Cristofano Allori.[1] The only other drawing known for the composition is Uffizi, inv.8970 F, of a similar type. It is worth noting that the Ashmolean drawing does not match every little detail of the painting, and that the artist seemed to view such studies as indicative and not intensely descriptive (for example, the robe in the painting has a set of four tassles

over each shoulder, and the right sleeve is narrower).[2]

Just above the left shoulder of the kneeling figure an oval drystamp can just be discerned. This is the mark of the Coccapani collection, and is an interesting record of the early provenance of the drawing (cf. p.15).[3]

Provenance: Coccapani family (L.2729); Sir Peter Lely (L.2092); purchased by the Ashmolean Museum, 1943, inv.WA1943.60 (P.II 199)

Not previously exhibited

Select literature: Parker, 1956, p.94, no.199, pl.XLVII; Bucci in San Miniato, 1959, p.93, under no.35; Forlani in San Miniato, 1959, p.140, under no.76; Matteoli in Pisa, 1980, p.344, under no. B.I.9; Chappell, 1983, p.50, no.29, fig.17; Faranda, 1986, p.153, under no.60a; Chappell in Florence,1992, p.XVIII, pp.133–4, under no.80

1. Matteoli in Pisa, 1980, p.344, Chappell in Florence, pp.133–136, 1992, under no.80, et al..
2. Repr. Contini, 1991, p.79, no.20.
3. As Miles Chappell has pointed out, the fact that this sheet also bears the collector's stamp of Peter Lely suggests that the Coccapani collection must have been dispersed in the third quarter of the seventeenth century, Chappell in Florence, 1992, p.XVIII.

Studies for the Virtues of Prudence and Faith

Black and red chalks, white heightening, on faded blue paper
390 × 265 mm

The Governing Body, Christ Church, Oxford

Probably one of Cigoli's finest figure studies, this drawing is preparatory for two of the Virtues in his painting of *St Jerome translating the Bible* in San Giovanni dei Fiorentini, Rome (1599; fig.35).[1] The painting was one of three commissioned on the re-dedication of the chapel of the Mancini family to St Jerome; Cigoli's work is on the right-hand wall, a painting of *St Jerome erecting a monastery* by Passignano on the left-hand wall, and one of *St Jerome in the Desert* by Santi di Tito over the altar.[2] The three paintings were made in Florence, and exhibited together in SS. Annunziata before being sent by boat to Rome; Cigoli's biographer (his nephew) claimed that his was the best-received.

Here the artist principally studies the central of the three Virtues, Prudence, in a drawing made from the life. She sits in contemporary clothes on a box draped with cloth, and the study delicately shows veristic details such as the pink blush of her knuckles, and the 'bracelet' of skin that appears as her left hand rests at right-angles on the hard surface. In the painting she is seated on a cloud, and the artist has smoothed out this detail. Also in the painting the attributes of Prudence are made clear; she carries a mirror bordered by a motif of a snake eating its own tail, and has two faces (the wise person knows him/herself; the snake derives from Matthew 10: 16 'Be ye wise as serpents'; the two faces enable one to look in both directions at the same time). Briefly sketched in behind Prudence in the drawing is the figure

Fig.35 Lodovico Cigoli, *St Jerome translating the Bible*, 1599, oil on panel, 412 × 206 cm, Rome, San Giovanni dei Fiorentini

of Faith, holding in her left hand a Cross, and in her right hand a shallow chalice and host (or perhaps baptismal bowl), which is also the subject of two subsidiary studies on the lower right of the sheet.[3] The contemporary clothes are substituted in the painting with more classical robes, and the hat with a helmet. Such tender and carefully observed figure studies as this sheet manifest themselves in Cigoli's painted work in a much greater naturalism. The fame and prestige of this commission in the prominent church of the Florentine community in Rome almost certainly contributed to Cigoli's increasing presence and success in the papal city from 1604.

A drawing in the Uffizi (inv.1030 F *verso*) has a variety of quick pen studies for the painting; curiously the *recto* has a study for a *St Jerome erecting a monastery* (the subject painted by Passignano in the chapel).[4]

Provenance: General John Guise; Christ Church, Oxford, inv.0232 (JBS 256)

Exhibited: U.S.A., 1972–3, no.17; Florence, 1986, p.121, no.2.67; Tokyo, 1994, no.67

Select literature: Bell, 1914, p.26, G.12 (as attributed to Cristofano Allori), pl.i; Bean, 1968, p.259; Byam Shaw in U.S.A., 1972–3, p.23, no.17; Byam Shaw, 1976, pp.93–94, no.256, pl.165; Chappell in Florence, 1979, pp.118–19, under no.75; Matteoli, 1980, p.199, under no.70; Chappell in Florence, 1986, p.121, no.2.67, fig.2.67; Faranda, 1986, p.143, under no.41; Chappell in Florence, 1992, p.88, under no.51; Whitaker in Tokyo, 1994, pp.216–17, no.67, fig.67

1. The connection was first noted by Jacob Bean; Bean, 1968, p.259.
2. Matteoli, 1980, p.198.
3. Matteoli, 1980, p.198 identified the Virtues as (left to right) Charity, Hope (the mirror reflects the future, and with the helmet she is armed and ready for it), and Faith. Chappell (in Florence, 1992, p.88) calls them Hope, Prudence and Faith, while Contini, 1991, p.66 identifies them as Divine Grace, Prudence, and Faith.
4. The various explanations offered for this are summarized by Chappell in Florence, 1992, pp.85–8, no.51.

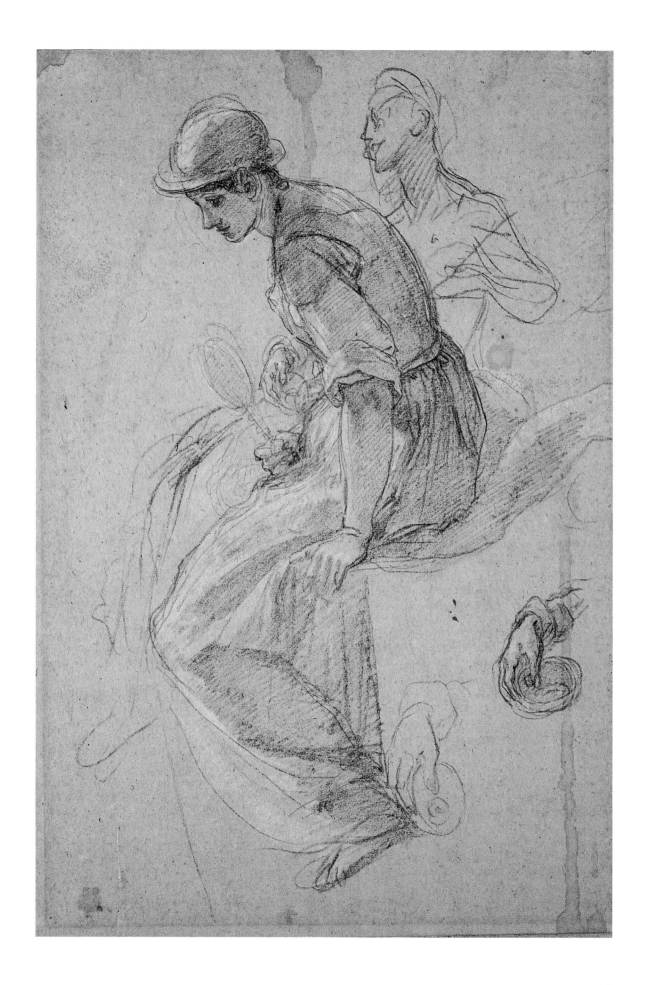

Joseph and Potiphar's wife

Pen and brown ink over traces of black chalk, brush with blue and brown washes, white heightening, on light blue paper
272 × 188 mm

The Trustees of the British Museum

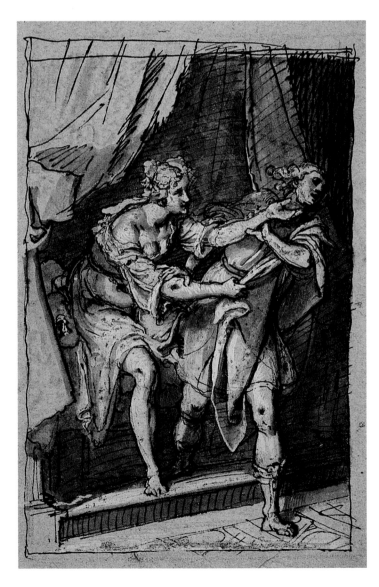

Joseph here flees the seductive advances of his employer's wife (Genesis 39: 7–20). Although the episode was regularly used to celebrate chastity, those who commissioned pictures of the subject were often more interested in its sensuous or erotic possibilities. In fact in this case earlier drawings for the painting of 1610, now in the Galleria Borghese, Rome (fig.36), are more revealing, and in cat.39 the artist has consciously decided to cover up the figures, perhaps reflecting the fact that the picture was commissioned by a Bishop, Antonio Ricci of Arezzo.[1] The drawing's few *pentimenti* and high level of finish, with white heightening and a vivid blue wash, suggest that it was a *modello* to show to the patron, although the final painting was executed in reverse.[2] Other drawings for the composition include sheets in the Szépmûvészeti Museum, Budapest and in the Hermitage, St Petersburg.[3] The dramatic diagonal composition was extremely influential for Cigoli's followers, many of whom produced derivative works.[4]

Fig.36 Lodovico Cigoli, *Joseph and Potiphar's wife*, 1610, oil on canvas, 220 × 152 cm, Rome, Galleria Borghese

Provenance: Purchased by the British Museum, 1963, inv.1963-5-18-5

Exhibited: London, 1986, no.201

Select literature: Thiem, 1977, p.294, under no.44; Chappell in Florence, 1979, pp.158–9, under no.106; Matteoli in San Miniato, 1985, under no.92; Turner in London, 1986, p.257, no.201, repr.p.258; Chappell in Florence, 1986, p.116, under no.I.23; Chappell in Florence, 1992, pp.175–77, under no.106

1. The painting is discussed by Matteoli, 1980, pp.124–6, Chappell in Florence, 1986, p.116, no.I.23, and Faranda, 1986, pp.167–8, no.81.
2. Chappell in Florence, 1992, p.176.
3. Budapest, inv.1830 discussed Thiem, 1977, p.294, no.44; Larissa Salmina-Haskell kindly informed me of the unpublished St Petersburg drawing.
4. For example, works by Giovanni Biliverti, Cristofano Allori, Orazio Fidani, Ottavio Vannini, Giovanni da San Giovanni, amongst others.

A Prince of the House of Habsburg

Pen and brown ink over black chalk, brush with brown wash. In ink in contemporary hands at top: *federigho quarto Impre.* (crossed out) *dalla 5 di Lodo. Buti* and *Rifarlo per che no*
264 × 188 mm

The Governing Body, Christ Church, Oxford

In 1607 Cigoli was recalled to Florence from Rome by Christine of Lorraine. The occasion was the triumphal entry (on 18 October, 1608) into Florence of Maria Maddalena of Austria for her marriage to the young Cosimo II, and Cigoli, given his experience in such matters, was required to undertake and oversee a large part of the work. In particular he was entrusted with the architecture and decoration of three of the seven triumphal arches, those at the Porta al Prato, Canto dei Nelli and Canto alla Paglia.[1] Within niches on these arches were statues made of plaster and papier maché, and cat.40 is a preparatory design for one of these, none of which survive today.

Seeking likenesses of the Habsburg dynasty, Cigoli turned to the seventy-four plates in Francesco Terzi's *Imagines Gentis Austriacae* (1554–73), which he modfied for the production of sculptural images, hence the relatively free black chalk underdrawing found in this sheet. The inscriptions at the top point to the peculiar history of the Christ Church sheet, where the image is derived from Terzi's depiction of Frederick the Fair. But while Frederick was crowned King of the Romans, he was never made Emperor; moreover, since he never had children, he could not have been an antecedent of Maria Maddalena, whom the decoration was intended to glorify. When this problem became apparent, perhaps when the drawings were sent for approval, the inscription *federigho quarto Impre.* at the top of the sheet was

crossed out, and *rifarlo perche no* written; *re-do it why not.* Cigoli then re-drew the figure, deriving it instead from Terzi's depiction of the next Emperor in the sequence, on a sheet in the Uffizi (inv.14316 F), also with the inscription *Federigho quarto*, and which is squared for transfer.[2] The Uffizi drawing is one of four sheets for the series published by Petrioli Tofani, previously considered to be by Albrecht Dürer.[3] The inscription at top left of the Christ Church drawing – *dalla 5 di Lodo. Buti* – might suggest the involvement of Lodovico Buti in the project, perhaps delegated to work up designs for five of the sculptures from Cigoli's sketches.

Provenance: General John Guise; Christ Church, Oxford, inv.0219 (JBS 265)

Not previously exhibited

Select literature: Bell, 1914, p.93, F.32 (as Attributed to F. Zuccari); Byam Shaw, 1976, p.96, no.265, pl.170 (as Attributed to Cigoli); Chappell in Florence, 1992, p.167, under no.98 (as Cigoli)

1. Petrioli Tofani, 1985, pp.785–86, with previous bibliography.
2. The history of this iconography is fully discussed in Radcliffe, 1986, pp.103–109, but without knowledge of this Christ Church sheet.
3. Petrioli Tofani, 1985, pp.785–86.

The Holy Family with the sleeping St John (recto); *The Holy Family with a kneeling figure of St John* (verso)

Pen and brown ink, brush with brown wash, over black and red chalks *(recto)*; Pen and brown ink over red chalk *(verso)*
227 × 171 mm

Edinburgh, National Gallery of Scotland

The dynamism of the draughtsmanship in this sheet contrasts strikingly with the peaceful nature of the subject. The Madonna sits under a tree with a stirring infant Christ, while the child St John the Baptist lies fast asleep on the ground. In the background the artist has experimented with the figure of Joseph in various walking and kneeling positions. The composition falls into the tradition of small-scale private devotional altar-pieces (cf. cats.49, 76), and illustrates the search for new interpretations of the subject.[1]

Chappell has proposed a possible link between this drawing and one of a similar subject at Bowdoin College, and they do seem stylistically similar in the construction of the figures.[2] The Bowdoin sheet is currently attributed to Francesco Vanni, an attribution accepted by Peter Anselm Riedl, while both Philip Pouncey and Nicholas Turner tentatively suggested Cigoli for it, and Chiara d'Afflitto proposed the name of Ottavio Vannini.

The *verso* of the Edinburgh sheet (fig.37) contains another compositional solution for the subject. It is drawn with simple but fluid ink lines over red chalk, and has a particularly striking *pentimento* in the position of the head of the Virgin. The very simple ink outline forming the figure of Joseph shows Cigoli's fluency in the commencement of such a study. Taken in isolation from the other studies on the sheet, this is the sort of drawing which could be mistaken for a drawn copy, as Julien Stock has pointed out.

Provenance: Thomas Dimsdale (L.2426); W.F. Watson, by whom bequeathed to the National Gallery of Scotland in 1881, inv.D. 3138

Not previously exhibited

Select literature: Andrews, 1968, p.39, figs.295–96 (as Cigoli); Chappell in Florence, 1992, p.124, under no.73 (as Cigoli)

1. Taken to extremes by Cristofano Allori in Uffizi, inv.7827 F, where the infant St John the Baptist is astride the seated donkey, trying to stir it into action.
2. Inv.1811.9; In conversation 24 November 2002. Chappell had previously pointed towards Giovanni Biliverti, Baldassare Franceschini, Il Volterrano), or Pignoni. Becker in Brunswick, 1985, pp.108–11, no.50, figs. on pp.108, 110, as Francesco Vanni. The drawing was originally given to Cigoli by Philip Pouncey.

Fig.37 *Verso* of cat.41

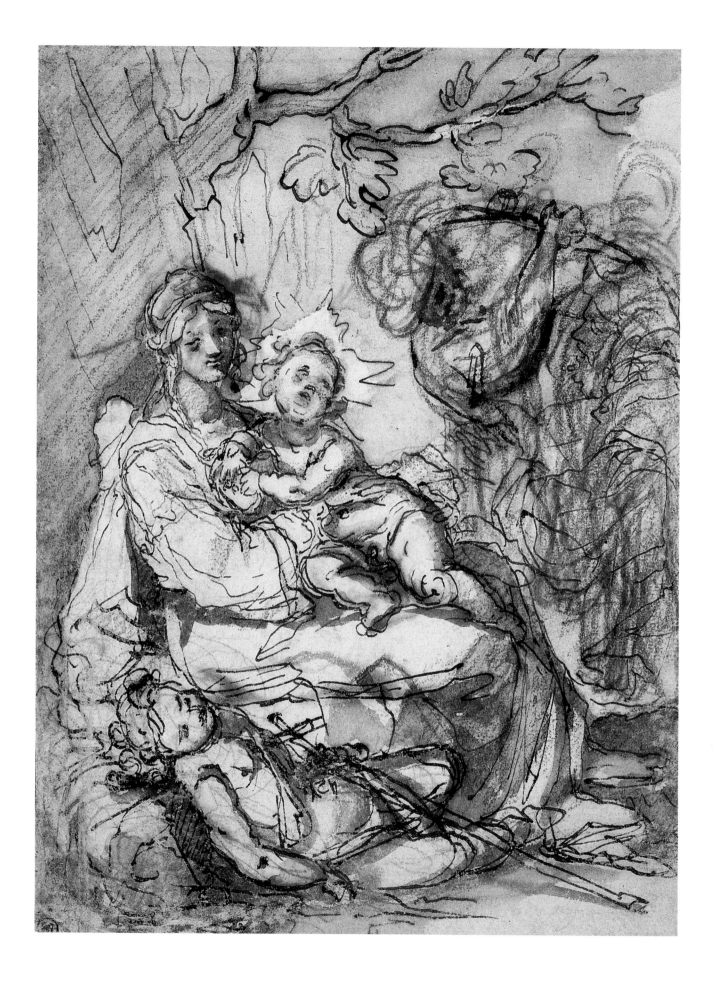

Two men operating an optical device (recto); *Studies of anamorphic distortion* (verso)

Pen and brown ink. Inscribed in ink in the artist's hand, twice, top left and centre, *Intagliato*, and lettered for reference to an alphabetical key
121 × 220 mm

The Trustees of the British Museum

Cigoli's nephew Giovanni Battista Cardi and Baldinucci both noted that the artist worked on a treatise on perspective, in which he was possibly aided by Sigismondo Coccapani (brother of Giovanni, cf. cat.43).[1] Left incomplete on his death, the manuscript, with additions by Cardi, is in the Uffizi (inv.Ms 2660A). The British Museum drawing was first connected to Cigoli by Timothy Clifford, and to the treatise by Mr J. Hammond.[2] The Uffizi manuscript is illustrated by a series of woodcuts and drawings; the woodcut copy of the present drawing appears on fol.92 of the volume, accounting for the annotation *intagliato* (engraved).[3] Baldinucci says that Sebastiano, Cigoli's brother, engraved the drawings. Although the treatise specifies in places that some of the illustrations would be engraved in copper, no doubt this would have been reserved for only the more complex illustrations. The woodcut of cat.42 is in the penultimate section of the treatise, which is concerned with the construction and use of a practical instrument for artists: it shows how the instrument could be employed in transferring a small drawing to a larger design on a wall, evidently useful for fresco and mural painters. Another illustration on the same page of the manuscript concerns the transfer of a design to a curved ceiling, and indeed in his cupola of Santa Maria Maggiore, Rome, 1610–12, Cigoli used an original perspective scheme to allow the fresco to make sense to the viewer from a

Fig.38 *Verso* of cat.42

number of lateral viewpoints.[4] Other sections of the treatise deal with the structure of the eye, various systems of architectural perspective, the use of perspectival aids, and a description of the five orders of architecture. With various annotations regarding the use of Cigoli's instrument, the *verso* of this sheet has studies demonstrating the anamorphic distortion of a profile portrait.

Provenance: Anonymous donation, 1933, inv.1933-3-10-7

Exhibited: London, 1986, no.202

Select literature: Turner in London, 1986, p.257, no.202, ill.no.202, p.259; Chappell, 1989, p.205, fig.13

1. Baldinucci, III, p.274; Chappell in Florence, 1979, pp.181–2, under no.120 F.
2. On the treatise see Profumo, 1992 and Filippo Camerota's unpublished *tesi di laurea* (1985–6), available in the Kunsthistorisches Institut, Florence.
3. Baldinucci, III, p.278.
4. Kemp, 1990, p.96.

43 GIOVANNI COCCAPANI (Florence 1582 – 1649 Florence)

Trained as a lawyer, Coccapani was a mathematician, engineer and architect. As well as a number of civil and military projects, he designed several churches in Florence and the surrounding area. Giovanni took part in the competition to redesign Villa Poggio Imperiale, won by Giulio Parigi. His academy was attended by numerous pupils from overseas, and he was a celebrated theorist. As an expert in hydraulics, Giovanni manufactured a range of portable fountains for the amusement of Cosimo II.

Self-portrait

Red chalk. Inscribed in black chalk on the *verso*: *di Gio: Coccapani fatto da se medmo.*
213 × 158 mm

The Visitors of the Ashmolean Museum

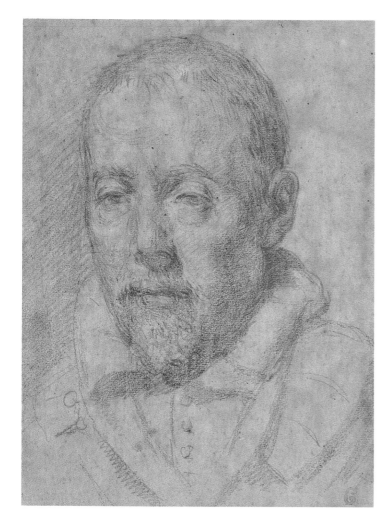

The early inscription on the *verso* of this sheet, identifying it as a self-portrait by Giovanni, seems plausible; as Parker noted, it seems unlikely that such a 'recondite [attribution] should have been gratuitously invented'.[1] In stylistic terms, the drawing is not as close to Cigoli as one might expect from someone who was such a follower of that artist; Cigoli recommended Giovanni to Galileo in a letter of August 1611.[2] Instead, the chippy fragmented lines have affinities with the drawings produced by Cecco Bravo (cf. cats.61–3), an artist with whom Sigismondo, Giovanni's artist-brother, associated. Although the drawing is of good quality, there are some weaknesses in the rendition of space in the nose and sitter's left eye which suggest that an amateur (such as Giovanni) might be responsible for it. Catherine Monbeig Goguel attributed the drawing to Ottavio Vannini, whereas Miles Chappell reasserted the attribution to Coccapani.[3]

Giovanni was an 'enemy of alchemy' and was one of a new breed of passionate observers of nature, who applied their research to the fields of engineering and design.[4] He and Sigismondo assembled an important collection of drawings (cf. p.15 and cat.37).

Provenance: Pseudo-Crozat mark (L.474); Francis Douce, by whom bequeathed to the Bodleian Library, 1834; transferred to the University Galleries, 1864, inv.WA1863.703 (P.II 827)

Not previously exhibited

Select literature: Parker, 1956, p.431, no.827 (Coccapani); Goguel, 1981, p.265, fig.5 (Vannini); Chappell, 1983, p.41, fig.5 (Coccapani)

1. Parker, 1956, p.431, no.827. He notes that the inscription seems to be in the same hand as one on cat.P.II 983 by Cignaroli, from the collection of F.M.N. Gabburri.
2. Chappell, 1983, p.41.
3. Monbeig Goguel, 1981, p.265; Chappell, 1983, p.41.
4. Baldinucci, IV, p.413.

44 JACOPO CONFORTINI (Florence 1602 – 1672 Florence)

Son of the painter Matteo, with whom he probably trained, Jacopo was a monk and painted principally religious scenes. He seems to have travelled little, and his first commission was for some frescoes for the Casino Mediceo near San Marco, in which the influences of Giovanni da San Giovanni and Matteo Rosselli are visible. Apart from his two lunette masterpieces in Santa Trinita, and his distinctive drawings, Confortini's works are principally to be found in provincial churches, and often repeat previous compositions.

Christ in the house of Simon

Black chalk. Inscribed in ink lower left: *Gio: S.Giovani* and numbered lower right: *54*. On the *verso*, visible through the backing, is: *No.82* and a large clumsily drawn star
242 × 347 mm

The Governing Body, Christ Church, Oxford

This preliminary study for Confortini's frescoed lunette (fig.39) in the refectory of the monastery of Santa Trinita, Florence, painted for the *camarlingo* Padre D. Lorenzo Brandolini in 1631, was made at a relatively late stage in the process.[1] There are very few differences between the drawing and the fresco. With its low viewpoint the drawing takes account of the high situation of the fresco, and its somewhat implausible elongated figures are transformed in the painting into solid forms. The scene tells the story of how, while Christ was at table with Simon the Pharisee (cf. cat.46), a reformed prostitute came and wept at his feet. Then, drying them with her long hair, she anointed them with oil; Christ told the diners that the woman's actions proved her love and penitence, and that she deserved to be forgiven her sins (Luke 7: 36–50). The woman is traditionally identified with Mary Magdalene, a popular figure at that time given the Counter Reformation emphasis on penitence. In this particular case, as a dining scene it would have been thought suitable or decorous for the wall of a refectory (the other subject painted there by Confortini was the *Wedding at Cana*).

Following the practice of the late sixteenth-century artistic reform in Florence (in turn reflecting Renaissance working methods) Confortini made studies for each of the figures in the painting; many of these survive, and three are re-united here (cats.45 to 47). In fact an entire

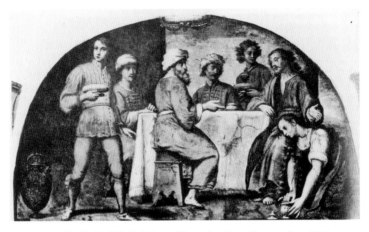

Fig.39 Jacopo Confortini, *Christ in the house of Simon*, 1631, fresco, Florence, Santa Trinita

range of these studies can be reconstructed for this composition (left to right): for the standing boy with a *tazza*, or bowl, Edinburgh, cat.45; the turbanned figure at the left end of the table, West Coburg Z.2996; Simon, British Museum, cat.46; for the seated silhouetted figure, Uffizi, inv.2308 S; standing boy near Christ with *tazza*, Florence, Private Collection, another, London, art market, and another, South German Private Collection; Christ, formerly New York, art market; the Magdalen, British Museum, cat.47, and another Berlin, KdZ16839.[2] Several of the drawings seem to feature the same model. The Christ Church sheet is a perfect example of Confortini's decorative, feathery and rather two-dimensional style of drawing.

Provenance: General John Guise; Christ Church, Oxford, inv.1157 (JBS 291)

Exhibited: U.S.A., 1972/3, no.19; Florence, 1986, no.2.215

Select literature: Parker, 1956, p.569 under no.898*; Thiem & Thiem, 1964, pp.154, n.6, 161, fig.8; Andrews, 1968, p.42; Byam Shaw in U.S.A., 1972/3, pp.23–4, no.19, fig.19; Byam Shaw, 1976, p.101, no.291, pl.177; Monbeig Goguel, 1977, p.109; Thiem, 1977, p.362, under no.141; Thiem & Thiem, 1980, p.82; Contini in Florence, 1986, p.255, no.2.215, fig.2.215

1. Giglioli, 1949, p.192; Thiem & Thiem, 1964 (hereafter TT64), pp.155, 159; Monbeig Goguel, 1977 (hereafter CMG77), pp.107–9; Thiem & Thiem, 1980 (hereafter TT80), pp.82–83.
2. TT64, pp.160–1; TT64, p.155; TT64, p.160; TT80, p.83; CMG77, pp.107–9; TT80, p.83; Thiem, 1977, no.142; TT80, pp.82–4; Thiem, 1977, no.141. Discussed by Contini in Florence, 1986, pp.254–5, under no.2.215, although he lists the Florentine Private collection drawing as a study for the serving boy on the left, and not that behind Christ, which the boy's two-handed carrying pose suits better.

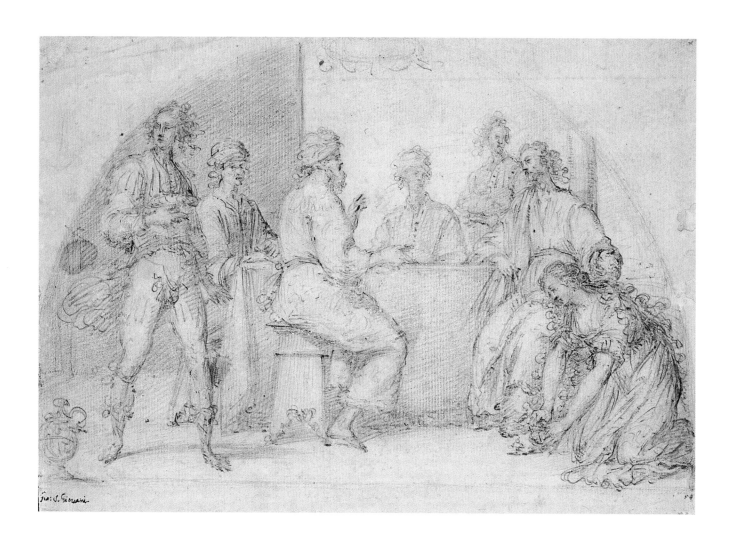

A youth holding a bowl with a carafe and a glass

Black and red chalks. Paper scraped away at lower left and right corners to delete inscriptions
241 × 186 mm

Edinburgh, National Gallery of Scotland

A study for Confortini's fresco in the convent of Santa Trinita, Florence (cf. cat.44), this sheet was formerly attributed to the English artist George Francis Joseph (1764–1846), following an inscription 'Joseph pin' on the old mount. Keith Andrews transferred it to the Italian school drawings, where Philip Pouncey connected it with cat.44.[1]

This delicate, even weak, drawing is a rapid sketch for the figure of the serving boy on the left of the fresco, particularly studying the upper part of his body. As is seen in cat.44, Confortini made a series of studies from the life for each figure; this was made at an early stage, as is shown by a number of changes between the figure, that in the Christ Church drawing, and that in the fresco. In particular in the Edinburgh drawing the boy's *tazza* supports a glass and carafe, which he stabilizes with his left hand. The *tazza* is the subject of a subsidiary study in red chalk alone at the lower right of the sheet, the purpose of which is difficult to assess since it seems almost identical to that in the main study, yet briefer. In the final solution for the figure the artist moved the *tazza* in front of the boy – presumably realizing that otherwise it would obstruct the figure seated at the end of the table – and omitted the glass and carafe, allowing the boy a much more dramatic 'struck' pose with his left arm down.

Already the artist is anticipating the high location of the fresco, since one sees the *tazza* from below.

Provenance: W.F. Watson, by whom bequeathed to the National Gallery of Scotland, 1881, inv.D. 3336

Not previously exhibited

Select literature: Thiem & Thiem, 1964, pp.160–1, 164, fig.12; Andrews, 1968, pp.41–2, fig.310; Thiem, 1977, p.362; Contini in Florence, 1986, pp.254, under no.2.215

1. Andrews, 1968, p.42.

Simon seated on a stool

Black, red, and white chalks
395 × 226 mm

The Trustees of the British Museum

A study for Confortini's fresco in the
convent of Santa Trinita, Florence (cf.
cat.44), this drawing relates to the
figure of Simon the Pharisee, who sits
centrally in the composition, and
gestures towards Christ. The figure
seems complete and carefully drawn
here, and must have been made at a
late stage in the design process; the
only change made in the Christ
Church drawing is the addition of a
prolific beard. The figure is also
bearded in the fresco, yet lacks the
long hair of this drawing; Confortini
has also dropped the raised left hand.
Through such a preparatory process
the artist filtered the attributes of his
live studio model into a reality-based
yet imagined figure for the fresco.

Confortini's use of mixed red and
black chalks in many of his figure
studies for this composition echoes its
widespread use amongst artists in
Florence in the first half of the
seventeenth century, following the
impetus given to its use by Federico
Zuccari.

Provenance: Sir Thomas
Lawrence (L.2445); Sir
Thomas Phillipps, Bart.;
T. Fitzroy Phillipps
Fenwick; presented to the
British Museum by
Count Antoine Seilern,
1946, inv.1946-7-13-1303

Not previously exhibited

Select literature: Popham,
1935, p.119, no.19 (as
Anon. Italian, XVII
century); Thiem &
Thiem, 1964, p.160,
fig.10; Thiem, 1977,
p.362, under no.141;
Contini in Florence,
1986, p.254, under
no.2.215

The Magdalen

Black and white chalks
375 × 270 mm

The Trustees of the British Museum

A study for Confortini's fresco in the convent of Santa Trinita, Florence (cf. cat.44), this sheet, with subsidiary studies of the left hand and arm, relates to the kneeling figure of the Magdalen on the right hand side of the painting. In the drawing, which must be an early study, the Magdalen is shown in a prone kneeling pose, supporting herself with her left hand. At some stage the artist must have realized that the figure could not support herself in such a pose and simultaneously take ointment from the pot; therefore he made a further study, now in Berlin, where he shifted the figure into a more upright pose.[1] This is the pose Confortini used in the fresco, and the Berlin drawing is made from a lower and more close-up viewpoint, as the artist considers her eventual placing.

Confortini's figures often have extremely curly 'flyaway' hair; in this case he accentuated the iconographically important detail of the Magdalen's hair and so drew it especially long, or deliberately chose a model with such hair.

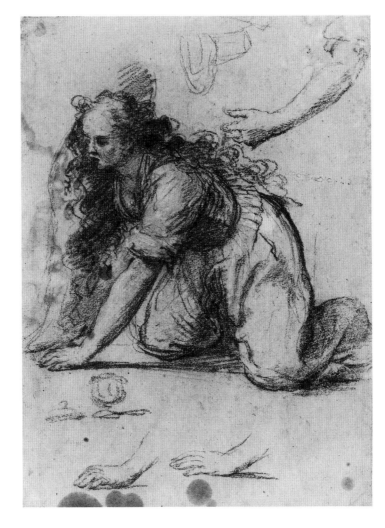

Provenance: Sir Thomas Lawrence (L.2445); Sir Thomas Phillipps, Bart.; T. Fitzroy Phillipps Fenwick; presented to the British Museum by Count Antoine Seilern, 1946, inv.1946-7-13-1301

Not previously exhibited

Select literature: Popham, 1935, p.119, no.17 (as Anon. Italian, XVII century; Thiem & Thiem, 1964, p.160, fig.11; Thiem, 1977, p. 362, under no. 141; Contini in Florence, 1986, p.254, under no.2.215

1. Berlin KdZ 16839; Thiem, 1977, p.362, no.141, pl.141.

48 JACOPO DI CHIMENTI, called JACOPO DA EMPOLI (Florence 1551 – 1640 Florence)

Called 'Empoli' after the Tuscan town from which his family came, Jacopo was apprenticed to the Vasarian Maso da San Friano (1531–1571), while he copied the works of Andrea del Sarto (1486–1530), Fra Bartolommeo (1472–1517), and Pontormo (1494–1556). Never travelling far from Florence, Jacopo made his reputation with a series of large-scale altar-pieces between 1595 and 1610, simply composed with iconic figures and a crystal clear light. A superb draughtsman, he made numerous studies of single figures with a concentration on outline, and finished compositional sheets. A great gourmand, Empoli seems to have eaten his fortune, and Leopoldo de' Medici supported him in his old age by buying his drawings.

An artist painting

Red chalk. Squared in red chalk
390 × 214 mm

The Visitors of the Ashmolean Museum

Appealingly informal in its atmosphere, this drawing is one of a number by Empoli showing young artists at work and play in his studio; in this case an artist sits on a box painting.[1] Jacopo ran an informal academy for young artists in his studio, probably in the 1620s and 30s, and also taught the sons of several noble families. These sheets are likely to date from this time, some of them perhaps made by Empoli for instruction. (cf. p.29).[2] Intriguingly, the Frankfurt sheet (fig.40) showing an artist drawing at a desk, features an identical and distinctive wooden box, with the same lateral section cut away; presumably this was used regularly as a seat in the studio. Most of Empoli's drawings of artists are in pen and ink: cat.48 differs in its use of red chalk and in its careful execution, in comparison, for example, with cat.51. Also unusually for this group, it is squared in a large grid, presumably for transfer to another sheet or to a painting, although no similar composition is currently known (the grid size suggests a relatively small or same-size work).

This sheet was at one time attributed to Annibale Carracci and it is significant how such informal studies were often presumed to be Bolognese; A.E. Popham first saw it as the work of Empoli.

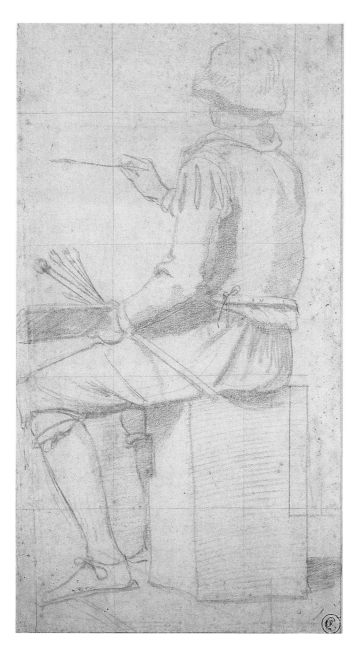

Provenance: Richard Cosway (L.628); Sir Thomas Lawrence (L.2445); Samuel Woodburn; Francis, first Earl of Ellesmere, by whom presented to the Ashmolean Museum, 1853, inv.WA1853.1.46 (P.II 214)

Not previously exhibited

Select literature: Parker, 1956, p.102, no.214; Marabottini, 1988, p.153, fig.LXXII

1. Others of artists at work are Uffizi, inv.961F, and Frankfurt, inv.540; Forlani in Florence, 1962, pp.41–2, no.55, fig.24; Thiem, 1977, p.9, fig.1.
2. Baldinucci, III, p.15.

Fig.40 Jacopo da Empoli, *A young man drawing*. Pen and brown ink over black chalk, brush with brown wash, 301 × 218 mm, Frankfurt, Stadel Institute, inv.540

The Virgin and Child with St Elizabeth and the child St John the Baptist

Pen and brown ink over black chalk, brush with light brown wash. Squared for transfer in red chalk
309 × 199 mm

The Syndics of the Fitzwilliam Museum, Cambridge

This drawing served as the *modello* for a painting whose whereabouts are now unknown (fig.41).[1] The painting corresponds almost exactly with the drawing even to the stones in the foreground, but lacks the branches and foliage of the tree along the top side, perhaps partly as a result of the picture being trimmed. It seems to be a replica made by Empoli and his workshop after his own painting in the Casa Guicciardini of *c.*1595, differing only in the tender placement of Christ's left foot in the left hand of the Virgin, the more prominent lower body of St John the Baptist, the drapery around the Virgin's neck, and the presence of a single wooden cross (instead of two).[2] Three other replicas of the Guicciardini painting are known, each featuring identical figural compositions yet each providing the tree with more foliage.[3] That the artist made so many replicas of the same work shows how popular this

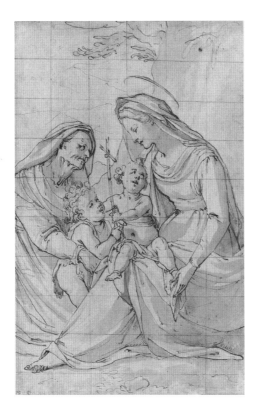

Fig.41 Jacopo da Empoli and Studio, *The Virgin and Child with St Elizabeth and the child St John the Baptist. c.*1605, oil on panel, *c.*115 × 85 cm, location unknown

particular composition was. It follows the strong Florentine tradition of pyramidal compositions for domestic altar-pieces, as in the work of Andrea del Sarto and Raphael; during the late sixteenth century such compositions were being resurrected with great success by Santi di Tito (cf. cat.76), whose work Jacopo must have known.

The technique shows the neatness with which Jacopo made compositional studies at the final stage of the design or for the production of replicas, in contrast with his extremely free handling for earlier ideas (cf. cat.50).[4]

Provenance: P. Sylvester (L.2108, 2877); Jonathan Richardson Junior (L.2997); Lord Palmerston; G.T. Clough, by whom presented to the Fitzwilliam Museum, 1913, inv.3035

Not previously exhibited

Unpublished

1. A photograph in the Kunsthistorisches Institut, Florence, gives the location as Switzerland, art market, 1939. The mount of the photograph records that on the reverse of the painting was an 'expertise' from P. Wescher dated 1 July 1939 attributing the painting to the School of Franciabigio. The photograph was correctly filed under Empoli thanks to Anchise Tempestini.
2. The Guicciardini picture is discussed with previous literature in Marabottini, 1988, p.186, no.22, ill.. The mini-sunburst around the head of the Christ Child in the 'Swiss' painting may be a later addition.
3. Marabottini, 1988, pp.188–89, nos.23, 24, and 25. Interestingly a drawing preparatory to the replica in the Innocenti (Uffizi, inv.9274 F), shares one small point in common with the Fitzwilliam drawing: the fact that the index finger on the Virgin's left hand is visible outside her drapery. In all the paintings except the 'Swiss' one it is put clearly under the drapery.
4. A small red chalk study of the head of a child has been identified by Marabottini as a study in reverse for the head of the Christ Child in the Guicciardini composition: Uffizi, inv.280 F (Marabottini, 1988, p.188, no.22b, fig.22b); Petrioli Tofani believes this to be by Andrea del Sarto (Petrioli Tofani in Florence, 1986 (Sarto), p.270, no.59), but to the present author it seems by Empoli. Another sheet in the Uffizi (inv.3392 F) with two studies of heads of children may also be related. In particular the drawing on lower right looks like a study for the child St John the Baptist; the main study may relate to the painting of the *Family of Adam and Eve'* (Marabottini, 1988, p.182, no.13, fig.13).

The presentation in the Temple

Pen and brown ink over black chalk, brush with brown wash. Squared in red chalk Inscribed lower left in ink: *Lod: Cigoli*
337 × 232 mm

The Visitors of the Ashmolean Museum

Unusually free and dramatic for a compositional study by Empoli, this drawing is for the panel commissioned by Tommaso Zeffi for the Chapel of the Purification in Santo Stefano in the town of Empoli (1604; fig.42).[1] The painting, destroyed during the Second World War, is recorded in an

Fig.42 Jacopo da Empoli, *The Presentation in the Temple*, 1604, oil on panel, 253 × 183 cm, formerly Empoli, Collegiata

Alinari photograph. While the principal figures are similar, the artist has modified the architecture and some of the figure poses: e.g. the kneeling couple on the right, presumably Zeffi and his wife, look to the viewer in the drawing, but in the painting Zeffi looks to the ceremony taking place. An early-stage compositional sketch, this drawing sets out the solidity of the spatial construction clearly with differing intensities of wash, and uses strong effects of light and shade. A precise drawing in the Uffizi (inv.950 F) reproduces the painting in almost every detail and would seem to be a *ricordo*, yet it curiously possesses some exploratory black chalk underdrawing. There are also a number of related studies for figures.[2]

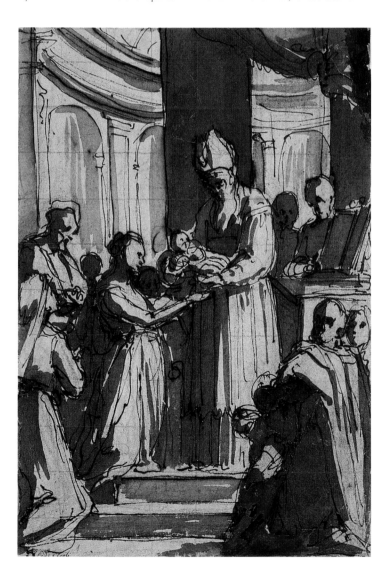

Provenance: H.C. Laurence; purchased by the Ashmolean Museum,1943, inv.WA1943.61 (P.II 213)

Not previously exhibited

Select literature: Parker, 1956, p.102, no.213; Forlani in Florence, 1962, pp.27–8, under no.26; Thiem, 1977, p.273; Marabottini, 1988, p.208, no.47a, fig.47a

1. First linked by K.T. Parker, 1956; the painting discussed Marabottini, 1988, pp.207–8, no.47, fig.47.
2. The painting, which was transferred to the Empoli Collegiata, is discussed by Marabottini, 1988, p.208, no.47b, fig.47b. Studies: For the head of Mary, Uffizi, inv.840 F (Forlani in Florence, 1962, p.28, no.27, fig.13); Mary full-length, Truro, inv.1928.362 (M. Joannides in London, 1994, p.36, no.13, fig.13); for the prophetess Anna, Lille, inv.1265 (Thiem, 1977, p.273, no.16, fig.16).

A young man standing, in contemporary dress (recto); *An alternative study of the same figure* (verso)

Red chalk
411 × 225 mm

The Governing Body, Christ Church, Oxford

This rapid red chalk figure study was clearly made from a posed assistant in Empoli's studio. Although the model wears simple contemporary clothes, a few brief lines skirting the left of the figure indicate that the drawing was preparatory for the figure of the archangel Gabriel in the *Annunciation* in the Strozzi chapel, Santa Trinita, Florence (fig.43; 1609); these lines become the billowing drapery of the flying angel in the painting.[1] The drawing is remarkable for its subtlety and the precision with which the figure is set in space, most obviously apparent in the dramatically convincing foreshortening of the right arm. Some of the most significant lines, around the upper body and along the right leg and foot, have

been strengthened in a more purple-red chalk.

Many such figure studies by Jacopo survive; he must have made a drawing for almost every important figure in each of his paintings. The Christ Church drawing exemplifies a type of 'destination drawing'; a study made from life but with a certain figure in mind. A red chalk study on the *verso* featuring an older figure in a similar pose (though with his right arm at his side) is riddled with spatial inconsistencies, and seems to be a studio copy of a lost Empoli drawing.[2] Jacopo and his studio made three further versions of the much-lauded Strozzi *Annunciation*, which is notable for its iconic figures, simplicity of composition, and clarity of light.[3]

Provenance: General John Guise; Christ Church, Oxford, inv.0562 (JBS 240)

Exhibited: U.S.A., 1972, no.25; Florence, 1980 (Primato), no.210; Florence, 1986, no.2.83; Tokyo, 1994, no.63

Select literature: Bell, 1914, p.37, Q.20 (as Cavedone); Byam Shaw in U.S.A., 1972, p.26, no.25; Byam Shaw, 1976, p.91, no.240, pl.147; Forlani Tempesti in Florence, 1980 (Primato), p.116, no.210; Testaferrata in Florence, 1986, p.137, no.2.83, fig.2.83; Marabottini, 1988, p.219, no.57a, fig.57a; Whitaker in Tokyo, 1994, pp.208–9, no.63, fig.63

Marittima; Marabottini, 1988, pp.219–21, nos.58, 59, 62, figs.58,59,62.

1. The attribution and connection was first made by Pouncey. In much of the literature the painting has been dated to 1603; Marabottini (1988, p.217, no.57) pointed out that the date inscribed on the painting is in fact 1609.
2. Uffizi, inv.3425 F, mentioned by Marabottini (1988, p.219, no.57b, fig.57b) in connection with this *Annunciation*, must, as he suggests, relate to another work, on account of its uncharacteristic differences from this painting.
3. San Domenico, Fiesole; Santa Maria Nuova, Cortona; Sant'Agostino, Massa

Fig.43 Jacopo da Empoli, *The Annunciation*, 1609, oil on panel, 267 × 180 cm, Florence, Santa Trinita

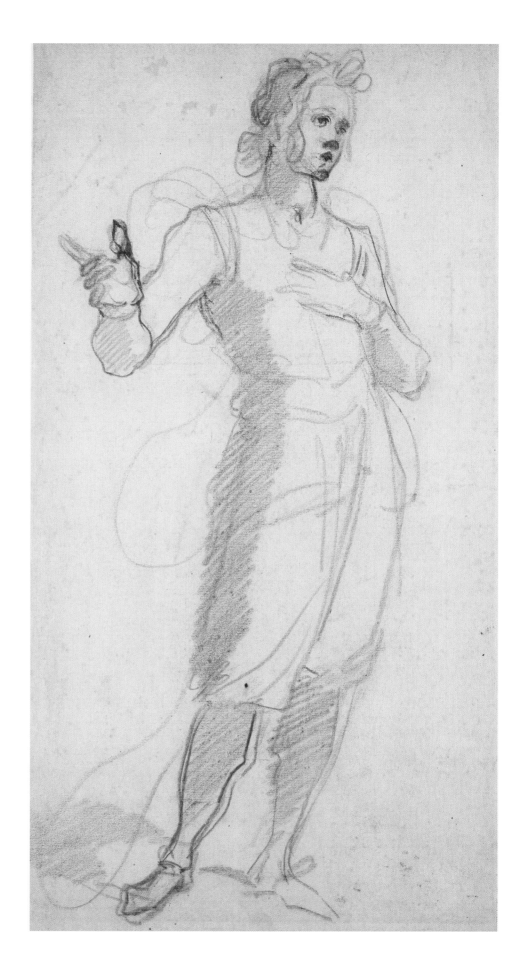

Study of a head of a boy, with his eyes closed, facing down to the left

Black chalk, traces of white heightening, on blue paper
240 × 189 mm

The Royal Collection

Formerly attributed to the Bolognese artist Sisto Badalocchio, the sheet was recognized as Empoli by Philip Pouncey.[1] The soft yet sculptural handling of the profile and the ear is particularly characteristic. The fact that the model's eyes are closed suggests that he has been posed to make a study for a particular figure, and indeed the attitude of the head is similar to that of Adam in Empoli's picture of the *Immaculate Conception* (1629) in the Cappella degli Undici, Sant'Agostino, Prato.[2] However, the somewhat tentative outlines, and the reminiscences of Santi di Tito in the relatively detailed handling of the hair, would suggest a date earlier in the artist's career.

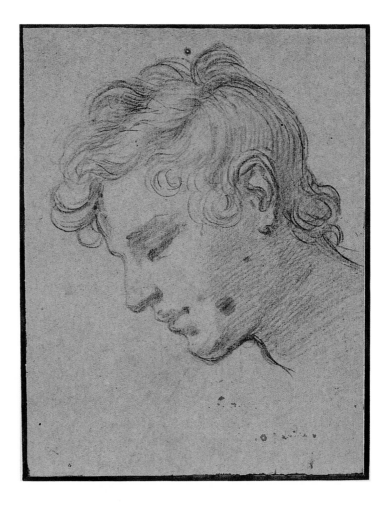

Provenance: King George III; Royal Library, Windsor Castle, inv.RL 5389

Not previously exhibited

Select literature: Kurz, 1955, p.80, no.9 (as Attributed to Sisto Badalocchio); Blunt, 1971, p.82, no.166 (as Empoli)

1. Blunt, 1971, p.82, no.166.
2. Marabottini, 1988, p.268–9, no.118, fig.118.

53 COSIMO GAMBERUCCI (Florence *c.*1560 – 1621 Florence)

A pupil of Santi di Tito, whose influence remained dominant throughout his life, Cosimo was first employed on frescoes at Santa Maria Novella (1582–4). His clear didactic style lent itself well to the large number of religious commissions on which he worked in Florence and its environs. From letters sent to his close friend Michelangelo Buonarroti the Younger we know that he travelled to Rome and Naples in 1606, and he later made a canvas for the *galleria* of the Casa Buonarroti. In 1612 he designed *apparati* for the exequies of Margaret of Austria.

St Peter raising the son of Theophilus

Pen and brown ink over black chalk, brush with brown and grey washes. Inscribed in pen and ink on *verso*: *Bat.ta Paggi* 300 × 212 mm (arched top)

The Trustees of the British Museum

The simple, iconic narrative of this scene, set in a clear foreground space, is typical of the kind of imagery demanded by the Catholic church following the Council of Trent. Extremely close in method of composition and figure type to the work of Santi di Tito, this drawing is by his close follower Cosimo Gamberucci, although it was once attributed to Passignano.[1] The story derives from the Golden Legend, and the main figures in this static composition are easily identifiable. Theophilus, Prefect of Antioch, who had imprisoned St Peter, released him on condition that he restored his son – who had been dead for fourteen years – to life. St Peter achieved the miracle; Theophilus converted to Christianity and made a pulpit for the apostle to preach at Antioch.

The drawing is relatively highly finished, and is presumably a final *modello* or design for an altar-piece, although none of this composition is known or recorded. Two slightly shallower arches at the top have been projected by the artist in black chalk, while an ink rendering of the book at the lower centre has been scratched out and redrawn slightly closer to the kneeling figure. Gamberucci's figure studies, of which there are a number in the Uffizi, have in the past often been attributed to Santi di Tito. They are similar to the work of Cigoli but are less energetic in effect and more dry in handling.

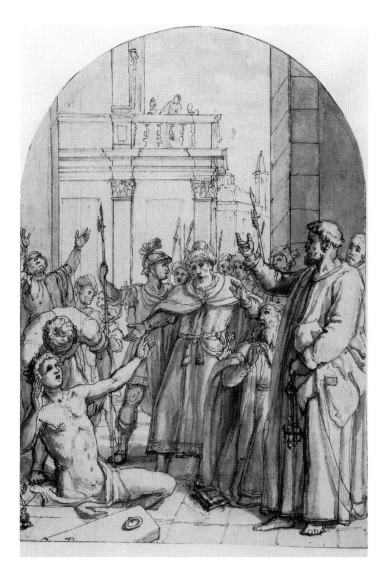

Provenance: The Marquess Conyngham; Sotheby's, London, 21 June 1978, lot 19, ill. (as Passignano); Sotheby's, London, 9 April, 1981, lot 82, ill. (as Passignano); purchased by the British Museum, 1982, inv.1982-7-24-5

Not previously exhibited

Unpublished

1. Gamberucci, relatively little-known as a draughtsman, is studied in Thiem, 1974 and Lecchini Giovannoni, 1982 particularly. Extremely similar drawings to this one are in the Louvre, inv.4416 and Fitzwilliam, inv.3088, preparatory to a *Resurrection of Lazarus*, see Thiem, 1974, pp.389–91, figs.7–9. The drawing was recognized as Gamberucci by Nicholas Turner.

54 JACOPO LIGOZZI (Verona 1547 – 1627 Florence)

One of a Veronese family of craftsmen and painters, Jacopo moved to Florence at the request of Grand Duke Francesco in 1576–7, and worked for the court for the rest of his life. He made designs for the decorative arts in particular and for printmakers, as well as precise watercolours of animals and plants. Grand Duke Ferdinando placed him in charge of organising the Medici art collections. Jacopo's large-scale projects included *apparati* and altar-pieces, although in 1600 he undertook an important cycle of frescoes of the life of St Francis for the Ognissanti under de'Bardi patronage. Jacopo's precise and rich style has affinities with that of Federico Zuccari, no doubt reflecting the influence of Northern prints on both artists.

Dante watching the sunrise in the dark forest

Pen and brown ink, brush with brown wash, white heightening, on brown-tinted paper. Signed and dated in pen and brown ink, lower centre: *iacopo Ligozzi inve[n]tor 1587*
201 × 275 mm

55

Dante surrounded by the three wild beasts, and Virgil appearing to Dante

Pen and brown ink over traces of black chalk, brush with brown wash, white heightening, on brown-tinted paper. Indented with a stylus. Signed and dated lower left: *iacopo Ligozzi inventore 1587*, and inscribed *Dant...* and *Vergilio* on the relevant figures
205 × 278 mm

The Governing Body, Christ Church, Oxford

Breathtakingly precise in their technique, these two sheets treat scenes from Dante's *Divine Comedy*. The first shows Dante lost in a dark wood at the beginning of his poem; his fear subsides as he looks up and sees the 'beams of the planet' (*Inferno* I: 16–18). In the second sheet he begins to ascend a hill, but is driven back by three beasts: a leopard, a lion, and a she-wolf; he is saved by an apparition of Virgil, who offers to be his guide (*Inferno* I: 31–136). Only four sheets of this series by Ligozzi are known, a third in Christ Church and one in the Albertina.[1] In two of them the outlines have been carefully gone over with a stylus, a technique normally used to transfer a design to a copper plate for producing a print, yet in this case none is known. Ligozzi's inscriptions describing himself as *inventor* are also characteristic of print terminology.

Dated 1587, the sheets seem to connect to other drawings of a similar size of subjects from the *Divine Comedy* made in Florence at the same time: twenty-six sheets by Stradanus are in the Biblioteca Laurenziana, also dated 1587, and two drawings by Lodovico Cigoli of the first and last *canti*, are in the Louvre and in the Uffizi.[2] The circumstances of the production of these sheets have been studied by Michael Brunner, who has highlighted their knowledgeable treatments of the text and their context in the intellectual circles around Luigi di Piero Alamanni, patron of Stradanus, and senior figure at the Accademia degli Alterati, where much discussion of Dante took place, and lessons were given on his poetry.[3] Federico Zuccari also produced a series of eighty-eight sheets of subjects from the *Divine Comedy* in 1587 while he was in Spain; these may have been intended to be engraved and seem to have been retained by him.[4]

The precision with which Ligozzi conveys the details, including the plants and animals, in his drawings is characteristic of his background as a minaturist and naturalist. He has used white heightening of varying intensity, thickly built up for brightness, and thinned and blurred for the less intense patches, such as the more distant rays of sun. It is a curiosity of the set of drawings that Ligozzi made a border in dark brown wash on the left and top edges, while leaving a light border, sometimes emphasized in white, on the right and lower edges, as if to make a fictive window; this is particularly noticeable in cat.55.

Four interesting paintings of Dante subjects in a British private collection, one of which reproduces the composition of the third Christ Church drawing (JBS 217), may reproduce lost drawings by Ligozzi from the series.[5]

1. Repr.Bacci in Florence, 1986, pp.74–77, nos.2.14, 2.15.
2. Baroni Vannucci, 1997, p.398; Louvre, inv.894, Viatte, 1988, pp.91–3, no.150, fig.150; Uffizi, inv.8951 F, Chappell in Florence, 1992, pp.7–9, no.4, fig.4a.
3. Brunner, 1997, pp.159–70.
4. Torre de' Passeri, 1993; Brunner, 1997, p.160.
5. Brunner, 1997, pp.163–5, fig.6; Gregori, 1998, pp.16–7, figs.16–19, as attributed to Ligozzi and his studio.

Provenance: General John Guise; Christ Church, Oxford, invs.0233, 0234 (JBS 215 and JBS 216)

Exhibited: Amsterdam, 1955, no.211; London, 1960, nos.42, 43; Liverpool, 1964, no.26; Venice, 1971, nos.103, 104; U.S.A., 1972-3, nos.37, 38; Florence, 1980 (Primato), nos.277, 278; Florence, 1986, nos.2.12, 2.13; Tokyo, 1994, nos.58, 59

Select literature: Bell, 1914, p.62, G.13, G.14; Voss, 1920, II, p.422; Amsterdam, 1955, no.211; Degenhart, 1955, p.101; Jeudwine, 1959, p.115, fig.iii; Schmitt in London, 1960, nos.42, 43; Schmitt in Liverpool, 1964, no.26; McGrath, 1967, pp.31-35, pls.18, 19; Mullaly in Venice, 1971, pp.81-2, nos.103, 104; Byam Shaw in U.S.A., 1972-3, pp.32-3, nos.37, 38; Byam Shaw, 1976, p.86, nos.215, 216, pls.140, 141; Petrioli Tofani in Florence, 1980 (Primato), p.135, nos.277, 278; Gregori, 1983, pp.112-3; Bacci in Florence, 1986, p.74, nos.2.12, 2.13, figs.2.12, 2.13; Brunner in Torre de'Passeri, 1994, p.123; Whitaker in Tokyo, 1994, pp.198-201, nos.58, 59, figs.58, 59; Brunner, 1997, pp.164-66, fig.6; Gregori, 1998, p.13, fig.6

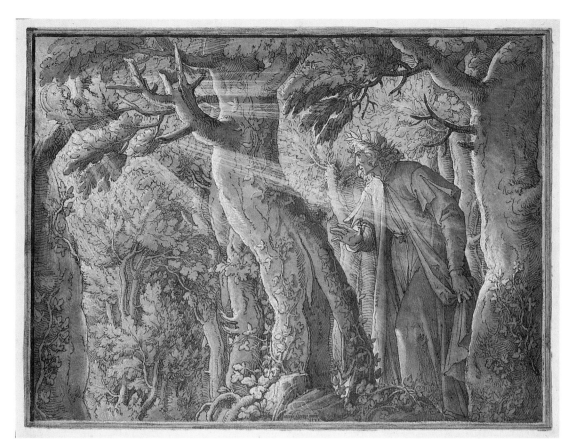

54

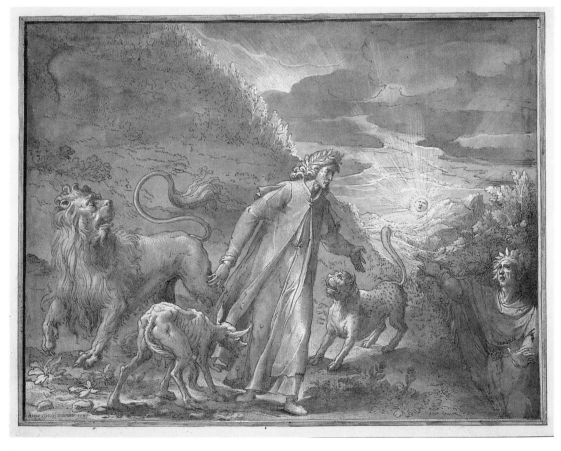

55

Allegorical representation of Tuscany receiving the crown, and handing the sceptre to Florence

Pen and brown ink over traces of black chalk, brush with brown wash, white heightening, on a light brown prepared ground; squared in black chalk
280 × 366 mm

Inscribed on the *verso*, in ink in the artist's hand: *di mi jacopo ligozza pittor*

The Trustees of the British Museum

Ligozzi made this neat compositional study for his painting on the seventh, and final, entry arch on Christine's triumphal route into Florence, situated on the facade of the Palazzo Vecchio (cf. p.30).[1] The high positioning of the picture above the arch is reflected in Ligozzi's choice of a low viewpoint for the scene, and the tiny squaring shows how meticulous the transfer process to the canvas must have been. This miniaturization of the scene is characteristic; he signed one of his large canvases for the Palazzo Vecchio (1591) not *pittore* or *pictor*, but *miniator*. Ligozzi's precise and highly-finished style is in contrast to that of, for example, Lodovico Cigoli in a similar-stage drawing, cat.34.

The allegory shows the seated female figure of Tuscany being crowned by Grand Duke Cosimo. She passes the sceptre of government to a woman on the left representing Florence, while on the right stands a woman representing Siena, with the she-wolf and Romulus and Remus at her feet. A river-god in the left foreground is the Arno, and that in the right foreground is the Tyrrhenian Sea with a winged serpent. As Turner and Saslow have pointed out, the seated figure of Tuscany bears more than a passing resemblance to Christine herself, who was also similarly attired on that day, and this was no doubt intentional: Christine had, after all, just been crowned Grand Duchess of Tuscany (cf. cat.34). Ligozzi's painting, now destroyed, is reproduced in three contemporary prints: two show it *in situ* on the arch, and a third is a commemorative engraving by Cherubino Alberti.[2] The present drawing and other prints show how Ligozzi's painting has been reproduced in a more vertical and much-simplified format in the etching in Gualterotti's book, presumably to fit the page better (fig.44).

Fig.44 Andrea Boscoli after Jacopo Ligozzi, *Allegorical representation of Tuscany receiving the Crown, and handing the Sceptre to Florence*. Etching, 225 × 165 mm, Warburg Institute

Provenance: Hugh Howard (cf. L.2957), d.1738; Charles Howard, 5th Earl of Wicklow; purchased by the British Museum, 1874, inv.1874-8-8-35

Exhibited: London, 1986, no.173

Select literature: Langedijk, 1981, I, pp.508–10, fig.27.192a; Turner in London, 1986, p.224, no.173, fig.173; Conigliello in Poppi, 1992, p.28, fig.no. 14; Saslow, 1996, p.196, under no.7

1. Saslow, 1996, pp.196–7, no. 7; Turner, 1986, p.224.
2. Gualterotti, p.170; Scarabelli, British Museum, inv.1897-1-13-38; Alberti, B.XVII, 108, 157.

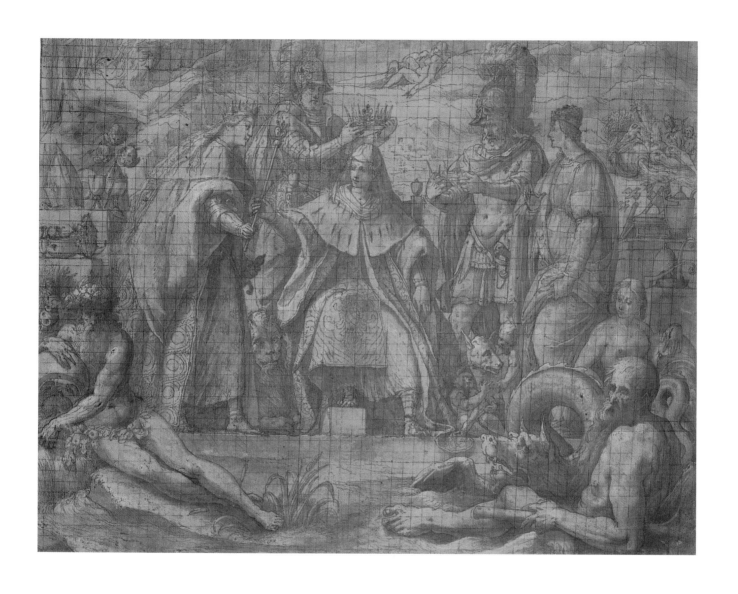

A victorious commander on horseback

Pen and brown-black ink, brush with brown wash, gold heightening, on light brown paper; traces of squaring in black chalk
331 × 222 mm

The Visitors of the Ashmolean Museum

Ligozzi's spectacular use of gold heightening is particularly well demonstrated in this sheet. Made from gold ground down to a fine powder and mixed with a binding agent, the heightening is here combined with a paper prepared with brown wash to give a rich and decorative effect.

Although it seems odd that an artist should use such a special effect on a simple preparatory drawing, Ligozzi often seems to have used gold on his studies.[1] It may be that the artist sold the drawings afterwards, or that he had a respect for the drawing as a finished work in its own right, following his experience in producing hundreds of studies of plants and animals earlier in his career. The

Fig.45 Jacopo Ligozzi, *The return of the fleet from the Battle of Lepanto*, c.1605, oil on canvas, 254 × 355 cm, Pisa, S. Stefano dei Cavalieri

sheet seems to relate to a painting Ligozzi made for the church of Santo Stefano dei Cavalieri in Pisa (fig.45; part of the same cycle as cat.37), which represents the return of the fleet from the Battle of Lepanto (7 Oct 1571), when the Catholic League commanded by Don Giovanni d'Austria, defeated the Turkish fleet. Although the composition of the drawing is somewhat different from the ceiling panel, all of the elements are extremely similar: a victorious commander with outstretched arm and baton, men carrying the spoils of war, and a boat in the background with prisoners. The wingless yet flying *putto* at the top is the only part of the drawing not heightened with gold, and the only element not present in the painting. Remains of small-scale squaring, visible on the empty left-hand side of the sheet, show us that at one stage this drawing was covered in a meticulous grid similar to that used by Ligozzi in cat.56. Such squaring, normally used on final *modelli*, seems strange in this case given the differences in the compositions.

Provenance: Uvedale Price; his sale, Sotheby's, London, 3–4 May 1854, lot 110; Christie-Miller; purchased by the Ashmolean Museum, 1950, inv.WA1950.68 (P.II 282)

Not previously exhibited

Select literature: Bacci, 1954, pp.51–3; Parker, 1956, p.128, no.282, pl.LXIV; Paliaga in Pisa, 1980, pp.345–7, under B.I.10, fig.p.346; Contini, 1992, p.214, n.25

1. For example, the series of drawings in Christ Church for his frescoes in the Ognissanti; Byam Shaw, 1976, pp.87–8, nos.218–21.

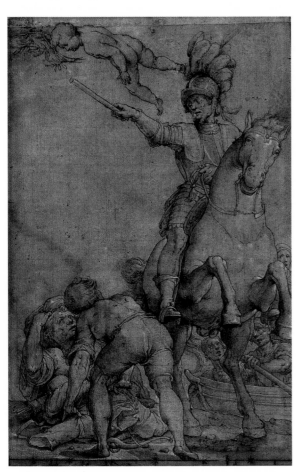

58 GIOVANNI MANNOZZI, called GIOVANNI DA SAN GIOVANNI
(San Giovanni Valdarno 1592 – 1636 Florence)

After training as a notary and refusing a church career, Giovanni studied in the workshop of Matteo Rosselli. His short yet productive career included a range of religious and domestic frescoes, notably a principal role in the facade decoration of the Palazzo dell'Antella in Piazza Santa Croce (1619–20). From 1621–7 he worked in Rome in the circle of the Barberini, which reinforced his affinities with a decorative Roman style. His clear compositions, planned in numerous decorative drawings, display a playful and original approach to their subject matter.

Studies of a seated female figure

Red and black chalks
214 × 342 mm (lunette shape)

The Trustees of the British Museum

Provenance: J.Deffett Francis, Esq., by whom presented to the British Museum, 1874, inv.1874-1-10-424

Not previously exhibited

Unpublished

1. Inv.1132 F; Della Monica in San Giovanni Valdarno, 1994, pp.78–9, n.n..

These two studies show Mannozzi successfully confronting the notoriously difficult problem of the lost profile, where a face is shown looking away from the viewer. The artist has attempted two slightly different angles for the head, in each case starting the profile with a single curved line, and then working with different pressures of chalk in successive lines to give an impression of the features in relief and distance. Seated, and resting her left arm on a block, the figure is also shown with her right hand both palm-up and palm-down, perhaps in the latter case holding something. The bare shoulder of the figure and classical-style drapery suggest that she might have been intended to be an allegorical or mythological figure, presumably in a decorative panel or occupying the right hand side of a picture as an onlooker. No related painting is yet known.

Another drawing showing the artist dealing with a similar problem in a similar way is in the Uffizi; such aspects as the exaggerated eyelashes of the figure lend a sweetness and decorative quality to both drawings.[1]

Studies for a Flight into Egypt

Black and red chalks, white heightening. Inscribed in pen and ink lower right: *Barocci* and stamped *BAR…*
270 × 212 mm

The Courtauld Institute Galleries, London (Witt Collection)

In this fresh and lively study the artist investigates the poses of Joseph, the Virgin Mary and the Christ Child on the Flight into Egypt in a dramatic foreshortening. The figure of the animated Christ Child is studied several times, and the Virgin is seen in two positions, in the principal study exchanging glances with her husband. *Pentimenti* reveal the artist's experiments with the type of hat worn by Joseph and the type of stick he carries: he is shown with a short stick over his right shoulder, a long pole held at an angle in both hands, and a short stick carrying his weight from the palm of his left hand. Similar experiments result in a donkey with four ears.

Although the drawing cannot be related to a known painting, it seems likely to have been made at the same time as a study of the same subject in the Fondazione Horne, Florence (inv.3343). Della Monica relates this to the small-scale figures on the *Flight* in a landscape lunette in Vico Val d'Elsa (1621), yet the Horne drawing seems instead a self-contained compositional study, enclosed by a tree at the left and with *putti* circulating above.[1] In the Horne drawing Joseph is placed awkwardly since he leads the donkey away from the viewer but the artist is forced to turn his body to show his face, and it may be that the Courtauld sheet attempts another resolution of the problem. The old attribution to Federico Barocci (*c*.1535–1612) is understandable given the liveliness of the drawing and the particular sweetness of facial expression.

Giovanni painted a tender treatment of the *Rest on the Flight into Egypt* in the convent of the Crocetta in Florence during the same period, with Joseph helping the Virgin and Child down from the donkey.[2] The account provided of the artist by Baldinucci reflects an intensely studious individual with not much care for the material world, and who dressed casually as if 'his clothes could have been thrown on him from a window'.[3]

Provenance: A.G.B. Russell (L.2770a); his sale, Sotheby's, London, 22 May 1928, lot 84; Sir Robert and Lady Witt, by whom bequeathed to the Courtauld Institute of Art, 1952, inv.Witt 2374

Not previously exhibited

Unpublished

1. Della Monica in San Giovanni Valdarno, 1994, pp.44–5, fig.n.n.; Mannini in Florence, 1986, p.245, no.2.205, fig.2.205 (as inv.5874); fresco repr. Banti, 1977, p.55, no.15, fig.29.
2. Banti, 1977, p.56, no.16, fig.30.
3. 'i panni gli fosero stati gettati addosso dalle finestre', Baldinucci, IV, pp.198–9.

The Wise and Foolish Virgins

Pen and brown ink over traces of black chalk, brush with brown and blue washes. Numbered in red chalk lower right: *88*, and inscribed on the *verso* in ink by Gabburri: *Originale indubitato di mano di Gio: da S. Giovanni bellissimo*
174 × 249 mm

The Visitors of the Ashmolean Museum

This is a highly finished compositional drawing of the parable of the Wise and Foolish Virgins (Matthew 25: 1–13), in which only five of the ten maids of honour in a wedding party had brought enough oil for their processional lanterns. The five without enough oil are shown on the right, one of whom stands with her smoking lamp, another tries in vain to light a lamp on the ground, while another attempts to cajole a colleague into transferring some oil. In the centre stands the bridegroom; in fact the artist has telescoped the narrative action, since in the biblical account the five foolish virgins leave to buy more oil, miss the arrival of the groom, and find the door to the wedding party – presumably represented here by the central classical portico – closed.

Gabburri's definitive attribution on the *verso* of this sheet is now not so secure. The drawing has been linked in the past to Uffizi, inv.1101 F, a design for a fresco in the Sala degli Argenti in Palazzo Pitti (started by Giovanni da San Giovanni and finished by Francesco Furini), and that sheet is now widely regarded as by Furini.[1] Yet it is difficult to see specific stylistic links between these two sheets beyond those of a master and a pupil. The inventive treatment of the subject matter, the clarity of composition, and the extremely high quality of the Ashmolean drawing are difficult to reconcile with the work of Furini.

The neat composition of the drawing and relatively high finish with the use of blue wash is unusual in the oeuvres of both Giovanni da San Giovanni and Furini. It is perhaps this which inspired Francesco Zuccarelli (1702–1788) to publish an etching of it in 1728, with an inscription which stated Gabburri's attribution to Giovanni da San Giovanni.

Provenance: F.M.N. Gabburri; Charles Rogers (L.624); his sale, T. Philipe, London, 15 April 1799, lot 601; ?Holland-Hibbert; purchased by the Ashmolean Museum, 1935, inv.WA1935.149 (P.II 898)

Not previously exhibited

Select literature: Parker, 1956, p.458, no.898, pl.cxcv (as Giovanni da San Giovanni); Roli, 1969, p.66, pl.84 (as Giovanni da San Giovanni); Cantelli in Florence, 1972, pp.32–3, under no.21 (as Furini); Macandrew, 1980, pp.301–2, no.898 (as Giovanni da San Giovanni)

1. See Cantelli in Florence, 1972, pp.32–3, no.21, fig.19; Macandrew, 1980, pp.301–2, no.898, who following Roli retains the attribution of the sheet to Giovanni; Cantelli in Florence, 1986, p.249, under no.2.209. Annamaria Petrioli Tofani, in conversation 21 February 2003, attributes cat.60 to Furini.

61 Francesco Montelatici, called Cecco Bravo (Florence 1601– 1661 Innsbruck)

Cecco learnt the rudiments of drawing in the studio of Biliverti and then worked closely alongside Sigismondo Coccapani on large-scale fresco projects, such as Poggio Imperiale, co-ordinated by Matteo Rosselli. In 1633 he finished a series of lunettes started by Poccetti in the SS. Annunziata, Pistoia, and later that decade worked with Furini to complete the frescoes at the Palazzo Pitti left unfinished after the death of Giovanni da San Giovanni. Further Tuscan projects, and particularly canvases of secular subjects, show Cecco's summary and dramatic brushwork, and vivid imagination. In 1660 he moved to Innsbruck to work for the Archduke Ferdinand Charles of Austria (1628–62).

Study of a standing male nude

Red and black chalks. Numbered upper left in ink: *158*
420 × 260 mm

The Visitors of the Ashmolean Museum

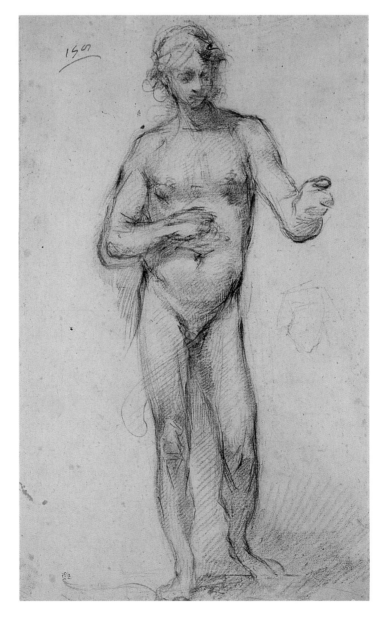

Of the drawings by Cecco Bravo that have come down to us, the vast majority are 'apparent academy' studies such as this.[1] Although such studies seem at first sight to be solely exercises in studying the model, they often contain props (a sword, arrows, a halo etc.) which would suggest instead that they were drawn as direct studies for a particular figure in a painted composition; the present sheet is a case in point, with a bow just visible beneath the model's right foot. Yet in fact very few of these sheets can be linked with painted works, and so their purpose seems ambiguous. This has led Masetti, in her groundbreaking 1962 monograph on the artist, after noting seven preparatory studies for paintings, to list a further 278 sheets as 'preparatory for lost works', a position gently ridiculed by Roberto Contini.[2] The Oxford sheet falls into this extensive category, seeming to be neither an academy nor a preparatory study.

The drawing shows very well Cecco Bravo's chippy style, where the form is created through numerous mainly-straight lines, resulting in a softening of the outline, and creating a *sfumato* effect. Such a technique is reminiscent of figure studies by artists such as Battista Naldini, and his follower Giovanni Balducci. The numbering on the current sheet is found on many by the artist, including cat.62, and presumably records a contemporary listing.[3]

Provenance: A.P. Oppé; purchased by the Ashmolean Museum, 1953, inv.WA1953.66 (P.II 916)

Exhibited: London, 1925, p.52, no.19, pl.XXIV

Select literature: Parker, 1956, p.465, no.916; Masetti, 1962, no.219, pl.104; MacAndrew, 1980, p.304, no.916

1. Cecco's drawings are concentrated principally amongst four institutions: Uffizi 226 sheets; Florence, Biblioteca Marucelliana forty sheets; Louvre twenty sheets; Edinburgh nineteen sheets. (Contini in Florence, 1999, p.37).
2. Contini in Florence, 1999, p.40.
3. As MacAndrew, 1980 points out, Uffizi, inv.10692 F of a male walking to the left, numbered *159*, must have followed this one in the sequence.

Study of a kneeling male nude with raised head and arms

Red chalk. Numbered upper left in ink: *39*
399 × 255 mm

Edinburgh, National Gallery of Scotland

This drawing is part of a series of striking 'apparent academies' held at the National Gallery of Scotland (cf. cat.61). In this case, however, a figure in a similarly distinctive pose – particularly the lower body – appears as Winter in the *Allegory of Spring triumphant over Winter*, Rome, Palazzo di Montecitorio (on deposit from the Uffizi), *c.*1658–60.[1] The connection might suggest that this is one of the rare sheets that can be linked with a painted work. The situation is confused, however, by a further drawing, also in Edinburgh, of a similarly-kneeling figure with wings and with a sword in his right hand, attributes which clearly do not fit with the vanquished figure of Winter.[2] Instead they suggest that the study might be linked to the large, lost, fresco of the *Fall of the rebel angels*, which Cecco painted in SS. Michele e Gaetano, Florence.[3]

In common with many other Cecco drawings, the sheet suffers visually from the fact that some of the lead white, used for the highlights on the figure, has oxidized to black. Although like cat.61 this sheet bears a number, it is difficult to locate in the sequence of Uffizi drawings, since they appear to have been numbered several times.[4]

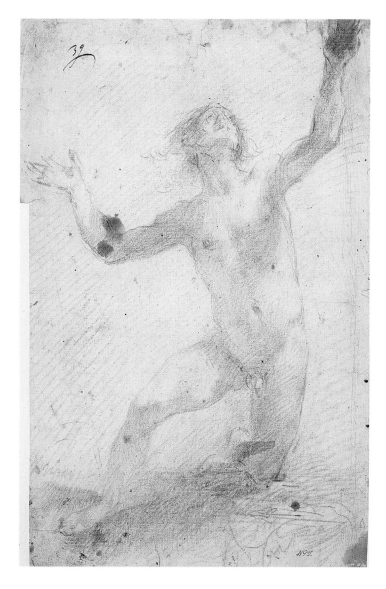

Provenance: (Allan Ramsay?); Lady Murray, by whom presented, 1860, inv.D. 1967

Not previously exhibited

Select literature: Andrews, 1968, p.76, fig.538

1. Matteoli, 1990, p.111, Barsanti/Contini, 2001, p.34
2. inv.D 1970; Andrews, 1968, p.76, fig.537.
3. Andrews, 1968, p.76, suggests that D. 1970 and D. 1967 might link with the fresco. The fresco is discussed in Masetti, 1962, pp.116–7, and Chini, 1984, pp.251, 295–6. Drawings relating to it have been most recently discussed in Fischer, 2001, pp.165–6, under no. 102.
4. Uffizi, inv.10597 F is numbered *39* as well as the current sheet, and *40* appears on two sheets: Uffizi, inv.10685 F of a standing figure with left foot on a block , and Uffizi, inv.10598 F of a falling winged figure.

A Dream

Black and red chalks. Inscribed in ink along lower edge of old backing, in Gabburri's hand: *Sogno di Francesco Montelatici Pittor Fiorentino per il suo spirito e per la sua bravura nel disegnare, chiamato dei tutti communamente Cecco Bravo*
311 × 460 mm

The Visitors of the Ashmolean Museum

This is one of a group of extraordinary drawings traditionally said to represent dreams had by the artist. The Florentine collector Niccolò Gabburri (1676–1742) noted thirty Cecco Bravo drawings from the Baldinucci collection 'in which were expressed various dreams', and the drawings were referred to as such in subsequent British sales (cf. p.18).[1] As MacAndrew postulated, the present sheet probably came from the fifth album of Gabburri's collection, which was sold in London in the late eighteenth century.[2] Twelve *Dreams* are now known, scattered in various collections.[3]

The present drawing represents a man, perhaps the artist, sitting up in bed, praying, while close by are ranged a chest, a large ewer and basin, and a chair. The soft red chalk at the top right of the sheet presumably represents a heavenly light entering the room. Some of the other *Dreams* contain scenes of desolation, lands populated by angels, and strange ceremonies. What purpose this series of drawings might have served is impossible to guess, and such mystical subjects are rare in art of the period. It has been suggested that the drawings might have been made as illustrations for a literary or religious text, and Catherine Monbeig Goguel has pointed out the religious symbolism apparent in many of them.[4] Yet near-contemporary accounts record that Cecco Bravo was of a melancholic temperament, often confusing his dreams with reality.[5] Further, there are very few religious works in his oeuvre, and he suffered accusations of heresy. While it is tempting to believe that these sheets simply represent dreams had by the artist, their quantity, substantial sizes and finish suggest that they more likely relate to a large-scale, almost public, exposition of a theme. It is even possible to see some threads of a narrative amongst the sheets: many feature a human, perhaps the artist, being shown events and sights by an angel; the angel gives him a large *tazza* of special liquid, which the attack of a vicious dog causes him to spill.[6] The *Dreams* seem to date from late in the artist's career, and are in several different formats and sizes. A sheet in the British Museum (fig.46) shows a scene with many aspects in common to the Ashmolean drawing; a man lies on a bed of similar design, with the same accoutrements around the room. A dog walks across the room, and in the background a figure appears in the sky.

Gabburri's inscription at the base of the sheet is almost identical to that on a number of other sheets (e.g. Edinburgh, RSA 189, Chicago, and the Willumsens sheet GS. 731), and tells why Cecco, a common abbreviation for Francesco, was called Bravo ('because he was a spirited character and a good draughtsman').

Provenance: F.M.N. Gabburri; Unknown paraphe (L.II 2661a); Nathaniel Hone (L.2793); ?Uvedale Price; Sotheby's, London, 3/4 May 1854, lots 143–4; Aylesford (L.58); Low (L.2222); Reitlinger (L.II 2274a); purchased by the Ashmolean Museum, 1954, inv.WA1954.49 (P.II 917)

Not previously exhibited

Select literature: Parker, 1956, p.466, no.917; Masetti, 1962, p.109, no.17; Thiem, 1977, p.394, no. 196, ill.; MacAndrew, 1980, p.304, no.917; Contini in Florence, 2001, p.42, ill.

1. Gabburri MS Vite de Pittori (*c*.1739): 'si ritrovavano già circa 30 disegni istoriati, a lapis rosso e nero, nei quali erano espressi vari sogni del medesimo Cecco Bravo, cosa, a dir vero, molto singolare, che fa vedere non tanto la stravaganza di quell'umore bizzarro, quanto eziandio il brio e l'intelligenza du quel grand'uomo. Presentamente gli stessi disegni, insieme con un gran libro di sopra altri 400, tutti dello stesso autore si trovano appresso di quegli che queste cose scrive.'
2. Knapton sale, 27 May 1807, lots 240–8; Sandby sale, 18 March 1812; Parker, 1956, p.466; MacAndrew, 1980, p.304.
3. Ashmolean, inv.WA1954.49; Edinburgh, inv.RSA 189; Chicago, inv.22.5468; Frederikssund, J.F. Willumsens Museum, invs.GS 730, 731, 732, 733; New York, Pierpont Morgan invs. IV, 178, 1958.17; Louvre, inv.1348; Copenhagen, Statens Museum fur Kunst, inv.2000–2; British Museum, inv.1979-10-6-85.
4. Fischer, 1984, p.80; Goguel in Paris, 1981, p.138, under no.83.
5. Cinelli, quoted by Barsanti in Florence, 1986, p.312, under 2.277-2.280.
6. Willumsens, inv.GS 732; Pierpont Morgan Library, inv.1958.17.

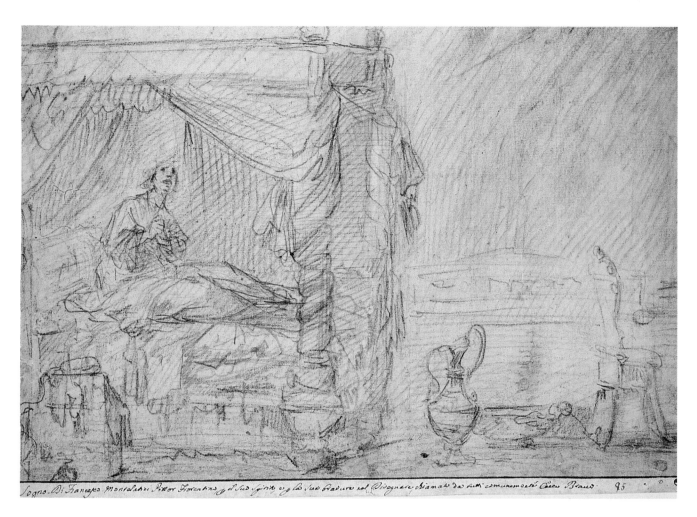

Sogno. Di Francesco Montelatici Pittor Fiorentino, g. il Suo Spirito e g. la Sua Gradura nel Disegnare chiamato da futi comunemente Cecco Bravo. 95

Fig.46 Cecco Bravo, *A Dream*. Red and black chalks, 292 × 195 mm, British Museum, inv.1979-10-6-85

64 GREGORIO PAGANI (Florence 1558 – 1605 Florence)

A pupil of Santi di Tito and life-long friend of Cigoli, Pagani worked on the frescoes in the cloister of Santa Maria Novella (1582–4), and thereafter was occupied with a series of altar-pieces in Florence and around Tuscany. In 1591 he travelled around north Italy. Pagani's simplified Counter Reformation-friendly style, and his numerous drawings from life, place him firmly in the tradition of artistic reform initiated by Santi di Tito.

A young couple dancing at a country gathering

Pen and brown ink over black chalk, brush with brown wash, white heightening, on faded blue paper
265 × 415 mm

The Governing Body, Christ Church, Oxford

First identified by Philip Pouncey, the present sheet makes an interesting comparison with cat.75 by Santi, Pagani's master, and cat.30 by Ciampelli, his contemporary in Santi's studio; all three sheets show scenes in the countryside, a rarity for the period. Pagani here displays many of the characteristics of Santi, particularly in his choice of similar media, and in his doll-like figures with unstable heads. The dependence on Santi favours an early date for the sheet, as Thiem and Petrioli Tofani have observed. Yet already Pagani uses the media in a different way: the white heightening is applied in a thick painterly fashion (visible best in the drapery of the figures on the left), as opposed to Santi's precise lines, and an unusual starved brush technique is used by Pagani to apply the wash that constitutes the cottage roof. Santi's branches are chromatic clumps; Ciampelli's are linear arrangements, Pagani's are sponged shade.

The scene represented is a country dance, with musicians at the left, and a young couple dancing in the centre of a gathered company; the effect, however, is of a stage performance arranged for the viewer of the drawing. A sense of movement in the principal figures is given by the poses and turbulent drapery. Cat.64 is close to a drawing of a similar type by Pagani in the Uffizi (inv.861 P), showing a hunting scene.[1] This is also in a wide horizontal format like that of the present drawing and of cat.30. Distinctively, the Christ Church drawing is executed within a thick linear border of brown wash, which may indicate – along with the rich mix of media – that it was made as a finished work of art in itself.

Provenance: Filippo Baldinucci; General John Guise; Christ Church, Oxford, inv.0793 (JBS 250)

Exhibited: Florence, 1980 (Primato), no.335; Florence, 1986, no.2.55

Select literature: Bell, 1914, X.22 (as Italo-Flemish School, 1550–1600); Thiem, 1970, p.83, Z.44, fig.55; Byam Shaw, 1976, p.92, no.250, pl.159; Petrioli Tofani in Florence, 1980 (Primato), p.153, no.335, fig.335; Thiem in Florence, 1986, p.113, no.2.55, fig.2.55; Gregori, 1998, p.27, fig.52

1. Thiem in Florence, 1986, p.113, no.2.56, pl.VI.

The Virgin and Child in a rose garden, with Saints Dominic and Sebastian

Pen and brown ink over black chalk, brush with brown wash, white heightening, on blue paper. Inscribed in brown ink, lower left: *24*
390 × 260 mm

The Board of Trustees of the Victoria and Albert Museum

St Sebastian, clasping his attributes of arrows and a martyrs palm, looks out at the viewer and gestures towards the Virgin, while the Christ Child presents a rosary to St Dominic. The invention of the rosary was attributed to St Dominic, who is said to received it in a vision of the Virgin and called it 'Our Lady's crown of Roses'. The ingenious idea here of setting the scene within a rose garden apparently came from Giovansimone Tornabuoni, the patron of the lost painting for which it is a study.[1] The blank roundels in this preparatory drawing were – according to Baldinucci's account of the painting – intended to be occupied by the three cycles of meditative prayers counted on a rosary. On the left in a palm tree would have been the five Joyful Mysteries, in the central rose bush the five Glorious Mysteries, and on the right in a thorn tree the five Sorrowful mysteries.

In the composition Pagani combines a simple symmetrical arrangement with active figures, characterised as always by his typical almond-shaped heads. His generous use of white heightening gives a sense of high finish to the composition. This sheet relates closely to a drawing in the Uffizi (inv.15160 F), which shows an almost identical composition, yet is only half-finished (the top section is incomplete).[2] The lines on that sheet have been partially incised, presumably for the transfer of the composition to cat.65, which must have been the *modello*, since a slight modification in the spacing of St

Sebastian's arrows and palm is the only change. The transfer process from the Uffizi sheet may be the cause of the weaknesses visible in the setting of St Sebastian's right foot and leg in space in the London drawing, despite its overall high quality. Thiem

dates it to *c.*1595.

A further drawing of a similar subject, in a similar style, is in the Louvre (inv.1386), which can also be connected with a lost painting described by Baldinucci.[3]

Provenance: Unidentified collector's drystamp lower centre; purchased by the Victoria and Albert Museum, 1883, inv.8942

Exhibited: Florence, 1980 (Primato), no.336; Cambridge, 1985, no.38

Select literature: Thiem, 1970, pp.30, 79, no.Z23, pl.36; Ward Jackson, 1979, p.107, no.214, fig.214; Petrioli Tofani in Florence, 1980 (Primato), pp.153–4; no.336; Viatte in Paris, 1981, p.28, under no.8; Scrase & Stock in Cambridge, 1985, no.38, fig.38; Smith in Detroit, 1988, pp.190–93, under no.82

1. Baldinucci, III, p.45. The singularity of the subject enabled Thiem to make the connection in 1970, while Pouncey first attributed it to Pagani.
2. Smith in Detroit, 1988, pp.190–3, no.82, fig.82. First attributed to Pagani, and the link to the V&A sheet pointed out, by Annamaria Petrioli Tofani.
3. Thiem, 1970, pp.78–9, no.Z20, fig.37; Viatte in Paris, 1981, p.28, no.8, fig.8.

Study of a standing nude youth

Red chalk, traces of white heightening. Inscribed in ink lower left: *di Gregorio Pagano*
425 × 284 mm

The Governing Body, Christ Church, Oxford

Although not related to a painting, the distinctive pose of the figure in this drawing would be suitable for that of a soldier holding a halbard on the left of a composition. Studied from the life, the figure is remarkable for the way it is sculpted out of space, the result of the thick plastic outlines and strong lighting. Such a result belies the casual testings of the chalk on the left and right of the sheet. Although Pagani often used copious amounts of white heightening on his life studies to give an effect of polish, in this case he was very restrained. Yet the Christ Church drawing has a polished effect which instead derives from the fact that the chalk on the sheet has been rubbed far beyond the intention of the artist, presumably through the way in which it was stored in early life. In other sheets the artist merely rubs patches of intense hatching a little with his finger to create shadow.[1] As Byam Shaw observed, this over-rubbing coarsens the drawing, and spoils the undoubted quality and subtlety in the sheet, particularly found in the less-rubbed area of the head.[2]

Provenance: Brandini stamp (L.2736), *verso;*[1] Filippo Baldinucci; General John Guise; Christ Church, Oxford, inv.1163 (JBS 251)

Not previously exhibited

Select literature: Thiem, 1970, p.98, no.Z157 (as not by Pagani); Byam Shaw, 1976, p.92–3, no.251 (as 'Gregorio Pagani?')

1. Cf. p.14
2. For example, Louvre, invs.1379, 1380 or Rome, inv.F.C.125394.
3. Byam Shaw, 1976, p.93.

67 DOMENICO CRESTI, called IL PASSIGNANO (Passignano 1559 – 1638 Florence)

Probably a pupil of Girolamo Macchietti, Domenico was particularly influenced by Federico Zuccari, with whom he worked on the cupola of the Duomo and travelled to Rome. In 1581 he was expelled with Zuccari from Rome after an alleged pictorial insult to certain Bolognese cardinals. Federico and Domenico spent the 1580s in Venice, and Domenico returned to Florence for the 1589 wedding preparations. In 1602 he moved to Rome and achieved great success there, including work for St Peter's. He returned to Florence in 1616, where he worked on various significant commissions, including one to be sent to Marie de' Medici in Paris, and was closely involved with the Accademia del Disegno.

The attempted martyrdom of St Catherine

Pen and brown ink over black chalk, brush with pink wash, white heightening (partly oxidized), squared in black chalk. Traces of incising to create arched top. Inscribed in black chalk along lower edge: *Pasignano*
365 × 250 mm (top corners cut)

The Royal Collection

In this compositional study the wheel, on which St Catherine of Alexandria was to have been martyred, is vigorously destroyed by an angel. As A.E. Popham noted, this drawing shows the strong influence, in composition and figure types, of Federico Zuccari, with whom Passignano worked on the frescoes in the cupola of the Duomo (cf. cats.80, 81), and in Rome, and Venice. Although Passignano is recorded as having painted the subject several times, notably for the Badia di Ripoli, Florence, and Santa Maria Formosa, Venice (documented *c.*1585), no painted composition is known.[1] The fact that this drawing is squared suggests that it was seen as complete and ready for transfer. Presumably in response to a revised demand from the patron, the artist has extended the design on both sides: black chalk traces of a narrower arch are apparent at the top, and the design has been continued with joining lines and new areas of hatching.

A drawing by Passignano in Munich (inv.2325, as Cigoli) shows a similar scene with very similar figure types, although at further distance from the action. Lacking the arched top, it may have been made at an earlier stage of the process before the shape had been decided, or else it relates to a different project. The composition of the Windsor drawing influenced Alessandro Tiarini (who worked with Passignano in the early 1600s) in his painting of the same subject in the Palazzo Serra di Cassano, Naples.[2]

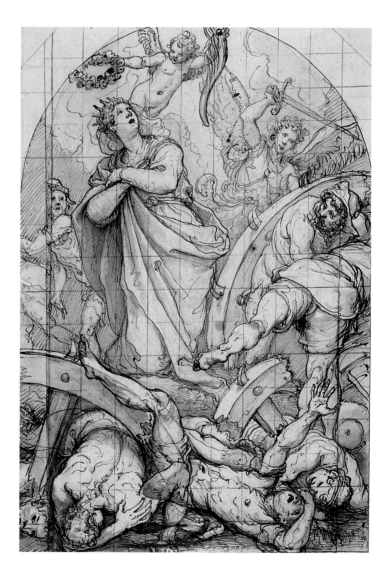

Provenance: King George III; Royal Library, Windsor Castle, inv.RL 5981 (P&W 675)

Not previously exhibited

Select literature: Popham & Wilde, 1949, p.292, no.675, fig.133

1. Baldinucci, III, p.439; Nissman, 1979, pp.43, 217, cat.no. 3.
2. Discussed in Faietti, 1999, pp.127–39.

St Peter healing the lame man at the Porta Speciosa

Pen and brown ink over traces of black chalk, brush with grey-brown wash. Inscribed in pen on *verso*: *No.35*, and calculations in red chalk
212 × 143 mm

The Governing Body, Christ Church, Oxford

Perhaps even more so than cat.67 this drawing shows, in the use of multiple soft discursive lines, the influence of Venetian art on Passignano, which he in turn passed on to many of his Florentine colleagues. The drawing represents the moment when St Peter healed a lame man at the gate of the Temple (Acts 3: 1–8). St Peter, at the right of the drawing, raises his hand in blessing as the lame man reaches out towards him. Behind St Peter stands St John, who accompanied him. Onlookers crowd around, including a figure clinging to the column of the Temple; this is a motif gathered from Federico Zuccari, who used it in various earlier commissions, including the *Submission of Emperor Barbarossa to Pope Alexander III* (Palazzo Ducale, Venice, 1582).[1]

This drawing is an early preparatory sketch for a composition known in two painted versions of *c.*1595, one in the Museo Nazionale Villa Guinigi in Lucca, removed from the destroyed church of San Pietro Maggiore, and one in the Pushkin Museum, Moscow.[2] The composition is drawn in a very rapid and exploratory style, with numerous *pentimenti*. In particular small ovals are used in several cases to act as alternative heads, for example with the small child in the lower left corner. Rapidity causes arms and legs to be conceived as tubular appendages, as can be seen in the scribble which forms the right leg of the lame man. Following the Christ Church drawing, Passignano decided to reverse the figures in the

foreground plane, and three other compositional drawings in the Uffizi, identified by Pouncey, continue to modify the design, slowly placing more emphasis on St Peter.[3] Nissman

has identified a number of figure studies for the composition, and a further sheet formerly on the art market focuses on the principal action.[4]

Provenance: The smaller Ridolfi album, possibly inserted later; General John Guise; Christ Church, Oxford, inv.1868 (JBS 254)

Exhibited: Florence, 1980 (Primato), no.345; Tokyo, 1994, no.66

Select literature: Byam Shaw, 1976, p.93, no.254, pl.181; Nissman, 1979, p.248; Petrioli Tofani in Florence, 1980 (Primato), p.156, no.345; Whitaker in Tokyo, 1994, pp.214–15, no.66, fig.66

1. Repr. Acidini Luchinat, 1999, p.133.
2. inv.455/29, repr. Lucca, 1968, p.195, fig.94, and Nissman, 1979, pp. 246–49, cat.19; the Pushkin picture publ. Markova, *Antichità Viva*, 5, 1994.
3. Uffizi, invs.873 F, 8393 F, 8304 F.
4. Nissman, 1979, pp.246–9; Uffizi invs.9193 F, 9195 F, 9221 F (repr.Thiem, 1977, no.26); Sotheby's, London, 4 July 1977, lot 97, ill..

69 BERNARDINO BARBATELLI, called IL POCCETTI (Florence 1548 – 1612 Florence)

Trained with Michele Tosini (1503–1577), Poccetti worked in his early life on facade decorations, earning the nickname Bernardino delle Grottesche. Learning perspective and architecture from Buontalenti, he specialized particularly in fresco, painting six lunettes in Santa Maria Novella (1582–4), working at the Certosa di Galluzzo, and carrying out numerous private palace commissions, notably Palazzo Capponi (1583–88). Working almost exclusively in Florence and its environs with a vast and productive studio, he increasingly emphasized compositional clarity and narrative lucidity.

Study of a man in profile to the right

Black chalk on green paper, white heightening. Inscribed lower centre in black chalk: *A – Carraci*
188 × 163 mm

The Trustees of the British Museum

Clearly drawn from life, the present sheet depicts a well-dressed youth in a hat holding close an unidentified object in his left hand. Seen from slightly below, the raised right arm combines with the rapid black chalk lines springing from the shoulder of the figure to create a sense of movement in the drawing. Studies such as these show the contact Poccetti had with Florentine artists of the reform, notably Santi di Tito and Jacopo da Empoli. The chalk is handled with great subtlety to create the effect of foreshortening in the youth's right arm and hand. In fact Poccetti made a number of studies to record such effects, including a drawing in Berlin of a youth holding a ewer and a flask, similar in character to the foreshortening exercises of boys drinking from glasses made by the contemporary Carracci family in Bologna.[1] Given this affinity, the former attribution of this drawing to Annibale Carracci (1560–1609) is understandable, as Nicholas Turner has pointed out. It was A.E. Popham who first attributed cat.69 to Poccetti on the basis of similarities with drawings at Rennes and one formerly in the Geiger Collection.[2]

Provenance: Sotheby's, London, 8 July 1853, lot 292 (as Annibale Carracci); purchased by the British Museum, 1853, inv.1853-8-13-26

Exhibited: London, 1986, no.191

Select literature: Turner in London, 1986, p.245, no.191, ill.p.246, no.191

1. Berlin, Kupferstichkabinett
2. Turner in London, 1986, p.245, no.245; the Geiger Collection drawing was sold at Sotheby's, London, 7–10 December 1920, lot 239, ill..

Study for the drapery of a reclining figure

Black chalk, white heightening, on paper washed light brown. Inscribed in ink on the *recto* lower left: *Bernardino Poccetti*, and on the *verso* in a contemporary hand: *Bernardino Poccetti*
355 × 250 mm

The Trustees of the British Museum

The blurred schematic form of this extraordinary drawing shows the great influence of the draughtsmanship of Jacopo Pontormo (1494–1556) and Rosso Fiorentino (1494–1540) on Poccetti in the mid-1580s.[1] The sheet is a study for one of Poccetti's earliest oil paintings, the *Christ carrying the Cross* (1586; fig.47), tellingly formerly attributed to Rosso, which was painted for the Florentine church of Santa Cecilia and is now in the museum in Arezzo.[2] In another sheet in the Uffizi, made before cat.70, Poccetti studied the same figure in red chalk. That drawing seems to have been made to establish the pose, and includes subsidiary studies with reworkings of the upper body and hands. Instead, in the British Museum sheet Poccetti studied the fall of light and shade on the figure and her setting in space, with sharp relief in the outlines and drapery.[3] For this purpose, the brown mid-tone preparation of the paper would have been especially suitable. Two further brief chalk studies for figures in the same painting have been identified by Paul Hamilton, although these are not close to the type of cat.70.[4]

Fig.47 Bernardino Poccetti, *Christ carrying the Cross*, 1586, oil on panel, 310 × 201 cm, Arezzo, Museo Statale d'Arte Medievale e Moderna

Provenance: Sir Thomas Lawrence (L.2445); Samuel Woodburn; his sale, Christie's, London, 4 June 1860, lot 27; Sir Thomas Phillipps, Bart.; T. Fitzroy Phillipps Fenwick; presented to the British Museum by Count Antoine Seilern, 1946, inv.1946-7-13-455

Exhibited: London, 1986, no.188

Select literature: Popham, 1935, p.81, no.2 (as Poccetti); Hamilton in Florence, 1980 (Poccetti), p.35, under no.15; Turner in London, 1986, p.243, no.188, ill. p.244; Pieraccini in Florence, 1986, p.83, under no.2.22

1. Poccetti's friend Andrea Boscoli also reflects such influence at this time, e.g. in Uffizi, inv.788 F of 1587; Forlani in Florence, 1959, pp.126–7, no.33, fig.11.
2. Most recently discussed in Carapelli, 1996, pp.57–8, tav.XV. After the church was deconsecrated the painting was sent to Arezzo in 1786 by Pietro Leopoldo di Lorena as the main altar-piece for the Pieve di Santa Maria, to replace Federico Barocci's *Madonna del Popolo*, which he desired for the Uffizi.
3. Uffizi, inv.1401 E; Pieraccini in Florence, 1986, p.83, no.2.22, fig.2.22.
4. Hamilton in Florence, 1980 (Poccetti), p.35.

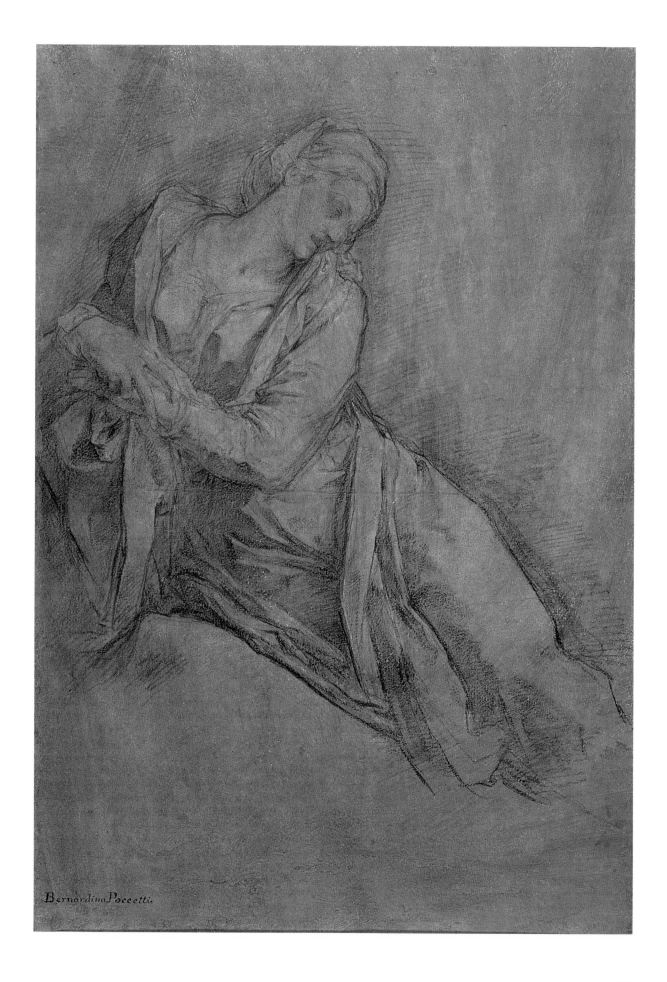

Bernardino Poccetti

The beginning of the Servite Order in the Compagnia dei Laudesi

Pen and brown ink over red chalk, brush with light grey wash, with traces of blue wash. Inscribed in ink below: *F.H.No.484*, and on the *verso*: *Tadeo Zuccaro* and *Scattoregia*
248 × 420 mm (lunette)

The Syndics of the Fitzwilliam Museum, Cambridge

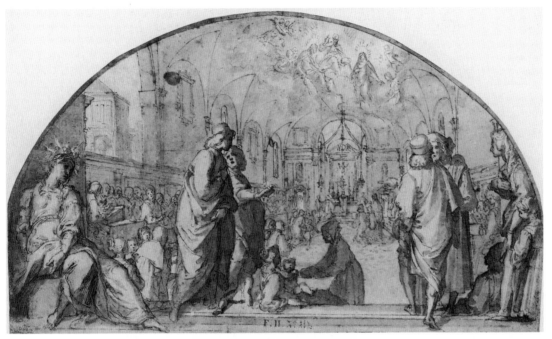

Provenance: Fleury-Hérard (L.1015); Bartholémi Giraud; M. Bouguignon; purchased by the Fitzwilliam Museum, 1980, with Grant-in-Aid from the Victoria and Albert Museum, inv.PD.15-1980

Exhibited: Cambridge, *Italian Old Master Drawings, c.1550–c.1620*, 1989, handlist p.3

Select literature: Becker in Brunswick, 1985, p.91, under no.41

1. Baldinucci, III, pp.139–40.
2. Venturi, IX, 7, p.607, fig.329.
3. Becker in Brunswick, 1985, p.91, no.41, fig.41.
4. Frerichs, 1973, no.105, ill.105; Hamilton in Florence (Poccetti), 1980, pp.79–81, under no.66. Hamilton has, following the pioneering work of Vitzthum, produced a list of Poccetti drawings related to the different lunettes.

Between 1604 and the end of his life Poccetti worked on a series of fourteen lunettes, featuring stories from the early history of the Servite Order, for the Chiostro dei Morti at SS. Annunziata, Florence.[1] This drawing is his preliminary design for the lunette depicting the founding fathers in the Compagnia dei Laudesi, 1233 (fig.48).[2] In contrast to the lunettes he painted for the church of Santa Maria Novella (*c.*1581), which are filled with a multitude of figures, Poccetti here looked back to Florentine precedents (such as works by Ghirlandaio or Andrea del Sarto), placing fewer figures in a more coherent space and giving them historical dress. Nevertheless, he still

Fig.48 Bernardino Poccetti, *The beginning of the Servite Order in the Compagnia dei Laudesi*, *c.*1608, fresco, Florence, Santissima Annunziata

inserted a number of extraneous genre figures, such as the woman and child in the centre. Poccetti made some relatively minor changes between the drawing and the fresco, including the elimination of the silhouetted figure approaching the mother and child,

the modification of several poses, and the lengthening of drapery to cover bare lower legs which would not have been decorous within a cloister decoration.

After making this compositional drawing, Poccetti drew a number of figure studies, including a black and red chalk drawing of the woman and little girl on the right, closer to their poses in the fresco than in cat.71.[3] This and a further – still earlier – drawing of the same group in Amsterdam, are the only other sheets currently related to this particular lunette.[4] A copy of the whole composition is in Berlin (inv.KK 21425), which has been unconvincingly attributed to Ligozzi.

The pleasures of Springtime

Pen and brown ink over black and red chalks, brush with brown wash. Squared in black chalk
274 × 274 mm

The Trustees of the British Museum

In the elegant courtly garden of a palace with a smoking chimney, a gentleman returns on horseback from hunting with a falcon, accompanied by dogs and retainers. A number of fish lie in the left foreground on the path. Adjacent sits a lady, serenaded by a companion while another female figure, a refuge for a child afraid of a barking dog, drops flowers into her lap. On a rooftop behind them is a peacock. In an ornamental garden in the background, a man chases a running woman, and another woos his companion with music. This drawing, showing the pleasures, flirtations, and fecundity of the season, seems to be a design for one of four tapestries of Springtime commissioned from the Medici tapestry works in March 1607, as Hamilton first observed.[1] The sheet was attributed to Poccetti by Philip Pouncey, and is characteristic of the careful and decorative compositions of the later part of his life.

A study in red chalk for the lady seated in a chair is in the Uffizi and, as Hamilton observed, has been re-drawn through the page on the other side of the sheet, creating a reversed image.[2] This would have been useful for the artist in anticipating – and countering – the tapestry production process, which would have produced a mirror-image of the cartoon provided. Hamilton also asserted that the perspective of cat.72 works better when seen in reverse.

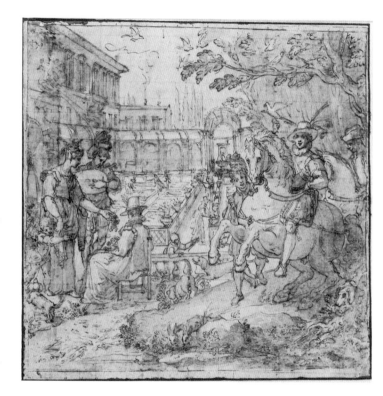

Provenance: Purchased by the British Museum, 1950, inv.1950-11-11-7

Not previously exhibited

Select literature: Hamilton in Florence, 1980 (Poccetti), p.107, under no.104, p.108, under no.106, and (principally) p.109, under no.107

1. Hamilton in Florence, 1980 (Poccetti), p.109, under no.107.
2. idem. Also Pieraccini in Florence, 1986, p.89, no.2.30, fig.2.30.

Placed aged eight in the studio of Gregorio Pagani, Rosselli remained there until Pagani's death (1605), with the exception of six months spent in Rome with Passignano. He completed Pagani's unfinished works, and thereafter was in constant demand. Among his very numerous works, in a sweetened Pagani mould, were four lunettes for SS. Annunziata (1614–18), frescoes for Santa Maria Maddalena de' Pazzi, and a canvas for the *galleria* of the Casa Buonarroti. Rosselli ran an important school frequented by Giovanni da San Giovanni, Francesco Furini, Volterrano, Stefano della Bella, and Filippo Baldinucci.

Design for the decoration of a chapel: two angels supporting a blank rectangular frame in the centre; over the altar two panels: St John the Evangelist and St Helena

Red chalk, brush with red wash. Inscribed in ink in a seventeenth-century hand on a joined piece of paper at the base of the sheet: *Disegno servito nella chiesa dei P.P. Vallombrosani di Matteo Rosselli in Mugello, detto Barberino*
280 × 200 mm

The Governing Body, Christ Church, Oxford

It was a common practice in churches to make a new setting for an older altar-piece as a way of re-invigorating a chapel decoration, and this drawing shows Rosselli planning a project with angels presenting the older work, and inset panels with saints at the sides. The central lower space has been left for the altar, and to the left and right of it a random pattern of chalk lines and wash has been used to produce the effect of two panels of marble, or simulated marble. Rosselli's figures of saints have typically small heads, ghost-like faces, and heavy drapery. Highly finished, the drawing was perhaps a *modello* to show to the patron who had commissioned the work.

The inscription suggests that the drawing was used for an altar in the Vallombrosan church in Barberino di Mugello, but the researches of Francis Russell revealed that no traces of it now remain; the church was completely remodelled in the 1740s.[1]

Provenance: Filippo Baldinucci; General John Guise; Christ Church, Oxford, inv.0929 (JBS 275)

Not previously exhibited

Select literature: Bell, 1914, p.82, no.CC.9; Byam Shaw, 1976, p.98, no.275, pl.172

1. Byam Shaw, 1976, p.98.

Duke Cosimo II reviewing his troops

Black chalk within an oval border. Inscribed in ink on the *verso*: *Dello Stradano nel Palazzo de Pitti*
241 × 333 mm

The Governing Body, Christ Church, Oxford

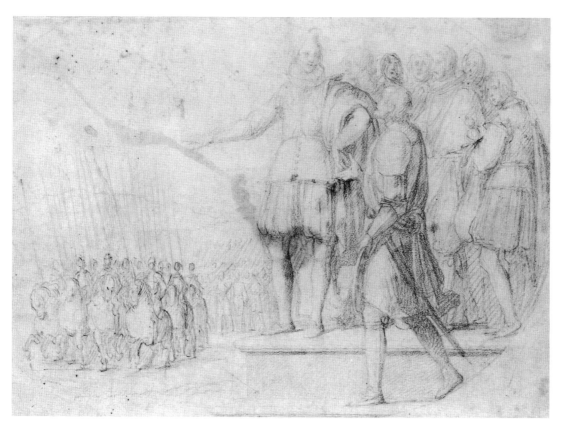

Provenance: Filippo Baldinucci; General John Guise; Christ Church, Oxford, inv.1168 (JBS 274)

Not previously exhibited

Select literature: Byam Shaw, 1976, p.98, no.274, pl.171

1. Byam Shaw, 1976, p.98. The connection was first noted, and attribution given, by Philip Pouncey.

In the 1620s Rosselli worked on frescoes for a series of important Medici commissions, including the Casino di San Marco, the Sala della Stufa in the Palazzo Pitti, and the Villa Poggio Imperiale. This drawing is a design for one of the frescoes of scenes from Medici history in the small room known as the *volticina* or *saletta di Cosimo II* in Poggio Imperiale.[1] Rosselli ran an efficient workshop and often delegated the execution of the frescoes. This sheet is a case in point, where the fresco was executed by Ottavio Vannini, yet the drawing is by Rosselli. The drawing illustrates well his light-pressure, measured style in preparatory sheets of this type. His handling is not strong or dynamic, but neater and more precise than Vannini's often erratic drawings. In the right background we see a range of types of head, from an expressive rendition of the youth on the right, to the brief oval shorthand of others. A sheet in the Uffizi (inv.9790 F) could be a study for the figure of Duke Cosimo II, although the left arm is in slightly different position, and the dress is also not that of a duke but 'studio' drapery arranged in a broadly similar way.

75 SANTI DI TITO TITI (Sansepolcro 1536 – 1603 Florence)

A pupil of Bronzino, Santi was the leader of a new artistic reform in Florence. He emphasized a drawing-based style of simpified compositions with clear pietistic narrative and naturalistic detail. Crucial to this was his experience with Federico Barocci and Federico Zuccari in Rome in the early 1560s. He was afterwards based almost entirely in Florence. Among his works were large-scale altar-pieces such as those for Santa Croce (1568–74) and temporary decorations for the Medici court. Also an architect and significant portraitist, his influence on other artists was felt well beyond his principal pupils Ciampelli, Cigoli, Boscoli, and Pagani.

Aeneas and Dido

Pen and brown ink over black chalk, brush with brown wash, white heightening, on light-blue paper. Inscribed in black chalk on the *verso* in a nineteenth-century hand: *Venus & Adonis*
212 × 171 mm

The Trustees of the British Museum

Pastoral scenes are unusual in Santi di Tito's drawings. As pointed out by Nicholas Turner, the influence of Federico Barocci is evident in Santi's treatment of the foliage, which is rendered with great subtlety of light and shade. Although in the past the subject has been identified as Venus and Adonis, it seems more likely – though not conclusively – to represent Aeneas and Dido. While out hunting one day the couple were caught in a sudden storm and became separated from the rest of the party; they sought refuge in a cave, and made love for the first time (*Aeneid* 4: 160–72). In the background can be seen members of the hunting party, and the bolting horses of the two lovers. An atmospheric light in the drawing perhaps represents the storm.

Santi's influence was widespread, and the effect of drawings such as this, in technique, figure type, and mode of composition, can be seen in the work of his pupils Boscoli, Ciampelli, and Pagani (cf. cats.19–22, 30, 64).

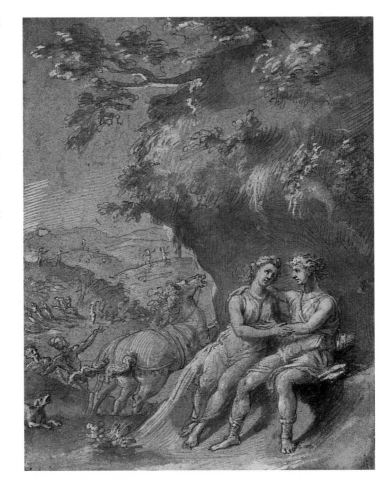

Provenance: Purchased by the British Museum, 1981, inv.1981-10-3-14

Exhibited: London, 1986, no.187

Select literature: Turner in London, 1986, p.241, no.187, ill.p.242

The Holy Family with the young St John the Baptist

Pen and brown ink, brush with grey-brown wash, white heightening, on pink prepared paper. Inscribed in ink at upper right: *89* and *Santi Titi fioro.*; in ink at lower lower left: *102* and *Sti Titi*
184 × 140 mm

The Visitors of the Ashmolean Museum

The intimate character and the setting of the figures close to the picture plane in this drawing show that it was intended as a study for a small-scale private devotional painting. Santi di Tito and his efficient studio specialized in such pictures, producing them in large quantities. The simple pyramidal composition shows the degree to which the reformer Santi looked back to works by Andrea del Sarto and Raphael. There are a large number of preparatory drawings of this subject by Santi in the Uffizi, mainly quick ink studies exploring various solutions to the composition, and obviously intended for a number of different works. The present sheet – with its pink prepared paper – is relatively highly finished, and may have been intended to show to a patron.[1] Parker signalled the existence of a larger-sized replica of cat.76 in the same technique.[2]

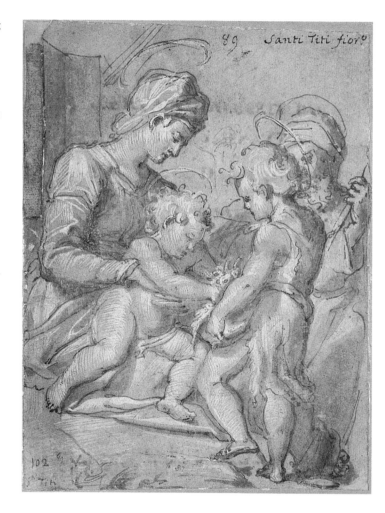

Provenance: Resta-Marchetti-Somers (L.2981); H.M. Roland; purchased by the Ashmolean Museum, 1952, inv.WA1952.97 (P.II 720)

Exhibited: Florence, 1980 (Primato), no.504

Select literature: Parker, 1956, p.386, no.720, pl.CLX; Forlani Tempesti in Florence, 1980 (Primato), p.208, no.504

1. Other highly finished sheets are Uffizi, inv.770 F and 754 F, compared to the exploratory nature of inv.7748 F. Parker believed the prominent inscription on the Ashmolean drawing to be by the same hand as that on several drawings in the Uffizi (e.g.770 F); this does not seem to be the case; in particular the formation of the letter T is different.
2. This was sold at Sotheby's, London, 28 January 1953, lot 29 (as Bedoli), and was on the London art market in 1989 (advertisement in the *Burlington Magazine*, June 1989).

77 JAN VAN DER STRAET or STRAETEN, called GIOVANNI STRADANO or STRADANUS (Bruges 1523 – 1605 Florence)

A pupil of Pieter Aertsen in Antwerp, Stradanus travelled to Florence via France and Venice in the 1540s. Entering the circle of artists around Vasari, whom he helped in the decoration of the Palazzo Vecchio, Stradanus became an important figure at the Medici court. His skill in narrative and invention, and his Northern connections, led to his specialization in tapestry and print design. The latter particularly spread his fame and influence.

The alchemist's laboratory

Pen and brown ink over black chalk, brush with brown wash, white heightening (partly oxidized), on yellow-prepared paper
302 × 219 mm

The Royal Collection

This is a preliminary drawing for the panel showing a busy alchemist's laboratory painted by Stradanus in 1570 for the Studiolo, a small study leading off the Sala del Cinquecento in the Palazzo Vecchio, Florence (fig.49).[1] With a decoration based around a complex iconography of the four Elements, the Studiolo was built by Grand Duke Cosimo as a private study for Prince Francesco de' Medici. The young prince was particularly interested in alchemy, but spent more time practising it in the Medici workshops at San Marco than studying in the Studiolo. The decoration was supervised by Vasari, and undertaken principally by artists in his circle. A wealth of detail has been packed into this composition, and for the artists concerned participation was prestigious and important. In conception the Studiolo prefigured the Tribuna of the Uffizi, made only a decade and a half later.[2]

One of the most interesting aspects of this drawing is the way in which the artist has attached small pieces of paper, cut from a letter, onto the original sheet in order to be able to make changes to parts of the composition without having to re-draw the whole design. This was done after he had sketched out the design on the main sheet in black chalk, with some pen and brown ink. The additions have since been taken off and mounted so that both versions of the composition can be seen. Four different pieces of paper have been added: one at the centre left to modify the position of the pots and

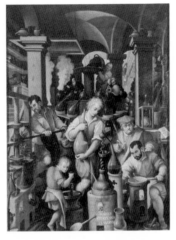

Fig.49 Giovanni Stradanus, *The Alchemist's laboratory*, 1570, oil on panel, 127 × 93 cm, Florence, Palazzo Vecchio

figure, one at the centre far right to clarify two shelves of flasks into one large one, and two joined pieces to modify the entire lower right-hand corner, replacing a man tending the flames in a small furnace with one warming material in a pan. In the painting this man is a portrait of Grand Duke Francesco, but there is no indication of this intention in the drawing. Presumably it was decided to insert Francesco's portrait at the same time as that of the pointing bespectacled man at the lower right, apparently directing the Grand Duke.[3] Given these changes, Stradanus probably made another drawing before starting to paint. Furthermore, a seated theorist in the left background has been repositioned to take account of the slightly narrower format of the painting; the

artist was aware of this after making cat.77, and has added a light vertical line in black chalk on the left side to indicate where the composition would have to be truncated.

Alchemical investigations, centred on the belief that base materials could be turned into gold, were at the time very popular. Francesco's successor Ferdinando gave less credibility to such studies, and over the coming decades belief in alchemy began to wane, thanks to the scepticism of a new type of science, which was based on the close observation of the natural world (cf. cat.8).

Provenance: King George III; Royal Library, Windsor Castle, inv.RL 12970 (van P 168, White 142)

Exhibited: Florence, 1980 (Astrologia), no.I.37

Select literature: Van Puyvelde, 1942, p.26, no.168, plate 168; Thiem, 1958, p.97; Vitzthum, 1968, pp.11–12; Schaefer, 1976, pp.414–8; Florence, 1980 (Astrologia), no.I.37; Schaefer, 1982, pp.126, 129; White & Crawley, 1994, p.76–7, no.142, plate 142; Baroni Vannucci, 1997, pp.139, 197–8, fig.114

1. Most recently studied by Feinberg in Florence, *et al.*, 2002, pp.57–75.
2. See Heikamp in Florence, 1997, pp.329–45.
3. Schaefer, 1982, p.126 suggests this might be Giuseppe Benincasa (Joseph Goedenhuis).

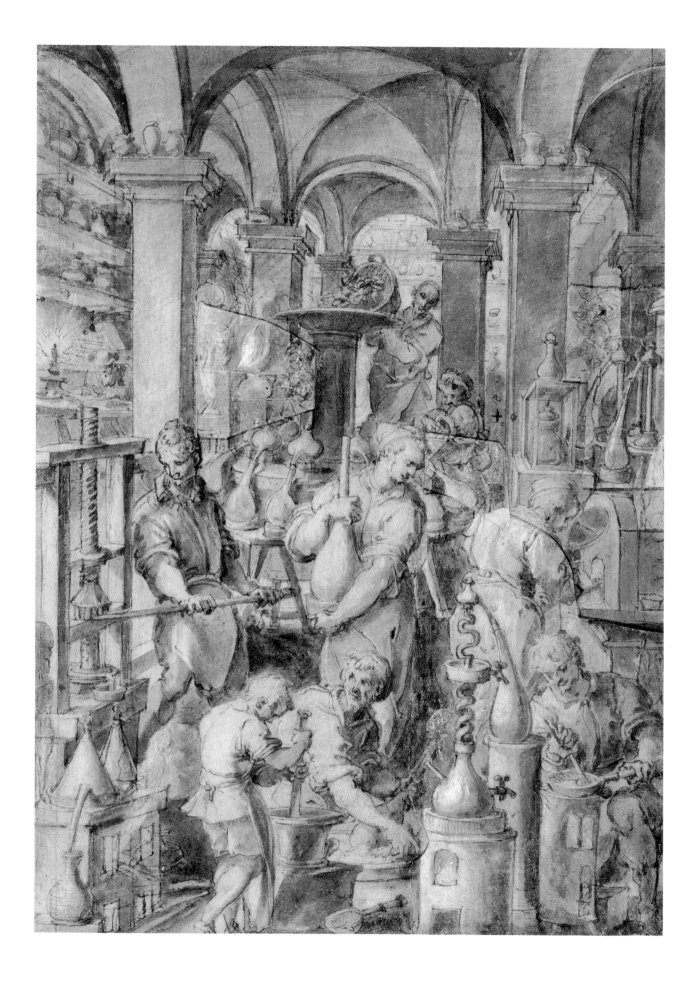

The chamois hunt

Pen and brown ink over black chalk, brush with brown wash, white heightening, on brown-prepared paper. Incised for transfer.
Signed lower right in brown ink: *Strada*
199 × 291 mm

Private Collection

Following his success with a series of tapestry designs of hunting scenes made for Cosimo de' Medici's villa at Poggio a Caiano, Stradanus undertook to design a set of prints of hunting subjects to be engraved by the Antwerp-based Philip Galle. The strong demand for the first forty-four prints (including a frontispiece dated 1578), prompted Stradanus to make a further sixty-one compositions, and these were then united to form the *Venationes Ferarum, Arium, Piscium Pugnae* (*c.*1596), one of the most famous series of hunting prints ever produced.

This drawing is Stradanus's highly-finished design for plate no.51.[1] It records the practice of hunting chamois by driving them to rocky outcrops, and killing them there with long spears, or driving them to suicide. The hunters in the left foreground strap crampons onto their bare feet to give them the required grip on the rocks, while others in the background engage the hunt with dogs. Stradanus's drawing is followed almost exactly in the print, though, as Baillie-Grohman pointed out, the firearm carried by the ascending figure on the right is depicted instead as a spear in the print; whether by accident or design is not known.

The major part of the drawings for this series, once in the collection of country sports writer William Baillie-Grohman (1851–1921), are now dispersed amongst museum and private collections, including sheets in the Louvre, Fondation Custodia, and Rijksmuseum. Many carry dates between 1580 and 1596. As Baroni Vannucci points out, there are also numerous brief studies for this series in the Cooper Hewitt Museum, New York.[2] As the Latin title implies, the prints in the series are divided into three broad categories: creatures of land, air and water. The powers of invention employed are remarkable, although much of the iconography for the series came from books such as Gaston Phébus *Livre de Chasse*; Pietro de'Crescenzi *Librum Ruralium Commodorum*, 1471, and Conrad Gesner *Historiae animalium*, Zurich, 1551.[3] Many of the themes are more ancient, deriving from Pliny's *Historia Naturalis*, a text often alluded to in the inscriptions beneath the plates.[4]

Provenance: William Baillie-Grohman (his mark, L.370, on the *verso*); Mrs Baillie-Grohman; her sale, Sotheby's, London, 14 May 1923, amongst lots 157ff.; C.F.G.R. Schwerdt; his sale, Sotheby's, London, 27 June 1939, part of lot 1305, pl.57; Marcel Jeanson; his sale, Sotheby's, Monaco, 1 March 1987, lot 517, pl.517

Not previously exhibited

Select literature: Baillie-Grohman, 1913, pp.116, 120, fig.60; Schwerdt, 1928, p.221, no.23

1. Baroni Vannucci, 1997, pp.371, 374, 380, no.493.51. The series discussed: Hollstein, VII, p.81, under nos.528–567; Bok van Kammen, 1982, pp.57–70, 231–551; The Illustrated Bartsch, 1989, 56, pp.401–44.
2. Baroni Vannucci, 1997, p.371.
3. For the present game Gaston Phébus describes a different technique involving huntsmen with crossbows standing on ridges and vantage points; Schlag, 1998, p.53 (fol.86).
4. Baroni Vannucci, 1997, pp.371, 374.

79 ANTONIO TEMPESTA (Florence 1555 – 1630 Rome)

Powerfully influenced by his master, Stradanus, Tempesta collaborated with Vasari on the decoration of the Palazzo Vecchio, and in *c.*1575 travelled to Rome, where he spent most of his career. He painted frescoes in the Vatican and in Roman churches, but is now best known for his prints of literary, hunting and historical subjects.

An ostrich hunt

Pen and brown ink over black chalk, brush with grey-blue wash. Inscribed in ink in an old hand, lower centre, partly erased: *tempesta*, and, top centre, with a number sometimes associated with the collector Lamberto Gori: *N.59=*. On *verso* in brown ink the contemporary (autograph?) truncated calligraphic beginning of a letter: *Al Illmo. Sr.*
173 × 260 mm

The Trustees of the British Museum

Provenance: ?L.Gori; ?Lawrence-Woodburn; Sir Thomas Phillipps, Bart.; T. Fitzroy Phillipps Fenwick; presented to the British Museum by Count Antoine Seilern, 1946, inv.1946-7-13-536

Exhibited: London, 1986, no.176

Select literature: Popham, 1935, p.166, no.3; Turner in London, 1986, p.227, no.176, fig.176

This dramatic and rapidly drawn sketch shows an ostrich hunt in progress, where the hapless birds are being driven into a trench by horsemen. A dog tries to scramble out of the trench, and in the background further horsemen attack another ostrich. The palm tree at the left and the turbans of the huntsmen emphasise the exotic setting of the scene.

Probably seeing the success of the printed hunting scenes produced by his master Stradanus (cf. cat.78) Tempesta produced a number of prints of these subjects himself. Although, as Turner pointed out, this drawing does not seem to relate to a known print, the ink line border which contains the drawing, with space left at the bottom for an inscription, is characteristic of a print design. The large-chested warrior horses are particularly typical of those found in Tempesta's works. Like Stradanus, he shows great powers of compositional invention in the range and number of the prints he produced.

80 FEDERICO ZUCCARI (Sant'Angelo in Vado, Marches 1540/2 – 1609 Ancona)

After being invited to Rome by his painter-brother Taddeo, with whom he trained, Federico was commissioned to paint works in the Vatican. In 1564 he worked on commissions in Venice, followed by a study trip through Lombardy with the architect Andrea Palladio (1508–80). After Taddeo's death in 1566 Federico completed a number of his brother's projects, and moved from commission to commission around the country. His sojourn in Florence 1575–9 had a significant impact on a generation of artists there. Federico also travelled abroad, studying in the Low Countries and working in England (1575) and Spain (1585–8). His mobility, extensive studio, output, and writings on art ensured his widespread influence.

The punishment of the proud

Pen and brown ink over black chalk, brush with brown and pink washes
496 × 754 mm

81

The punishment of the lustful

Pen and brown ink over black chalk, brush with brown and pink washes
507 × 753 mm

The Trustees of the British Museum

Provenance: Mr Hamilton; purchased by the British Museum, 1862, invs.1862-10-11-188 and 1862-10-11-190

Exhibited: London, 1986, nos.165, 167

Select literature: Gere & Pouncey, 1983, p.193, nos.303, 305, pls.292-3; Turner in London, 1986, p.218, nos.165, 167, fig.167; Acidini Luchinat, 1999, p.119, n.108

Following Vasari's death on 27 June 1574, the vast programme of decoration he had commenced for the interior shell of the cupola of the Duomo in Florence was left incomplete. After some deliberation, and perhaps through the good offices of the influential Bernardo Vecchietti (1514–90), Federico Zuccari was chosen by Francesco I de' Medici to finish the task, which he commenced on 30 August 1576.[1] Of the scheme of iconography devised for the huge space by Vincenzo Borghini (1515–1580), Vasari and his students had completed significant upper parts of four of the eight sections. Although Vasari had left drawings for the rest of the project, Federico drew from his own imagination and modified significantly the subjects of the lower zones, representing the seven deadly sins and the church triumphant (fig.5). Instead of Vasari's plans for animal mouths with intense jumbles of nude figures, as shown by drawings in the Louvre, Federico made striking depictions of punishments with huge figures. Pride, in the west section, is represented by Lucifer, and Lust, in the north-west, by a wild boar. The other animals were: Envy, represented by a many-headed monster, the hydra; Wrath, by a bear; Sloth, by a camel; Gluttony, by the monstrous dog of the underworld, Cerberus; and Avarice by a toad. In the background angels lead away the blessed to Paradise. Four écorché figures marking boundary divisions have been noted by Acidini Luchinat as significant in the diffusion of such images, and as reflecting interest in anatomical subjects at the time.[2] One of them (not shown here) directly illustrates a description in a text by Dante, whom Vasari had portrayed in the cupola among the Elect.[3]

These two drawings follow the painted composition almost exactly. Acidini Luchinat has noted that they might be amongst those made by Zuccari for the manufacture of prints subsequent to the unveiling of the decoration on 19 August 1579; Gere and Pouncey instead saw them as preparatory modelli for the paintings.[4] Another set of five drawings in the Albertina seem instead to be preparatory; in the drawing there of the *Punishment of the Lustful*, the écorché is unfinished, and the state of preservation reflects that of a working drawing.[5] The size of the British Museum sheets seems beyond that required for even large prints, and their high quality and finish – and remarkable state of preservation – perhaps makes them more likely to have been made by the artist as presentation drawings.

1. For the decoration of the cupola see particularly Acidini Luchinat, 1999, pp.65–102 and Heikamp, 1967, pp.44–61. The British Museum drawings were formerly attributed to Frans Floris, and were recognized as by Zuccari and related to the cupola by A.M. Hind.
2. Acidini Luchinat, 1989, pp.36–8.
3. The one at south-west west pulls apart the opening on his chest to spill his guts (*Inferno* XXVIII: 22–36), Acidini Luchinat, 1993, pp.49–50.
4. Acidini Luchinat, 1999, p.119, note 108; Gere & Pouncey, 1983, p.194.
5. Inv.14332; repr. Acidini Luchinat, 1999, p.99, fig.66.

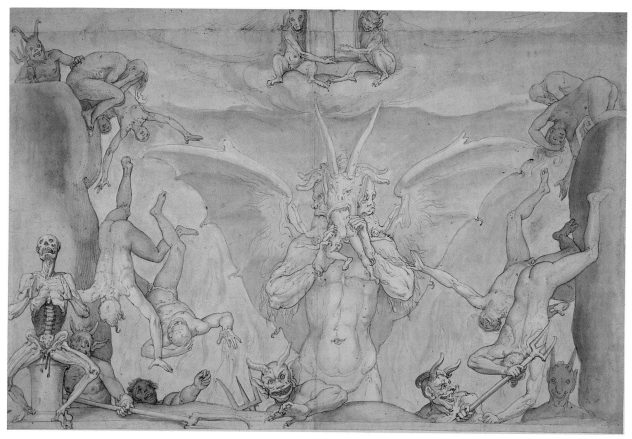

80

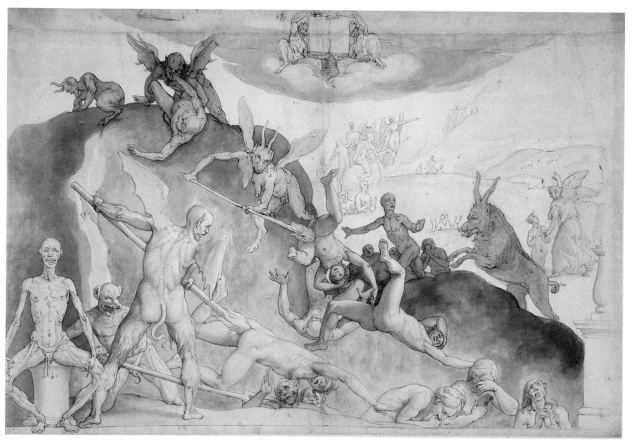

81

St John the Baptist and San Bernardo degli Uberti (after Andrea del Sarto)

Black and red chalks
187 × 122 mm

The Trustees of the British Museum

Federico was an avid copyist of the painted works of previous generations, and a devotee of Andrea del Sarto (cf. p.26). Consequently, it is not surprising that during his August breaks at Vallombrosa in 1576 and 1577 (cf. cat.83) he made several drawn copies of Sarto's altar-piece in the church of the Romitorio there, also called the *Paradisino*. This drawing is a neat and precise copy of the right-hand wing of that picture, the right edge of which is delineated by a brief black chalk line, containing Federico's hatching.

Heikamp identified another copy by Federico of the whole construction in Vienna, inscribed *Andrea del Sarto. a valle ombrosa 2 agosto.*[1] A copy of the left-hand wing is in the Art Museum, Worcester, Mass., and copies of both wings are in the Metropolitan Museum, New York.[2]

Provenance: Sir Peter Lely (L.2092); J. van Haecken (L.2517); Thomas Hudson (L.2432); William Esdaile (L.2617); his sale, Christie's, London, 18 June 1840, lot 185; Hawkins; John Malcolm (L.1489); purchased by the British Museum, 1895, inv.1895-9-15-657

Exhibited: London, 1986, no.171

Select literature: Robinson, 1876, no.216; Gere & Pouncey, 1983, pp.197–8, no.311, pl.285; Turner in London, 1986, p.222, no.171, fig.171; Acidini Luchinat, 1999, p.120, n.141

1. Albertina, inv.143; Heikamp, 1967, pp.60, 67, pl.30b; the Sarto repr. Shearman, 1965, no.86.
2. Heikamp, *idem*; Gere & Pouncey, 1983, p.198. The altar-piece was moved in 1810 to the Uffizi, where the Sarto panels are now displayed.

View of the terrace of the Badia at Vallombrosa, with Florence in the background

Black and red chalks. Inscribed in black chalk lower left: *a* and numbered *8* in brown ink. Numbered lower right: *125*.
On the *verso* in pencil: *Zuccharo*
251 × 408 mm

Edinburgh, National Gallery of Scotland

From his work in the interior of the cupola, which would have become a veritable inferno in the summer months, Federico took breaks at Vallombrosa in the forested hills outside Florence. This view from the terrace of the *Paradisino* would have been taken in the August of either 1576 or 1577, when Federico made other drawings at the monastery.[1] It shows a monk seated on the balustrade of the terrace, with a view of the Arno valley stretching behind; fainter use of black chalk and a lack of definition in the farther trees give an impression of aerial perspective. In the distance between the hills is a view of Florence; clearly visible is Brunelleschi's cupola, which was the focus of all Federico's attention (see cats.80–81). Yet from the mood of the drawing, the commission seems to have been mentally as well as physically distant. At Vallombrosa Federico made friends with many of the monks and workmen, as testified by a number of inscribed portrait drawings of them, and he included the likenesses of several in the cupola decoration.[2] He seems to have been accompanied by a number of the associates who were working with him on the cupola, and drawings in Stockholm and Vienna show them casually making drawings in the woods around the abbey.[3]

Andrews has postulated a possible provenance of this drawing with Pierre Crozat, in whose collection twenty-five drawings made by Federico 'during his travels' were listed. Sixteen of these were bought by Count Tessin and are now at Stockholm, including one of the Abbot of the Badia, dated 1576. Yet there is no specific evidence concerning our drawing's provenance from Crozat and the descriptions given in the sources are extremely vague.[4]

Provenance: Purchased by the National Gallery of Scotland, 1965, inv.D. 4895

Not previously exhibited

Select literature: Heikamp, 1967, p.60, fig.32; Andrews, 1968, p.131, fig.876; Acidini Luchinat, 1999, p.120, n.140

1. Heikamp, 1967, pp.59–61.
2. idem.
3. For example Vienna, inv.13329 *recto* and *verso*; repr.Tordella in Florence, 1997, pp.248–9, no.197.
4. Andrews, 1968, p.131.

Design for the decoration of the choir of the Duomo of Florence

Pen and brown ink over red chalk, brush with brown wash
518 × 480 mm

The Governing Body, Christ Church, Oxford

Although the decorations made by Federico in the cupola were unveiled on 19 August 1579, and fully finished on 15 October of the same year, he was already actively seeking more work in the Duomo by 6 November.[1] This drawing was one that Federico made to show to Francesco de' Medici in order to persuade him to commission the decoration of the choir of the Duomo, just under Federico's giant vault. In the end, Federico's aspirations came to nothing, perhaps because of the mixed reactions to his monumental work in the cupola, and perhaps because the *Provveditore* of the Opera del Duomo, Benedetto Busini, who disliked the artist, thought it too costly.

Given the nature of Federico's plans shown in this drawing, this may have been just as well. Despite their differences, he shared a similar view to Vasari on the preservation of works by earlier artists, and gave primacy to his own iconographic uniformity. The drawing shows no sign of the two famous marble *cantorie* of Donatello and Luca della Robbia which stood on that pier, nor of Luca's terracotta bas-relief above the door. The roundel windows are filled with small panes of clear glass, instead of the stained glass made to the designs of Ghiberti, Donatello, Paolo Uccello, and Andrea del Castagno, presumably to throw more light on Federico's cupola decorations. Federico projected a large *quadro riportato* (illusionistic framed painting) of the *Deeds of the Antichrist*, together with an organ over the door, and painted seated sibyls and prophets between the windows. Although none of this was carried out, figures of standing prophets were painted on each side of the windows for the 1589 wedding decorations by Santi di Tito, Cigoli, Poccetti, Boscoli, Boschi, Empoli, Pagani, Balducci, Passignano, and Pietro Sorri.[2]

Provenance: P.H. Lankrink (L.2090); General John Guise; Christ Church, Oxford, inv.1389 (JBS 543)

Exhibited: U.S.A., 1972–3, no.85

Select literature: Bell, 1914, p.93 (as F. Zuccaro); Heikamp, 1967, p.48, fig.18; Byam Shaw in U.S.A., 1972–3, pp.56–7, no.85; Byam Shaw, 1976, p.155, no.543, pl.296; Chappell, 1989 (Cupola), p.59; Heikamp, 1997, pp.142–44, fig.4; Acidini Luchinat, 1999, p.97, fig.69

1. Heikamp, 1967, p.47–8, and 1997, pp.142–4, whence this account is taken.
2. Chappell, 1989 (Cupola), pp.57–60.

Stucco

Abbreviations

ASF Archivio di Stato di Firenze
D.V.M. Alexandre de Vesme and Phyllis
 Dearborn Massar, *Stefano della Bella:
 Catalogue Raisonné*, New York, 1971
L. Frits Lugt, *Les Marques de Collections de
 dessins et d'estampes*, Amsterdam, 1921
L.Suppl. Frits Lugt, *Les Marques de Collections de
 dessins et d'estampes. Supplément*, The
 Hague, 1956
Louvre Cabinet des Dessins, Musée du
 Louvre, Paris
Farnesina Villa della Farnesina/Istituto
 Nazionale della Grafica/Gabinetto
 Nazionale delle Stampe, Rome
Uffizi Gabinetto Disegni e Stampe degli
 Uffizi, Florence

Select bibliography

Acanfora, 1989
Elisa Acanfora 'Sigismondo Coccapani
disegnatore e trattista', *Paragone*, 477, 1989,
pp.71–99

Acanfora, 1990
Elisa Acanfora, 'Sigismondo Coccapani, un
artista equivocato', *Antichità Viva*, xx, 1990,
pp.11–25

Acanfora, 2001
Elisa Acanfora, 'La pittura ad affresco fino a
Giovanni da San Giovanni', in ed.Mina
Gregori, *Storia delle Arti in Toscana: Il Seicento*,
Florence, 2001, pp.45–60

Acidini Luchinat, 1980
Cristina Acidini Luchinat, 'Niccolò Gaddi
Collezionista e Dilettante del Cinquecento',
Paragone, 359–61, 1980, pp.141–75

Acidini Luchinat, 1989
Cristina Acidini Luchinat, 'Federico Zuccari e
la cultura Fiorentina. Quattro singolari
immagini nella cupola di Santa Maria del
Fiore', *Paragone*, 467, 1989, pp.28–56

Acidini Luchinat, 1998
Cristina Acidini Luchinat, *Taddeo e Federico
Zuccari, fratelli pittori del Cinquecento*, vol. I, Milan
& Rome, 1998

Acidini Luchinat, 1999
Cristina Acidini Luchinat, *Taddeo e Federico
Zuccari, fratelli pittori del Cinquecento*, vol. II, Milan
& Rome, 1999

Alberti, ed.1956
Leonbattista Alberti, *On Painting*, 1435–6, ed. J.
Spencer, New Haven & London, 1956

Amsterdam, 1973
Amsterdam, Rijksmuseum, *Italiaanse Tekeningen I,
en 17de eeuw*, Amsterdam, 1973, by L.C.J. Frerichs,

Amsterdam, 1981
Amsterdam, Rijksmuseum, *Italiaanse Tekeningen
II, de 15de en 16de eeuw*, Amsterdam, 1981, by
L.C.J. Frerichs

Andrews, 1968
Keith Andrews, *National Gallery of Scotland:
Catalogue of Italian Drawings*, Cambridge, 1968

Armenini, ed.1977
Giovanni Battista Armenini, *De veri precetti della
pittura*, Ravenna, 1586, ed.Edward J. Olszewski,
New York, 1977

Arnolds, 1934
Gunther Arnolds, *Santi di Tito, pittore di
Sansepolcro*, Arezzo, 1934

Avery, 1987
Charles Avery, *Giambologna: The Complete
Sculpture*, London, 1978

Bacci, 1954
Mina Bacci, 'Qualche opere del Ligozzi',
Paragone, 57, 1954, pp.51–3

Baillie-Grohman, 1913
William Baillie-Grohman, *Sport in Art: an
iconography of sport*, London, 1913

Baker, Elam and Warwick, 2003
eds.Christopher Baker, Caroline Elam and
Geneviève Warwick, *Collecting Prints and Drawings
in Europe c. 1500–1700*, Aldershot, 2003

Baldinucci
Filippo Baldinucci, *Notizie dei professori del
Disegno*, Florence, 1688, ed.Ranalli, 1846, re-
published 1975, seven volumes, with appendix
by Paola Barocchi and index by Antonio
Boschetto.

Banti, 1977
Anna Banti, *Giovanni da San Giovanni, Pittore della
Contraddizione*, Florence, 1977

Barone, 2001
Juliana Barone,'Illustrations of figures by
Nicolas Poussin and Stefano della Bella in
Leonardo's Trattato', *Gazette des Beaux-Arts*, 143,
2001, pp.1–14

Barocchi, 1975
Paola Barocchi, Appendix (volume VII) to
Baldinucci, 1688 (ed.1846), 1975

Baroni Vannucci, 1997
Alessandra Baroni Vannucci, *Jan Van Der Straet
detto Giovanni Stradano, flandrus pictor et inventor*,
Milan & Rome, 1997

Barzman, 1989
Karen-Edis Barzman, 'The Florentine
Accademia del Disegno: Liberal education and
the Renaissance artist', in 'Academies of Art
between Renaissance and Romanticism', *Leids
Kunsthistorisch Jaarboek* V-VI, 1986–7, 'S-
Gravenhage, 1989

Barzman, 2000
Karen-Edis Barzman, *The Florentine Academy and
the Early Modern State: the discipline of disegno*,
Cambridge, 2000

Bastogi, 1994
Nadia Bastogi, 'Nuove scoperte sull'ultima attivita e sulla morte di Andrea Boscoli', *Paragone*, 1994, 527, pp.3–28

Bastogi, 1996
Nadia Bastogi, 'Regola e digressione nei disegni di altari del Boscoli' in ed.Anna Forlani Tempesti, *Altari e immagini nello spazio ecclesiale*, Florence, 1996, pp.128–141.

Baxandall, 1971
Michael Baxandall, *Giotto and the Orators. Humanist Observers of Painting in Italy and the Discovery of Pictorial Composition, 1350–1450*, Oxford 1971

Bell, 1914
Charles Bell, *Drawings by the Old Masters in the Library of Christ Church*, Oxford, 1914

Berlin, 1997
Berlin, Kupferstichkabinett, *Eine unbekante Sammlung italienischer Zeichnungen aus Berliner Privatbesitz*, Berlin, 1997, by Hein-Th. Schulze Altcappenberg

Bertani, *et al.*, 1989
Licia Bertani, *et al.*, *La Compagnia della SS. Annunziata; Restauro e restituzione degli affreschi del chiostro*, Florence, 1989

Bigongiari, 1982
Piero Bigongiari, *Il Seicento Fiorentino*, (2nd ed.), Milan, 1982

Blumenthal, 1986
Arthur Blumenthal, *Giulio Parigi's Stage Designs: Florence and the Early Baroque Spectacle*, New York, 1986

Blumenthal, 1990
Arthur Blumenthal, 'Medici Patronage and the Festival of 1589', in ed. Marilyn Aronberg-Lavin, *IL 60: Essays honoring Irving Lavin on His Sixtieth Birthday*, New York, 1990, pp.97–106

Blunt, 1956
Anthony Blunt, *Hand-list of the drawings in the Witt Collection*, London, 1956

Bok van Kammen, 1982
Welmoet Bok van Kammen, *Stradanus and the Hunt*, Ann Arbor, 1982

Borroni Salvadori, 1983
Fabia Borroni Salvadori, 'Ignazio Enrico Hugford, collezionista con la vocazione del mercante', *Annali della Scuola Normale Superiore di Pisa*, xiii, 1983, 4, pp.1025–56

Borsook, 1969
Eve Borsook, 'Art and Politics at the Medici Court, III: Funeral Decorations for Philip II of Spain', *Mitteilungen des kunsthistorischen Institutes in Florenz*, xiv, 1969, pp.91–114, 245–50

Brejon de Lavergnée, 1997
Barbara Brejon de Lavergnée, *Catalogue des Dessins Italiens, Collections du Palais des Beaux-Arts de Lille*, Paris & Lille, 1997

Briganti, 1938
Giuliano Briganti, 'Notizie e Lettere, Review of G. Arnolds Santi di Tito, 1934', *Critica d'Arte*, iii, 1938

Briganti, 1987
Giuliano Briganti, *La Pittura in Italia: Il Cinquecento*, Milan, 1987

Brooks, 1999
Julian Brooks, *The Drawings of Andrea Boscoli (c.1560–1608)*, University of Oxford, D.Phil. thesis (university microfilms), 1999

Brooks, 2000
Julian Brooks, 'Andrea Boscoli's 'Loves of Gerusalemme Liberata'', *Master Drawings*, XXXVIII, no.4, 2000, pp.448–59

Brooks, 2002
Julian Brooks, 'Santi di Tito's studio: the contents of his house and workshop in 1603', *Burlington Magazine*, cxliv, 2002, pp.279–88

Brooks, 2003
Julian Brooks, 'Boscoli in the Marches. A drawing and a document for a lost commission', *Apollo*, clvii, 2003, pp.3–5

Brückle, 1993
Irene Brückle, 'Blue-Colored paper in Drawings', *Drawing*, xv, 1993, pp.73–7

Brunetti, 1990
Giulia Brunetti, *I disegni dei secoli XV e XVI della Biblioteca Marucelliana*, Rome, 1990

Brunner, 1994
Michael Brunner, 'Imprese tardocinquecentesche di illustrazione dantesca: circostanze e motivazioni' in Acts of the conference, *Federico Zuccari. Le Idee, gli Scritti*, Milan, 1997, pp.159–70

Brunswick, 1985
Brunswick, Bowdoin College Museum of Art, *et al.*, *Old Master Drawings at Bowdoin College*, Brunswick, 1985, by David Becker

Buoncristiani, 1986
Virgilio Buoncristiani, *Agostino Ciampelli a Palazzo Corsi*, Florence, 1986

Byam Shaw, 1976
James Byam Shaw, *Drawings by Old Masters at Christ Church, Oxford*, Oxford, 1976

Caen, 1998
Caen, Musée des Beaux-Arts, *Stefano della Bella*, ed. Caroline Joubert, Paris, 1998

Cambridge, 1985
Cambridge, Fitzwilliam Museum, *The Achievement of a Connoisseur: Philip Pouncey*, Cambridge, 1985, by Julien Stock and David Scrase

Campbell, 1991
Malcolm Campbell, 'Giambologna's Oceanus Fountain: Identifications and Interpretations', in Acts of the conference, *Boboli 90*, Florence, 1991, pp.89–106

Carapelli, 1996
Riccardo Carapelli, *La perduta chiesa di Santa Cecilia in Firenze*, Florence, 1996

Carman, 1978
Charles Carman, 'An early interpretation of Tasso's 'Gerusalemme Liberata', *Renaissance Quarterly*, xxxi, no.1, 1978, p.31

Cecchi, 1997
Alessandro Cecchi, 'Per Jacopo Ligozzi disegnatore di apparati festivi e costumi teatrali', *Verona Illustrata*, x, 1997, pp.5–14

Chappell, 1971
Miles Chappell, *Lodovico Cigoli: Essays on his Career and Painting*, Ann Arbor, 1971

Chappell, 1975
Miles Chappell, 'Cigoli, Galileo, and Invidia', *Art Bulletin*, lvii, 1975, pp. 91–8

Chappell, 1981
Miles Chappell, 'Missing pictures by Lodovico Cigoli. Some problematical works and some proposals in preparation for a catalogue', *Paragone*, 373, 1981, pp.92–3

Chappell, 1982
Miles Chappell, 'On the identification of 'Crocino pittore di gran' aspettazione' and the early career of Lodovico Cigoli', *Mitteilungen des Kunsthistorischen Institutes in Florenz*, xxvi, pp.325–338

Chappell, 1983
Miles Chappell, 'On the identification of a Collector's Mark (Lugt 2729)', *Master Drawings*, xxi, 1983, pp.36–58

Chappell, 1989
Miles Chappell, 'On drawings by Ludovico Cigoli', *Master Drawings*, xxvii, 1989, pp.195–214

Chappell, 1989 (Cupola)
Miles Chappell, 'The Decoration of the cupola of the Cathedral in Florence for the wedding of Ferdinando I de' Medici in 1589', *Paragone*, 467, 1989, pp.57–62

Chappell, 1990
Miles Chappell, 'Drawing in Seventeenth-Century Florence', *Drawings*, pp.53–7, xii, 1990

Chappell, 1992
Miles Chappell, review of F. Viatte, *Dessins italiens du Musée du Louvre. Dessins Toscans XVIè – XVIIIè siècles, I, 1560 – 1640*, Paris, 1988, *Master Drawings*, xxx, 1992, pp.330–6

Chappell, 1994
Miles Chappell, 'The Shaping of Giovanni and Sigismondo Coccapani', *Antichità Viva*, xxxiii, 1994, pp.32–28

Chappell, 1998
Miles Chappell, 'Renascence of the Florentine Baroque', *Dialoghi di Storia dell'Arte*, 7, 1998, pp.56–111

Chiarini de Anna, 1976
Gloria Chiarini de Anna, 'Leopoldo de' Medici e la formazione della sua raccolta di disegni', in eds. Anna Forlani Tempesti and Anna Maria Petrioli Tofani, *Omaggio a Leopoldo de' Medici, Parte I, Disegni*, Uffizi, Florence, 1976, pp.26–39

Chiarini de Anna, 1982
Gloria Chiarini de Anna, 'Per la ricostruzione della collezione di disegni del Cardinale Leopoldo de' Medici', *Paragone*, 387, 1982, pp.44–80

Chini, 1984
Ezio Chini, *La chiesa e il convento dei Santi Michele e Gaetano a Firenze*, Florence, 1984

Ciardi, 1994
Roberto Ciardi, *La Pittura a Lucca nel primo Seicento*, Lucca, 1994

Colnaghi, 1928
Dominic Colnaghi, *A Dictionary of Florentine Painters*, London, 1928

Contini, 1991
Roberto Contini, *Il Cigoli*, Soncino, 1991

Contini, 1992
Roberto Contini, Roberto Paolo Ciardi, Gianni Papi, *Pittura a Pisa tra Manierismo e Barocco*, Milan, 1992

Corti, 1977
Gino Corti, 'Notizie inedite sui pittori fiorentini Carlo Portelli, Maso di San Friano, Tiberio Titi, Francesco Furini, Fabrizio e Francesco Boschi, Giovanni Rosi', *Paragone*, 331, 1977, pp.55–64

Dal Pozzolo, 2003
Enrico Maria dal Pozzolo, 'Cercar quadri e disegni nella Venezia del Cinquecento', in eds. Enrico Maria dal Pozzolo and Leonida Tedoldi, *Tra Committenza e Collezionismo. Studi sul mercato dell'arte nell'Italia settentrionale durante l'età moderna*, Vicenza, 2003, pp.49–65

Dearborn Massar, 1975
Phyllis Dearborn Massar, 'A set of prints and a drawing for the 1589 Medici marriage festival', *Master Drawings*, xiii, 1975, pp.12–23

Degenhart, 1955
Bernhart Degenhart, 'Die Illustrationen zum Dante', *Römisches Jahrbuch für Kunstwissenschaft*, vii, 1955

Del Bravo, 1997
Carlo del Bravo, 'Cecco Bravo: un pittore e gli angeli' in ed.Carlo del Bravo, *Bellezza e Pensiero*, Florence, 1997, pp.231–243

Del Bravo, 1999
Carlo Del Bravo, 'Il Passignano e la libertà', *Artista*, 1999, pp.150–63

Detroit, 1988
Detroit, Institute of Arts, *Sixteenth-century Tuscan drawings from the Uffizi*, New York/Oxford, 1988, by Annamaria Petrioli Tofani and Graham Smith

Doni, 1547
Antonio Francesco Doni, *Disegno del Doni partito in più ragionamenti nel quale si tratta della scoltura et pittura*, Venice, 1547

Duval, 1829
Pierre Amaury Pineu Duval, *Monuments des arts du dessin chez les peuples tant anciens que modernes, recueillis par le baron V. Denon, lithographiés; décrits et expliqués par A. Duval*, Paris, 1829

Edgerton, 1984
Samuel J. Edgerton Jr, 'Galileo, Florentine "Disegno", and the "Strange Spottednesse of the Moon"', *Art Journal*, 44, 1984, pp.225–32

Edinburgh, 2002
Edinburgh, National Gallery of Scotland; Nottingham, Lakeside Arts Centre, Djanogly Art Gallery, *Rubens Drawing on Italy*, Edinburgh, 2002, by Jeremy Wood

Ewald, 1965
Gunther Ewald, 'Studien zur Florentiner Barockmalerei', *Pantheon*, xxiii, 1965, pp.302–18

Faietti, 1999
Marzia Faietti, *Una commissione del Passignano a Tiarini?: il Martirio di Santa Caterina d'Alessandria a Napoli*, in ed. Sylvie Béguin, *Scritti di storia dell'Arte in onore di Jürgen Winkelmann*, Naples, 1999, pp.127–39

Faranda, 1986
Franco Faranda, *Ludovico Cardi, detto il Cigoli*, Rome, 1986

Feinberg, 2000
Anat Feinberg, 'Quacks and mountebanks in Stuart and Caroline drama', *Ludica*, 5–6, 2000, pp.116–126

Fileti Mazza, 1993
Miriam Fileti Mazza, *Archivio del collezionismo mediceo. Il Cardinal Leopoldo. Vol II. Rapporto con il mercato emiliano*, Milan & Naples, 1993

Fischer, 1984
Chris Fischer, *Italian drawings in the J.F. Willumsens Collection*, Copenhagen, 1984

Fischer, 2001
Chris Fischer, *Italian Drawings in the Department of Prints and Drawings, Statens Museum for Kunst: Central Italian Drawings, Schools of Florence, Siena, the Marches and Umbria*, Copenhagen, 2001

Florence, 1940
Florence, Palazzo Strozzi, *Mostra del 500 Toscano*, Florence, 1940, by Giovanni Poggi, et al.

Florence, 1959
Uffizi, *Mostra di disegni di Andrea Boscoli*, Florence, 1959, by Anna Forlani

Florence, 1969
Uffizi, *Feste e Apparati Medicei da Cosimo I a Cosimo II*, Florence, 1969, by Giovanna Gaeta Bertelà and Annamaria Petrioli Tofani

Florence, 1970
Florence, Palazzo Strozzi, *Disegni di Cecco Bravo*, Florence, 1970, by Giuseppe Cantelli & Piero Bigongiari

Florence, 1971
Florence, Palazzo Pitti, *Firenze e l'Inghilterra. Rapporti artistici e culturali dal XVI al XX secolo*, Florence, 1971, by Mary Webster

Florence, 1972
Uffizi, *Disegni di Francesco Furini e del suo ambiente*, Florence, 1972, by Giuseppe Cantelli

Florence, 1975
Florence, Palazzo Medici-Riccardi, *Il luogo teatrale a Firenze: Brunelleschi, Vasari, Buontalenti, Parigi*, Florence, 1975, eds. Mario Fabbri, Elvira Garbero Zorzi and Annamaria Petrioli Tofani

Florence 1979
Uffizi, *Disegni dei Toscani a Roma (1580–1620)*, Florence, 1979, by Miles Chappell, William Chandler Kirwin, Joan Nissman, Simonetta Prosperi Valenti Rodinò

Florence, 1980 (Astrologia)
Florence, Palazzo Strozzi, *et al.*, *La corte il mare i mercanti; La rinascita della Scienza, Editoria e Società, Astrologia, magia e alchimia*, Milan, 1980, by Cesare Ciano, *et al.*

Florence, 1980 (Poccetti)
Uffizi, *Disegni di Bernardino Poccetti*, Florence, 1980, by Paul Hamilton

Florence, 1980 (Potere/Spazio)
Florence, Forte di Belvedere, *Il Potere e lo Spazio: La scena del principe*, Milan, 1980, by Franco Borsi, *et al.*

Florence, 1980 (Primato)
Florence, Palazzo Strozzi, *Il Primato del Disegno*, Florence, 1980, by Luciano Berti, *et al.*

Florence, 1984
Florence, Palazzo Pitti, *Cristofano Allori*, Florence, 1984, by Miles Chappell

Florence, 1984 (Anatomiche)
Uffizi, *Immagini Anatomiche e Naturalistiche nei disegni degli Uffizi*, Florence, 1984, by Roberto Ciardi and Lucia Tongiorgi Tomasi

Florence, 1985
Uffizi, *Disegni di Santi di Tito (1536–1603)*, Florence, 1985, by Simona Lecchini Giovannoni and Marco Collareta

Florence, 1986
Florence, Palazzo Strozzi, *Il Seicento Fiorentino. Arte a Firenze da Ferdinando I a Cosimo III*, Florence, 1986. Vol.I *Pittura*; Vol.II *Disegno/Incisione/Scultura/Arti Minori*; Vol.III *Biografie*, eds. Giuliana Guidi and Daniela Marcucci

Florence, 1986 (Maddalena)
Florence, Palazzo Pitti, *La Maddalena tra Sacro e Profano*, Milan, 1986, by Marilena Mosco, *et al.*

Florence, 1986 (Sarto)
Florence, Palazzo Pitti, *Andrea del Sarto (1486–1530)*, Florence, 1986, by Alessandro Cecchi, *et al.*

Florence, 1991
Florence, Palazzo Pitti, *Bellezze di Firenze, disegni fiorentini del Seicento e del Settecento dal Museo di Belle Arti di Lille*, Milan, 1991, by Marco Chiarini

Florence, 1992
Uffizi, *Disegni di Lodovico Cigoli (1559–1613)*, Florence, 1992, by Miles Chappell

Florence, 1997
Florence, Palazzo Pitti, *Magnificenza alla corte dei Medici*, Florence, 1997, by Detlef Heikamp, *et al.*

Florence, 1998
Florence, Biblioteca Marucelliana, *Nuove attribuzioni, nuove acquisizioni*, Florence, 1998, by Rossella Todros, *et al.*

Florence, 1998 (Buontalenti)
Uffizi, *Bernardo Buontalenti e Firenze. Architettura e Disegno dal 1576 al 1607*, Florence, 1998, catalogue by Amelio Fara

Florence, 1999
Florence, Casa Buonarroti, *Cecco Bravo: Pittore senza regola*, Milan, 1999, by Anna Barsanti and Roberto Contini

Florence, 1999 (B.R.)
Uffizi, *I disegni della Biblioteca Riccardiana di Firenze*, Florence, 1999, by Marco Chiarini

Florence, 2001
Florence, Palazzo Pitti, *L'arme e gli amori. La poesia di Ariosto, Tasso e Guarini nell'arte fiorentina del Seicento*, Florence, 2001, by Elena Fumagalli, Massimiliano Rossi, Riccardo Spinelli, *et al.*

Florence, 2002
Florence, Palazzo Strozzi; Chicago, The Art Institute; Detroit, Institute of Arts, *The Medici, Michelangelo, and the Art of late Renaissance Florence*, New Haven & London, 2002, by Alan Darr, *et al.*

Forlani, 1963
Anna Forlani, 'Andrea Boscoli', *Proporzioni*, iv, 1963, pp.85–208

Forlani Tempesti, 1992
Anna Forlani Tempesti, 'Lodovico Buti: il quinto disegno e gli affreschi nel chiostro grande di Santa Maria Novella a Firenze', *Arte Documento*, vi, 1992, pp.251–56

Forlani Tempesti, 2001
Anna Forlani Tempesti, 'Disegni di Cecco Bravo a Pasaro' in ed. Anna Carina *et al. Mélanges en hommage à Pierre Rosenberg*, Paris, 2001, pp.185–192

Fusconi and Prosperi Valenti Rodinò, 1982
Giulia Fusconi and Simonetta Prosperi Valenti Rodinò, 'Note in margine ad una schedatura: I disegni del fondo Corsini nel Gabinetto Nazionale delle Stampe', *Bollettino d'Arte*, lxvii, 1982, pp.81–118

Gamurrini, 1685
Eugenio Gamurrini, *Istoria Genealogica delle famiglie nobili Toscane et Umbre*, Florence, 1685

Gere & Pouncey, 1983
John Gere and Philip Pouncey, *Italian drawings in the Department of Prints and Drawings in the British Museum: Artists working in Rome c.1550–c.1640*, London, 1983

Goldberg, 1988
Edward L. Goldberg, *After Vasari. History, Art and Patronage in Late Medici Florence*, Princeton, 1988

Gregori, 1962
Mina Gregori, 'Avant-propos sulla pittura fiorentina del Seicento', *Paragone*, 145, 1962, pp.21–40

Gregori, 1974
Mina Gregori, 'A cross-section of Florentine Seicento Painting; The Piero Bigongiari Collection', *Apollo*, c, 1974, pp.210–17

Gregori, 1983
Mina Gregori, 'Un pictura poesis: rappresentazioni fiorentine della 'Gerusalemme liberata' e della 'Divina Commedia', *Paragone*, 401–3, 1983, p.107–21

Gregori (Rubens), 1983
Mina Gregori, 'Rubens e i pittori riformati Toscani', in Acts of the conference, *Rubens e Firenze*, Florence, 1983, pp.46–57

Gregori, 1998
Mina Gregori, 'Federico Zuccari a Firenze: Un punto di Vista', *Paragone*, 575, 1998, pp.9–45

Gualterotti
Raffaello Gualterotti, *Descrizione del Regale apparato per Le Nozze della Serenissima Madama Cristina di Loreno Moglie del Serenissimo Don Ferdinando III Gran Duca di Toscana*, Florence, 1589

Hall, 1979
Marcia Hall, *Renovation and Counter-Reformation*, Oxford, 1979

Hanover, 1980
Dartmouth College, Hanover, N.H., *Theater Art of the Medici*, Hanover, 1980, by Arthur Blumenthal

Heikamp, 1956
Detlef Heikamp,'Arazzi a soggetto profano su cartoni di Alessandro Allori', *Rivista d'Arte*, xxxi, 1956 [1958], pp.105–55

Heikamp, 1957
Detlef Heikamp, 'Vicende di Federigo Zuccari', *Rivista d'arte*, xxxii, 1957, pp.200–15

Heikamp, 1961
Detlef Heikamp, *Scritti d'arte di Federico Zuccaro*, Florence 1961

Heikamp, 1967
Detlef Heikamp, 'Federico Zuccari a Firenze: La cupola del Duomo. Il diario disegnato', *Paragone*, 205, 1967, pp.44–68

Heikamp, 1967 (Casa)
Detlef Heikamp, 'Federico Zuccari a Firenze: Federico a casa sua', *Paragone*, 207, 1967, pp.3–34

Heikamp, 1997
Detlef Heikamp, 'Federico Zuccari e la cupola di Santa Maria del Fiore. La fortuna critica dei suoi affreschi', in Acts of the conference, *Federico Zuccari. Le Idee, gli scritti*, Milan, 1997, pp.139–57

Hodges, 1968
C. Walter Hodges, *The Globe Restored, A study of the Elizabethan Theatre*, London, 1968

Ilg, 1889
Albert Ilg, 'Francesco Terzio, der Hofmaler Erzherzogs Ferdinand von Tirol', *Jahrbuch der Kunsthistorischen Sammlungen des A.H. Kaiserhauses*, ix, 1889, pp.235–373

Ingamells, 1997
John Ingamells, *A Dictionary of British and Irish Travellers in Italy 1701–1800 Compiled from the Brinsley Ford Archive*, New Haven & London, 1997

Katritzky, 2001
Margaret Katritzky, 'Marketing Medicine, the image of the early modern mountebank', *Renaissance Studies*, xv, 2001, pp.121–153

Kemp, 1990
Martin Kemp, *The Science of Art: Optical Themes in Western Art from Brunelleschi to Seurat*, New Haven & London, 1990.

Langedijk, 1981
Karla Langedijk, *The Portraits of the Medici*, Florence, 1981–3, 3 vols.

Laver, 1932
James Laver, 'Stage designs for the Florentine Intermezzi of 1589', *Burlington Magazine*, lx, 1932, pp.294–300

Lawner, 1998
Lynne Lawner, *Harlequin on the Moon: Commedia dell'Arte and the Visual Arts*, New York, 1998

Lecchini Giovannoni, 1982
Simona Lecchini Giovannoni, 'Cosimo Gamberucci: Aggiunte al catalogo; problemi attributivi nelle cartelle di disegni di Santi di Tito degli Uffizi e del Louvre', *Antichità Viva*, xxi, 1982, pp.5–29

Lecchini Giovannoni, 1991
Simona Lecchini Giovannoni, *Alessandro Allori*, Turin, 1991

Lecchini Giovannoni, 1994
Simona Lecchini Giovannoni, 'Nuove proposte per l'attivita giovanile di Agostino Ciampelli', *Antichità Viva*, xxxiii, 1994, pp.27–31

Lille, 1989
Lille, Musée des Beaux-Arts, *Renaissance and Baroque. Dessin Italiens du Musée de Lille*, Lille, 1989, by Barbara Brejon de Lavergnée

Liverpool, 1964
Liverpool, Walker Art Gallery, *Masterpieces from Christ Church: the drawings*, 1964, with an introduction by James Byam Shaw

London, 1960
London, Matthieson Gallery, *Paintings and drawings from Christ Church (loan exhibition in aid of the Christ Church United Clubs, Kennington)*, London, 1960, catalogue by James Byam Shaw, et al.

London, 1986
London, British Museum, *Florentine Drawings of the Sixteenth Century*, London, 1986, by Nicholas Turner

London, 1994
London, Phillips, Son and Neale, *Master Drawings from the De Pass collection, Royal Cornwall Museum, Truro*, London, 1994, by Marianne Joannides

Lucca, 1968
Lucca, Museo di Villa Guinigi, *La Villa e le Collezioni*, Lucca, 1968, by Giorgio Monaco, Licia Bertolini Campetti, and Silvia Meloni Trkulja

Macandrew, 1980
Hugh Macandrew, *Catalogue of the Collection of Drawings in the Ashmolean Museum, vol.III, Italian Schools, Supplement*, Oxford, 1980

Mahon, 1947
Denis Mahon, *Studies in Seicento Art and Theory*, London, 1947

Mamone, 1991
Sara Mamone, *Il teatro nella firenze medicea*, Milan, 1991

Marabottini, 1988
Alessandro Marabottini, *Jacopo Chimenti da Empoli*, Rome, 1988

Masetti, 1962
Anna Rosa Masetti, *Cecco Bravo*, Venice, 1962

Matteoli, 1970
Anna Matteoli, 'Una biografia inedita di Giovanni Biliverti', *Commentari*, xxi, 1970, pp.326–66

Matteoli, 1974
Anna Matteoli, 'Studi intorno a Lodovico Cardi Cigoli', *Bollettino della Accademia degli Euteleti della Città di San Miniato*, lv, 1974, pp.133–206

Matteoli, 1980
Anna Matteoli, *Lodovico Cardi-Cigoli Pittore e Architetto*, Pisa, 1980

Matteoli, 1988
Anna Matteoli, 'Filippo Baldinucci Disegnatore', *Mitteilungen des Kunsthistorischen Institutes in Florenz*, xxxii, 1988, pp.353–437

Matteoli, 1990
Anna Matteoli, 'Documenti su Cecco Bravo', *Rivista d'arte*, 42, 1990, pp.95–146

McCullagh & Giles, 1997
Suzanne Folds McCullagh and Laura Giles, *Italian Drawings before 1600 in The Art Institute of Chicago*, Chicago, 1997

McGrath, 1967
Raymond McGrath, 'Some drawings by Jacopo Ligozzi illustrating Dante's 'The Divine Comedy'', *Master Drawings*, v, 1967, pp.31–5

Metz, 1798
Conrad Metz, *Imitations of Ancient and Modern Drawings from the Restoration of the Arts in Italy to the Present Time*, London, 1798

Moir, 1967
Alfred Moir, *The Italian followers of Caravaggio*, Cambridge (Mass.), 1967

Molinari, 1985
Cesare Molinari, *La Commedia dell'Arte*, Milan, 1985

Monbeig Goguel, 1977
Catherine Monbeig Goguel, 'Note sur Confortini', *Mitteilungen des Kunsthistorischen Institutes in Florenz*, xxi, 1977, pp.107–110

Monbeig Goguel, 1981
Catherine Monbeig Goguel, 'A propos de Sigismondo Coccapani', *Revue de Louvre*, iv, 1981, pp.264–69

Monbeig Goguel, 1987
Catherine Monbeig Goguel, "Le dessin encadré", *Revue de l'Art*, 76, 1987, pp.25–31

Nancy, 1992
Nancy, Musée Historique lorrain, *Jacques Callot (1592-1635)*, Nancy, 1992, by Paulette Choné, *et al.*

Newcome, 1991
Mary Newcome, "Drawings by Paggi, 1577–1600", *Antichità Viva*, xxx, 1991, pp.14–23

Nissman, 1979
Joan Nissman, *Domenico Passignano*, Ann Arbor, 1979

Oberlin, 1991
Oberlin College, Allen Memorial Art Museum; Bowdoin College Museum of Art; Dartmouth College, Hood Museum of Art, *From Studio to Studiolo*, Seattle & London, 1991, by Larry Feinberg with an essay by Karen-Edis Barzman

Olivari, 1990
Mariolina Olivari, *Faustino Bocchi e l'arte di figurar pigmei 1659-1741*, Rome, 1990

Olomouc, 2000
Olomouc (Czech Republic), *Agostino Ciampelli 1565-1630 Disegni*, Olomouc, 2000, by Milan Togner

Ottawa, 1996
Ottawa, National Gallery of Canada, *The Ingenious Machine of Nature*, Ottawa, 1996, by Mimi Cazort, Monique Kornell, and K.B. Roberts

Ottley, 1808–23
William Young Ottley, *The Italian School of Design*, London, I, 1808, II–III, 1823

Oxford, 1992
Oxford, Ashmolean Museum; Rome, Farnesina, *Old Master Drawings from the Ashmolean Museum*, Oxford, 1992, by Christopher White, Catherine Whistler, and Colin Harrison

Oxford, 2001
Oxford, Christ Church Picture Gallery, *Design into Architecture*, Oxford, 2001, by Caroline Elam

Paatz, 1940–52
Walter and Elizabeth Paatz, *Die Kirchen von Florenz*, Frankfurt, 1940–52, 6 vols.

Pagliarulo, 1996
Giovanni Pagliarulo, '"Iuvenilia" di Cecco Bravo', *Paradigmata*, xi, 1996, pp.31–48

Pagliarulo, 1997
Giovanni Pagliarulo, 'Poccetti, Vignali, Melissi tra i fogli pseudo-lippeschi alla Marucelliana', *Copyright*, 1997, pp.37–49

Paris, 1981
Musée du Louvre, *Dessins baroques florentins*, Paris, 1981, by Françoise Viatte and Catherine Monbeig Goguel

Parker, 1956
Karl Parker, *Catalogue of the Collection of Drawings in the Ashmolean Museum: II. Italian Schools*, Oxford, 1956

Passerini, 1858
Luigi Passerini Orsini de Rilli, *Genealogia e storia della famiglia Corsini*, Florence, 1858

Pesciolini, 1903
Ugo Pesciolini, *Il Chiostro Grande della SS. Annunziata di Firenze e il pittore Bernardino Poccetti*, Florence, 1903

Petrioli Tofani, 1981
Anna Maria Petrioli Tofani, 'I Montaggi', *Restauro e conservazione delle opere d'arte su carta*, Uffizi, catalogue by the Laboratorio di Restauro del Gabinetto Disegni e Stampe degli Uffizi, Florence, 1981, pp.161–180

Petrioli Tofani, 1985
Annamaria Petrioli Tofani, 'Drawings by Cigoli for the Entrata of 1608', *Burlington Magazine*, cxxvii, 1985, pp.785–6

Petrioli Tofani, 1991
Annamaria Petrioli Tofani, *Gabinetto Disegni e Stampe degli Uffizi: Inventario. Disegni di figura. 1*, Florence, 1991

Petrioli Tofani, 1992
Annamaria Petrioli Tofani, 'L'illustrazione teatrale e il significato dei documenti figurativi per la storia dello spettacolo', in Acts of the conference, *Documentary Culture: Papers from a colloquium held at the Villa Spelman, Florence 1990*, Bologna, 1992, pp.49–62

Petrioli Tofani, *et al.*, 1993–94
Anna Maria Petrioli Tofani, Simonetta Prosperi Valenti Rodinò and Gianni Carlo Sciolla, *Il Disegno. II. I grandi collezionisti*, Turin, 1993–94

Pignatti, 1977
Terisio Pignatti, *I grandi disegni italiani nelle collezioni di Oxford, Ashmolean Museum e Christ Church Picture Gallery*, Milan, 1977

Pisa, 1980
Numerous simultaneous venues, *Livorno e Pisa: due città e un territorio nella politica dei Medici*, Pisa, 1980, by Anna Matteoli, Franco Paliaga, *et al.*

Pizzorusso, 1982
Claudio Pizzorusso, *Ricerche su Cristofano Allori*, Florence, 1982

Popham, 1935
Arthur E. Popham, *Catalogue of Drawings in the collection formed by Sir Thomas Phillipps, Bart., FRS, now in the possession of his grandson, T. Fitzroy Phillipps Fenwick of Thirlestaine House, Cheltenham*, privately printed, 1935, 2 vols.

Popham & Pouncey, 1950
Arthur E. Popham and Philip Pouncey, *Italian Drawings in the Department of Prints and Drawings in the British Museum. The Fourteenth and Fifteenth Centuries*, London, 1950

Popham & Wilde, 1949
Arthur E. Popham and Johannes Wilde, *The Italian Drawings of the XV & XVI centuries in the Royal Library at Windsor Castle*, London, 1949

Poppi, 1992
Poppi, Castello dei Conti Guidi, *Jacopo Ligozzzi: Le vedute del Sacro Monte della Verna, i dipinti di Poppi e Bibbiena*, Poppi, 1992, by Lucilla Conigliello

Porter, 1995
Mary Allen Porter, *The Draftsmanship of Jacopo Chimenti da Empoli*, Ann Arbor, 1995

Pouncey, 1951
Philip Pouncey, 'A modello at Hampton Court for a fresco in Rome', *Burlington Magazine*, xciii, 1951, pp.323–24

Procacci, 1965
Ugo Procacci, *La Casa Buonarroti a Firenze*, Florence, 1965

Profumo, 1992
Roberto Profumo, *Tratto pratico di prospettiva di Ludovico Cardi detto il Cigoli*, Rome, 1992

Prosperi Valenti, 1972
Simonetta Prosperi Valenti, 'Un pittore fiorentino a Roma e i suoi committenti', *Paragone*, xxiii, 1972, pp.80–99

Prosperi Valenti, 1973
Simonetta Prosperi Valenti, 'Ancora su A. Ciampelli disegnatore', *Antichità Viva*, xii, 1973, pp.6–17

Py, 2001
Bernadette Py, *Everhard Jabach Collectionneur 1618–1695. Les dessins de l'inventaire de 1695*, Paris, 2001

Radcliffe, 1986
Anthony Radcliffe, 'The Habsburg Images: Cigoli, Terzio and Reichle', *Burlington Magazine*, cxxviii, 1986, pp.103–9

Reynolds, 1974
Thomas Reynolds, *The Accademia del Disegno in Florence: its formation and the early years*, Ann Arbor, 1974

Richa
Giuseppe Richa, *Notizie istoriche delle chiese fiorentine*, Florence, 1754–62

Robinson, 1876
John C. Robinson, *Descriptive catalogue of drawings by the Old Masters forming the collection of John Malcolm of Poltalloch*, London, 2nd edn., 1876

Rogers, 1778
Charles Rogers, *A collection of prints in imitation of drawings. To which are annexed lives of their authors, and notes*, London, 1778

Roli, 1969
Renato Roli, *I disegni italiani del Seicento: scuole emiliana, toscana, romana, marchigiana e umbra*, Treviso, 1969

Rome, 1959
Farnesina, *Disegni Fiorentini del Museo del Louvre dalla collezione di Filippo Baldinucci*, Rome, 1959, by Rosaline Bacou & Jacob Bean

Rome, 1977
Farnesina, *Disegni Fiorentini 1560–1640 dalle collezioni del Gabinetto Nazionale delle Stampe*, Rome, 1977, by Simonetta Prosperi Valenti Rodinò

San Giovanni Valdarno, 1994
San Giovanni Valdarno, Casa Masaccio, *Giovanni da San Giovanni. Disegni*, Bologna, 1994, by Ilaria Della Monica

San Miniato, 1959
San Miniato, Accademia degli Eutelèti-Palagini, *Mostra del Cigoli e del suo ambiente*, San Miniato, 1959, by Mario Bucci, Anna Forlani, Luciano Berti, Mina Gregori

San Miniato, 1985
San Miniato, *Immagini del Cigoli e del suo ambiente*, San Miniato, 1985, by Anna Matteoli

Saslow, 1996
James Saslow, *The Medici Wedding of 1589*, New Haven & London, 1996

Savioli & Spotorno, 1973
A(...) Savioli & Pierdamiano Spotorno, *Incisioni di cinque secoli per S. Giovanni Gualberto*, Vallombrosa, 1973

Schaefer, 1976
Scott Schaefer, *The Studiolo of Francesco I de' Medici in the Palazzo Vecchio in Florence*, Phd. Bryn Mawr College, 1976

Schaefer, 1982
Scott Schaefer, 'The Studiolo of Francesco I de' Medici: A checklist of the known drawings', *Master Drawings*, XX, 1982, pp.126–29

Sebregondi Fiorentini, 1982
Ludovica Sebregondi Fiorentini, 'Francesco dell'Antella, Caravaggio, Paladini e altri' *Paragone*, 383–5, 1982, pp.107–22

Shearman, 1965
John Shearman, *Andrea del Sarto*, Oxford, 1965

Spalding, 1982
Jack Spalding, *Santi di Tito*, New York & London, 1982

Spalding, 1983
Jack Spalding, 'Santi di Tito and the reform of Florentine Mannerism', *Storia dell'arte*, xlvii, pp.41–52, 1983

Strong, 1973
Roy Strong, *Splendour at Court: Renaissance Spectacle and the Theater of Power*, Boston, 1973

Strong, 1984
Roy Strong, *Art and Power: Renaissance Festivals, 1450–1650*, Berkeley, 1984

Thiem, 1974
Christel Thiem, 'Kompositionsentwürfe des Cosimo Gamberucci', *Mitteilungen des Kunsthistorischen Institutes in Florenz*, xviii, 1974, pp.383–392

Thiem, 1971
Christel Thiem, 'The Florentine Agostino Ciampelli as a draughtsman', *Master Drawings*, iv, 1971, pp.358–64

Thiem, 1977
Christel Thiem, *Florentiner zeichner der fruhbarock*, Munich, 1977

Thiem, 1983
Christel Thiem, 'Some drawings by Giovanni Biliverti and their iconography', *Master Drawings*, xxi, 1983, pp.275–89

Thiem, 1958
Günther Thiem, 'Studien zu Jan van der Straat, genannt Stradanus', *Mitteilungen des Kunsthistorischen Institutes in Florenz*, vii, 1958, pp.88–111, 155–66

Thiem & Thiem, 1964
Cristel and Günther Thiem, 'Der Zeichner Jacopo Confortini.I', *Mitteilungen des Kunsthistorischen Institutes in Florenz*, xi, 1964, pp.153–165

Thiem & Thiem, 1980
Cristel and Günther Thiem, 'Der Zeichner Jacopo Confortini.II', *Mitteilungen des Kunsthistorischen Institutes in Florenz*, xxiv, 1980, pp.79–102

Togner, 1998
Milan Togner, 'Neznaámé kresby Agostino Ciampelli pelliho v moravské sbirce' ('Disegni inediti di Agostino Ciampelli in una collezione morava'), *Uméni*, xlvi, 1998, pp.100–108

Tokyo, 1994
Japan, Tokyo Station Gallery, *et al.*, *Florentine Renaissance Drawings from Christ Church, Oxford*, Tokyo, 1994, by Lucy Whitaker (catalogue in Japanese)

Tonini, 1876
P(...) Tonini, *Il Santuario della SS. Annunziata di Firenze*, Florence, 1876

Tordella, 1996
Piera Giovanna Tordella, 'Documents inédits sur l'entrée au Musée du Louvre de la collection de dessins de Filippo Baldinucci', *Revue du Louvre*, 1996, 5/6, pp.78–87

Torre de'Passeri, 1993
Torre de'Passeri (PE), Casa di Dante in Abruzzo, *Federico Zuccari e Dante*, Milan, 1993, by Corrado Gizzi, *et al.*

Torre de'Passeri, 1994
Torre de'Passeri (PE), Casa di Dante in Abruzzo, *Giovanni Stradano e Dante*, Milan, 1994, by Corrado Gizzi, *et al.*

Turner, 1999
Nicholas Turner with Rhoda Eitel-Porter, *Italian Drawings in the Department of Prints and Drawings in the British Museum: Roman Baroque Drawings, c.1620–c.1700*, London, 1999

Turner, 2003
Nicholas Turner, 'The Italian Drawings of Cavaliere Francesco Maria Gabburri 1676–1742', in Baker, Elam and Warwick, 2003, pp.183–204

U.S.A., 1972–3
Washington, National Gallery of Art; Philadelphia, Museum of Art; New York, Pierpont Morgan Library; Cleveland, Ohio, Museum of Art; St Louis, Art Museum, *Old Master Drawings from Christ Church, Oxford*, Oxford, 1972, by James Byam Shaw

U.S.A., 1989
United States Tour, *Treasures from the Fitzwilliam*, Cambridge, 1989, by Jane Munro

Van Tuyll, 2000
Carel van Tuyll van Serooskerken, *The Italian Drawings of the 15th and 16th Centuries in the Teyler Museum*, Haarlem, 2000

Vasari-Milanesi
Giorgio Vasari, *Le vite de'più eccellenti pittori, scultori e architettori*, ed. G. Milanesi, Florence, 1878–85, 9 vols.

Vasaturo, 1973
R. Nicola Vasaturo, *et al.*, *Vallombrosa*, Florence, 1973

Vasaturo, 1994
R. Nicola Vasaturo, *Vallombrosa L'Abbazia e la Congregazione*, Florence, 1994

Vasetti, 1996
Stefania Vasetti, 'Alcune puntualiezzazioni sugli allievi di Bernardino Poccetti e un inedito ciclo di affreschi', *Annali, Fondazione Roberto Longhi*, Florence, 1996, pp.69–98

Vasetti, 2001
Stefania Vasetti with Litta Maria Medri, *Palazzo Capponi sul Lungarno Guicciardini e gli affreschi restaurati di Bernardino Poccetti*, Florence, 2001

Veldman, 1977
Ilja Veldman, *Marten an Heemskerck and Dutch humanism in the 16th century*, Maarssen, 1977

Venice, 1971
Venice, Fondazione Giorgio Cini, *Disegni Veronesi del Cinquecento*, Venice, 1971, by Terence Mullaly

Venturi
Adolfo Venturi, *Storia dell'Arte Italiana*, Milan, 1901–39, 11 vols.

Viatte, 1972
Françoise Viatte, 'Stefano della Bella: Le cinque morti', *Arte Illustrata*, xlix, 1972

Viatte, 1988
Françoise Viatte, *Musée du Louvre, Cabinet des Dessins: Inventaire general des dessins italiens III. Dessins Toscans XVI–XVIII siecles. Tome I. 1560–1640*, Paris, 1988

Vitzthum, 1972
Walter Vitzthum, *Die Handzeichnungen des Bernardino Poccetti*, Berlin, 1972

Vliegenthart, 1976
Adriaan Vliegenthart, *La Galleria Buonarroti, Michelangelo e Michelangelo Giovane*, Florence, 1976

Voss, 1920
Hermann Voss, *Die Malerei der Spätrenaissance in Rom und Florenz*, Berlin, 1920

Voss, 1928
Hermann Voss, *Zeichnungen der Italienischen Spätrenaissance*, Münich, 1928

Warburg, 1895
Aby Warburg, 'I costumi teatrali per gli intermezzi del 1589: I disegni di Bernardo Buontalenti e il Libro di conti' di Emilio de'Cavalieri', in ed.Gertrud Bing, *Gesammelte Schriften*, Leipzig, 1895, pp.259–300 (reprinted Liechtenstein, 1969)

Ward-Jackson, 1979
Peter Ward-Jackson, *Catalogue of Italian drawings in the Victoria and Albert Museum*, London, 1979

Warwick, 2000
Geneviève Warwick, *The Arts of Collecting. Padre Sebastiano Resta and the market for drawings in early modern Europe*, Cambridge, 2000

Washington, 1975
Washington, National Gallery of Art, *Jacques Callot: Prints and Related Drawings*, Washington, 1975, by Helene Diane Russell, Jeffrey Blanchard, and John Krill

Washington, 1979
National Gallery of Art, *Prints and Related Drawings by the Carracci Family: A Catalogue Raisonné*, Washington D. C., 1979, by Diane De Grazia Bohlin

Wazbinski,1987
Zygmut Wazbinski, *L'Accademia Medicea del Disegno a Firenze nel Cinquecento. Idea e istituzione*, Firenze, 1987

White & Crawley, 1994
Christopher White & Charlotte Crawley, *The Dutch and Flemish drawings of the fifteenth to the early nineteenth centuries in the Collection of Her Majesty The Queen at Windsor Castle*, Cambridge, 1994

Williams, 1989
Robert Williams, 'A treatise by Francesco Bocchi in praise of Andrea del Sarto', *Journal of the Warburg and Courtauld Institutes*, lii, 1989, pp.111–140

Wood, 1994
Jeremy Wood, 'Rubens's collection of drawings: his attributions and inscriptions', *Wallraf-Richartz-Jahrbuch*, lv, 1994, pp.333–351

Wood, 2003
Jeremy Wood, 'Nicholas Lanier (1588–1666) and the origins of drawings collecting in Stuart England', in Baker, Elam and Warwick, 2003, pp.85–121

Index of related works

Compiled by Romilly Eveleigh

This index refers to works not in the exhibition but mentioned in the catalogue entries. It is organized by location: paintings are listed with the artist and title, drawings are listed with the inventory number only.

inv.9599 F, cat.11
inv.9639 F, cat.14
inv.9649 F, cat.14
inv.9790 F, cat.74
inv.10340 F, cat.13
inv.10692 F, cat.61
inv.14316 F, cat.40
inv.15160 F, cat.65
inv.91772, cat.11
inv.433 Orn., cat.10
inv.Ms 2660A, cat.42

Villa Poggio Imperiale,
Ottavio Vannini, *Duke Cosimo II reviewing his troops*, cat.74

Frankfurt, Stadel Institute,
inv.540, cat.48

Frederikssund, J.F. Willumsens Museum,
invs.GS 730, 731, 732, 733, cat.63

Genoa, Palazzo Rosso,
inv.1822, cat.34

Impruneta, San Lorenzo delle Rose,
Andrea Boscoli, *The Miracle of St Nicholas of Bari*, cat.18

Lille,
Musée des Beaux Arts,
inv.Pl.665, cat.18
inv.1265, cat.50

London,
British Museum,
sketchbook no.201a.10, p.33, cat.12
inv.1979-10-6-85, cat.63
Courtauld Institute Galleries,
inv.3960, cat.2

Lucca, Museo Nazionale Villa Guinigi,
Passignano, *St Peter healing the lame man*, cat.68

Milwaukee, Milwaukee Art Museum,
inv.M1954.13, cat.22

Montepulciano, Sant'Agostino,
Alessandro Allori, *Resurrection of Lazarus*, cat.1

Moscow, Pushkin Museum,
inv.455/29, cat.68

Münich, Graphische Sammlung,
inv.2325, cat.67

Naples, Palazzo Serra di Cassano,
Alessandro Tiarini, *The attempted martyrdom of St Catherine*, cat.67

New York, Pierpont Morgan,
invs. IV, 178, 1958.17, cat.63

Olomouc, State Library,
inv.I./125, cat.32

Oxford, Ashmolean Museum,
inv.WA1954.49, cat.63

Paris,
Louvre,
inv.36, cat.11
inv.894, cat.55
inv.1348, cat.63
inv.1386, cat.65
inv.4416, cat.53
inv.13928, cat.13

Pisa, Santo Stefano dei Cavalieri,
Lodovico Cigoli, *Cosimo 1st receiving the robes of Grand Master of the Order of St Stephen*, cat.37
Jacopo Ligozzi, *The return of the fleet from the Battle of Lepanto*, cat.57

Pistoia
Alessandro Allori, *Resurrection of Lazarus*, cat.1

Rome,
Farnesina,
inv.F.C.127628, cat.32
Galleria Borghese,
Lodovico Cigoli, *Joseph and Potiphar's wife*, cat.39
San Giovanni dei Fiorentini,
Lodovico Cigoli, *St Jerome translating the Bible*, cat.38
Palazzo di Montecitorio,
Cecco Bravo, *Allegory of Spring triumphant over Winter*, cat.62
Vatican, Sala Regia,
Taddeo Zuccari, *Siege of Tunis*, cat.35

Prato, Sant'Agostino,
Jacopo da Empoli, *Immaculate Conception*, cat.52

St Petersburg, Hermitage,
no inv., cat.39

Truro, Royal Cornwall Museum,
inv.1928.362, cat.50

Venice
Palazzo Ducale,
Federico Zuccari, *Submission of Emperor Barbarossa to Pope Alexander III*, cat.68

Vico Val d'Elsa,
Giovanni da San Giovanni, *Flight into Egypt*, cat.59

Vienna, Albertina,
inv.143, cat.82
inv.14332, cat.81
Alessandro Allori, *Christ in the house of Martha and Mary*, cat.1

West Coburg, Graphische Sammlung,
inv.Z.2996, cat.44

List of artists represented

(catalogue numbers)

Allori, Alessandro	*1*
Allori, Cristofano	*2, 3*
Anonymous Florentine, close to Baccio del Banco	*9*
Balducci, Giovanni, called il Cosci	*4, 5*
Barbatelli, Bernardino, called Il Poccetti	*69, 70, 71, 72*
Bella, Stefano della	*6*
Bianco, Baccio del	*7, 8*
Biliverti, Giovanni	*10, 11, 12, 13, 14*
Bologna, Giovanni, called Giambologna	*15*
Boschi, Fabrizio	*16*
Boscoli, Andrea	*17, 18, 19, 20, 21, 22*
Buontalenti, Bernardo	*24, 25*
Buontalenti, Bernardo, and Andrea Boscoli	*23*
Buti, Lodovico, Attributed to	*26*
Callot, Jacques	*27*
Cantagallina, Remigio	*28, 29*
Ciampelli, Agostino	*30, 31, 32, 33*
Cardi, Lodovico, called il Cigoli	*34, 35, 36, 37, 38, 39, 40, 41, 42*
Coccapani, Giovanni	*43*
Confortini, Jacopo	*44, 45, 46, 47*
Chimenti, Jacopo di, called Jacopo da Empoli	*48, 49, 50, 51, 52*
Cresti, Domenico, called il Passignano	*67, 68*
Empoli, Jacopo da, called Jacopo di Chimenti	*48, 49, 50, 51, 52*
Gamberucci, Cosimo	*53*
Giambologna, Giovanni Bologna	*15*
Ligozzi, Jacopo	*54, 55, 56, 57*
Mannozzi, Giovanni, called Giovanni da San Giovanni	*58, 59, 60*
Montelatici, Francesco, called Cecco Bravo	*61, 62, 63*
Pagani, Gregorio	*64, 65, 66*
Passignano, Domenico Cresti	*67, 68*
Poccetti, Bernardino Barbatelli	*69, 70, 71, 72*
Rosselli, Matteo	*73, 74*
Santi di Tito Titi	*75, 76*
Stradanus, Jan van der Straat, called Giovanni Stradano	*77, 78*
Tempesta, Antonio	*79*
Zuccari, Federico	*80, 81, 82, 83, 84*

Lenders

Her Majesty Queen Elizabeth II

Cambridge
The Syndics of the Fitzwilliam Museum

Edinburgh
National Gallery of Scotland

London
The Trustees of the British Museum
Courtauld Institute Gallery
The Board of Trustees of the Victoria and Albert Museum

Oxford
The Visitors of the Ashmolean Museum
The Governing Body, Christ Church

Private Collections

Photographic credits

All photographs Copyright © The Ashmolean Museum, Oxford, with the exception of the following catalogue numbers and/or their accompanying illustrations (catalogue numbers are in *italics*):

British Museum, London
1, 4, 5, 9, 11, 16, 33, 39, 42, 46, 47, 53, 56, 58, 69, 70, 72, 75, 79, 80, 81, 82;
figs.1, 11, 12, 13, 25, 26, 27,46

The Governing Body, Christ Church, Oxford
10, 18, 26, 28, 35, 38, 40, 44, 51, 54, 55, 64, 66, 68, 73, 74, 84;
figs.3, 4

Courtauld Institute Gallery, London
7, 19, 59; fig.17

Fitzwilliam Museum, University of Cambridge
13, 36, 49, 71

Fratelli Alinari
figs.5, 7, 20, 21, 36, 42, 47

Milwaukee Museum of Art (Larry Sanders)
fig.24

Ministero dei Beni e le Attività Culturali, Florence
figs.8, 9, 18, 32

National Gallery of Scotland
41, 45, 62, 83; figs.6, 10

Photo © RMN
fig.2

Royal Collection © 2003 Her Majesty Queen Elizabeth II
17, 52, 67, 77

The Board of Trustees of the Victoria and Albert Museum
14, 23, 24, 25, 27, 65

Warburg Institute, London
figs.15, 19, 31, 44